# HOW TO CREATE
# MANGA

T0013681

## THE ULTIMATE BIBLE
## FOR BEGINNING ARTISTS

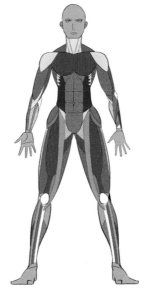

# DRAWING THE HUMAN BODY

With Over **1500** Illustrations

*MATSU*

**TUTTLE** Publishing

Tokyo | Rutland, Vermont | Singapore

# Contents

## PART 1
## The Basics

## PART 2
## Drawing Faces

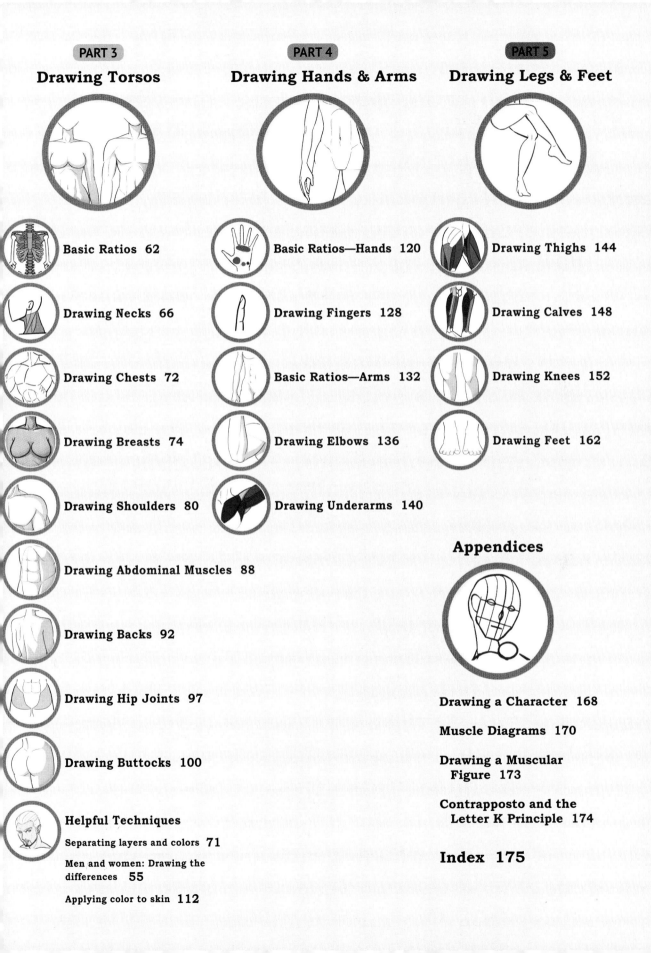

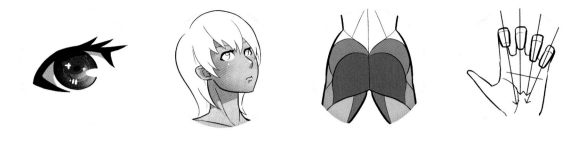

# Why I Wrote This Book

You may have picked up a manual like this one before in the hopes of learning to draw better. But not all manuals will suit your needs. Some leave you with no more understanding of the content than when you first opened them. I have had this experience myself, often becoming irritated at manuals that offer only vague explanations or skim over crucial aspects of what I want to know.

After this happened several times, I decided to use the notes I'd taken in the course of my own research to put together a book on how to draw. I used it as a reference when I was drawing.

Two years ago, with my "Notes on How to Draw" as a base, I began broadcasting a drawing course on the live streaming platform Nico Nico Live. The program has since moved to YouTube and has attracted a lot of viewers, allowing me to find out what's important to people who are just starting to draw as well as their problems and stumbling blocks.

This book brings all the knowledge gained from these experiences into one volume. I believe that the most important thing when drawing a character is the preparatory sketch, with blocking-in also crucial in order to achieve accuracy. It's the elements in

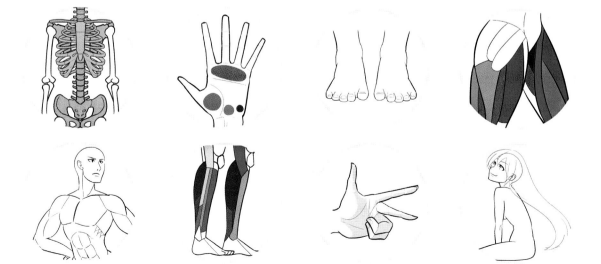

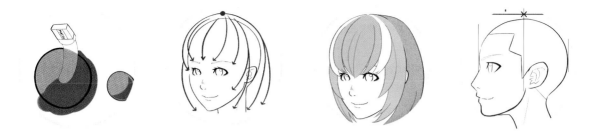

the blocking-in that make a figure look human, and if the blocking-in is accurate, you won't have problems with the sketch. And if the sketch is right, the stages that follow such as rough drawing and adding in lines will be problem-free.

In this book, I have omitted the explanations about complex anatomical structures that are studied in medicine, and I cover only the parts of the body compositions that are useful for sketching and blocking-in. By following the steps involved in blocking-in a simplified anatomical structure, you will learn how to compose and fill in a human figure when creating a character illustration. This will allow you to pursue sketching with more confidence.

Further, instead of vaguely introducing the shape and form of various body parts, I have detailed why they are a particular shape and incorporated examples of bad drawing and points to watch out for. There's also advice that will help you improve your skill level, with descriptions of more detailed anatomical compositions allowing those at an intermediate level and beyond to gain a deeper understanding.

It's my hope that this book will result in fewer frustrated readers and that drawing will lead you to new discoveries.

— **Matsu**

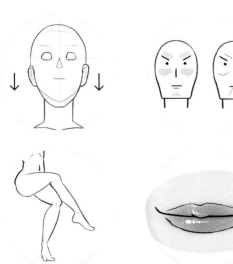

# How to Use This Book

In this book, the drawing and sketching of various body parts is explained along with how to block-in these parts as part of the process. If you're a digital artist, the paint software used is Paint Tool SAI version 1.2.5.: the basic functions are covered here, so you can adapt the tips to your chosen software.

**The steps needed to draw each body part are explained. The sketch takes shape, starting from Step 1 .**

**Q Critical Point**
Knowledge and techniques to master

**This section gives a detailed analysis of anatomical structure and introduces the body parts and their various related ratios.**

✓ = good example
X = bad example

**This feature gives effective and ineffective examples of blocking-in and sketching.**

**Red lines**
Lines to be drawn at this stage of the composition.

**Green lines**
The lines drawn one step before this stage of the composition.

**Q Critical Point** — Knowledge and techniques to master

**Helpful Hint** — Information to help you improve

**Tips & Tricks** — Tips and tricks to boost your skills even further. You can skip these if you like

**Digital Tools** — Information on using the digital paint tool

**Helpful Techniques**
Illustration techniques used in drawing a range of body parts.

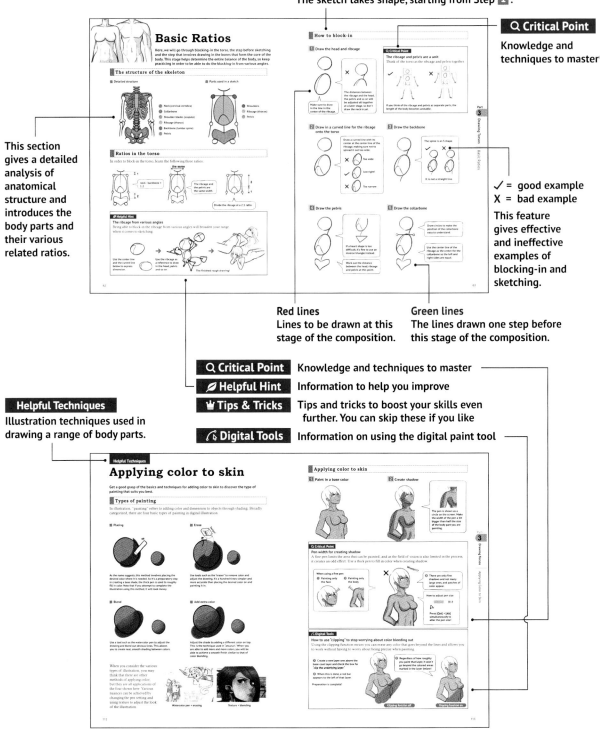

# The Basics

**Anatomical Ratios**

**The Five Basic Steps**

**Important Body Parts**

**Helpful Tips and Tricks**

# Anatomical Ratios

Here, we look at the anatomical ratios you'll need to know in order to draw people accurately and realistically—either complete figures or partial ones. Maintaining the ratios of hand to arm and hand to face is the first step in accurately drawing the human figure.

## Basic ratios

I'm using a character whose height is about seven times that of his head in order to introduce the basics of anatomical ratios. These ratios don't have to be followed exactly of course. Just use them as a guide when creating various characters.

■ Divide the body in half (1:1) with the crotch at the center

■ Chest : waist = 5:4

These are nearly equal in length, but the chest should be slightly longer.

5

4

It's not a mistake to make the legs slightly longer than this, but if they're overextended, the figure will become alien-like.

■ Thighs : calves : feet = 3:3:1

3

It's also fine for the ratio to be thighs = calves + feet.

3

1

If the body ratio goes to 4:6 with the crotch at the center, it's difficult to achieve balance in the legs.

1

1

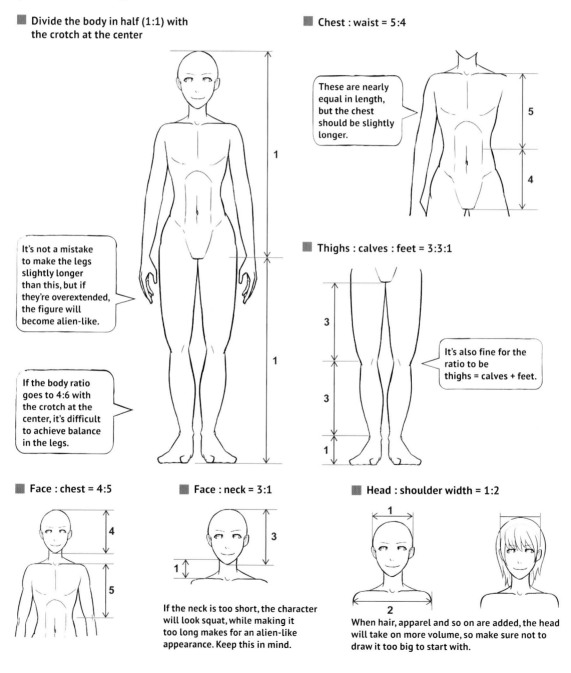

■ Face : chest = 4:5

4

5

■ Face : neck = 3:1

3

1

If the neck is too short, the character will look squat, while making it too long makes for an alien-like appearance. Keep this in mind.

■ Head : shoulder width = 1:2

1

2

When hair, apparel and so on are added, the head will take on more volume, so make sure not to draw it too big to start with.

# Hand and arm lengths

In order to maintain anatomical proportions, the most important ratios to consider are the length of the hands and the arms. Even if the other parts of the body are a bit off, the overall illustration will appear to be in proportion as long as these are correct. Use these to design physiques to suit your taste.

## ▌ Hand, forearm and upper arm ratios

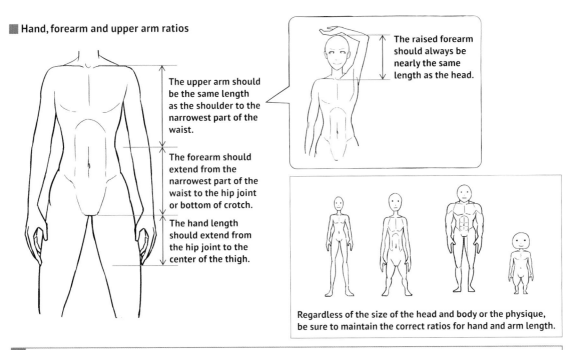

The upper arm should be the same length as the shoulder to the narrowest part of the waist.

The forearm should extend from the narrowest part of the waist to the hip joint or bottom of crotch.

The hand length should extend from the hip joint to the center of the thigh.

The raised forearm should always be nearly the same length as the head.

Regardless of the size of the head and body or the physique, be sure to maintain the correct ratios for hand and arm length.

# Hand and head ratios

It's also important to make sure the hand length and the size of the head match up. The hands should be nearly the same size as the head from chin to hairline.

For male characters, the hands can be slightly bigger than the head.

Pay particular attention to detail when drawing figures in closeup or from the waist up, as they will look strange if the balance between hand and face is not correct.

### ✐ Helpful Hint

**Relationships between feet, face and hands**
Here, we look at the relationship between the feet and face and between the ankles and hands. It's not as important as that between the hands and face, but it's still important to know.

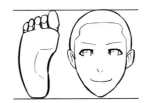

The length of the feet is about the same as the height of the head.

The height of the ankles is about the same as the length of the palm of the hand.

# The Five Basic Steps

Here, we look at each step involved in the process of drawing a character, with emphasis placed on the processes of blocking-in and sketching.

### 1 The blocking-in stage

Draw the body parts that correspond to the bone structure. This line drawing is called the blocking-in. Keeping the anatomical ratios in mind, decide on the length of various body parts and the character's pose.

> If you measure the length of a body part accurately, you don't need to follow the lines of the bones.

**Q Critical Point**

**Make the blocking-in easier to see**
When body parts are layered one over the other, use different colors to make things easier to see and understand.

### 2 Completing the sketch

> This is the process of deciding on the fullness of each body part, and where it's positioned. You could think of it as adding muscle to the blocking-in (bones).

**Q Critical Point**

**Create realistic muscles**
Once you can depict the shape and size of muscles in accurate detail, you'll be able to draw realistic human figures.

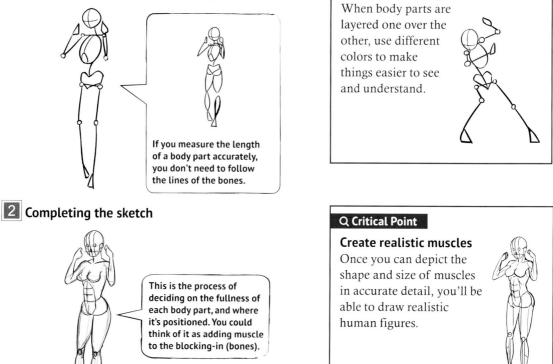

### 3 Drawing the rough illustration

### 4 Completing the line drawing

### 5 Filling in the color

> At the same time you draw in the body, decide on the character's defining details, such as hair and clothing, and roughly sketch them in too.

> Use the rough illustration as a guide to neatly draw in the lines.

> Paint in the color however you like to complete the illustration!

## Sketching your characters

When you're just starting out, divide your sketching into two steps. First, decide on the general shape and size of the body parts and, second, fill in the muscles.

### Step 1

As you're only deciding the approximate shape and size of the body parts, this part can rough.

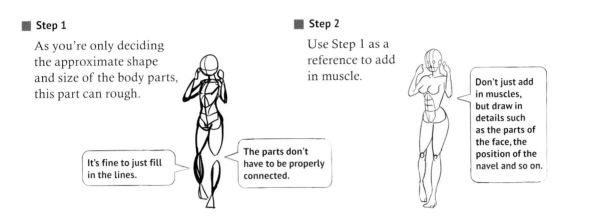

It's fine to just fill in the lines.

The parts don't have to be properly connected.

### Step 2

Use Step 1 as a reference to add in muscle.

Don't just add in muscles, but draw in details such as the parts of the face, the position of the navel and so on.

## How to think about sketching body parts

The more you keep in mind the body's details, including muscles, joints and bones, and attempt to depict a realistic human figure as you draw, the more you will achieve a natural-looking illustration.

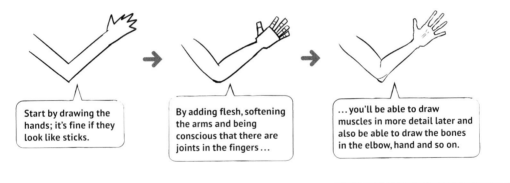

Start by drawing the hands; it's fine if they look like sticks.

By adding flesh, softening the arms and being conscious that there are joints in the fingers ...

... you'll be able to draw muscles in more detail later and also be able to draw the bones in the elbow, hand and so on.

### 🖌 Digital Tools

**Reduce the degree of opaqueness in each drawing layer**

As you complete the blocking-in, sketching and rough drawing stages, select the appropriate layer and adjust the [opaqueness] bar in the center of the [connect layers] panel to reduce the level of opaqueness.

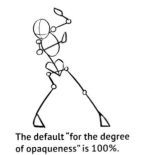

The default "for the degree of opaqueness" is 100%.

This shows the degree of opaqueness set at 50%. At 0%, the image disappears entirely.

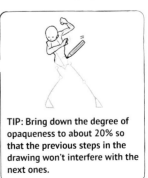

TIP: Bring down the degree of opaqueness to about 20% so that the previous steps in the drawing won't interfere with the next ones.

# Important Body Parts

When sketching, you can avoid making mistakes by paying particular attention to these eight parts of the body. The explanations in this section are more in-depth than in Part 2, so make sure you get a basic understanding first before moving on to the more complex renderings ahead.

## The clavicle

The clavicle is a reference point when drawing shoulder width, chest muscles and other upper-body sections. It also creates a pivot point for the upper body that informs the direction and slant of the body.

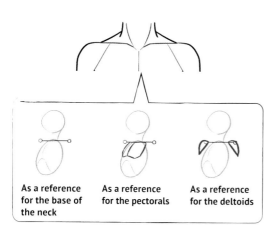

As a reference for the base of the neck

As a reference for the pectorals

As a reference for the deltoids

## The pelvis

The pelvis supports the base of the hip joints. It gives a lot of people trouble when they attempt to sketch it.

The pelvis is the reference when drawing the hip joints, so make sure to get it right.

## The shoulders

Stretching from the chest to the arms and connecting to the back, the shoulders often can present a problem. In order to draw a pose involving movement, it's crucial to understand how the shoulders work.

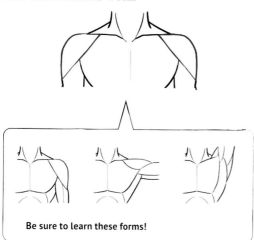

Be sure to learn these forms!

## The abdominal muscles

The abdominals are important as they help indicate volume around the torso. The thickness of the upper body is set by the lines that the abdominals create.

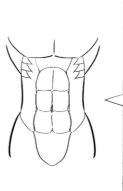

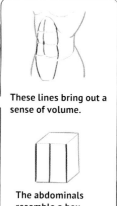

These lines bring out a sense of volume.

The abdominals resemble a box.

## The arms

The arms are important for adjusting overall balance. The length of the arms influences the balance of the entire body.

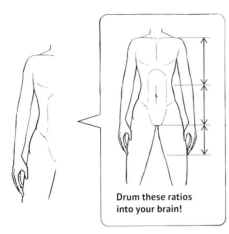

Drum these ratios into your brain!

## The hands

The hands highlight one's drawing ability to such an extent that it's said a person's skill at illustration can be seen in the hands that they draw.

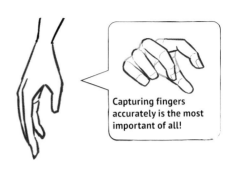

Capturing fingers accurately is the most important of all!

## The thighs

The thighs connect the buttocks to the knees. Depending on the degree to which the legs are bent, the thighs need to be depicted at different angles. So in addition to grasping their structure, you'll also need to understand their dimensions.

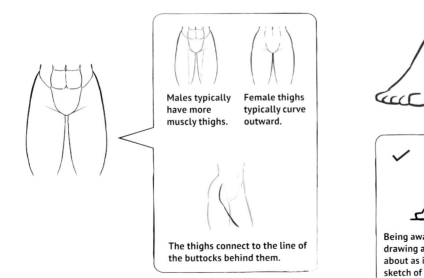

Males typically have more muscly thighs.

Female thighs typically curve outward.

The thighs connect to the line of the buttocks behind them.

## The feet

The feet of course plant your figure firmly on the ground. It's important to know about their structure in order to achieve balance between the figure and the ground.

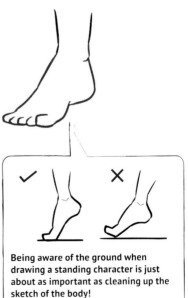

Being aware of the ground when drawing a standing character is just about as important as cleaning up the sketch of the body!

# Helpful Tips and Tricks

Here, we look at the common mistakes that beginners make when sketching, along with basic digital techniques that are helpful when sketching for illustration.

## Blocking-in is a must

You may think that blocking-in is a waste of time, but for people who have just started drawing, it actually takes more time and effort to create a drawing without it.

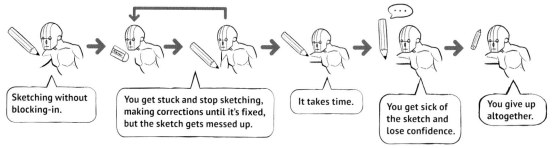

Sketching without blocking-in.

You get stuck and stop sketching, making corrections until it's fixed, but the sketch gets messed up.

It takes time.

You get sick of the sketch and lose confidence.

You give up altogether.

Sketching after blocking-in takes less time and results in a neater illustration. Sketching without blocking-in is something to try after you've become accustomed to the technique.

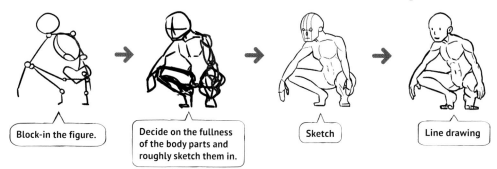

Block-in the figure.

Decide on the fullness of the body parts and roughly sketch them in.

Sketch

Line drawing

### 🖉 Digital Tools

**Reverse the images to check if it is correct**

Once the sketch is finished, one way of checking whether anything looks awkward or unrealistic is to reverse it or generate a mirror image. When you've been working on a sketch for a while, your eyes become accustomed to it and you won't notice any oddities, so reverse the image and check it from a fresh perspective.

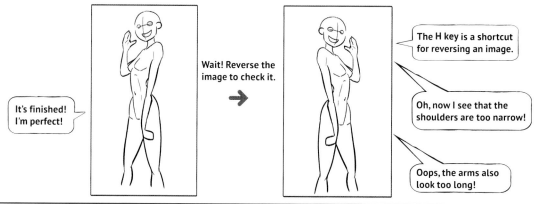

It's finished! I'm perfect!

Wait! Reverse the image to check it.

The H key is a shortcut for reversing an image.

Oh, now I see that the shoulders are too narrow!

Oops, the arms also look too long!

# Don't fill up the entire page or screen

If you start drawing without really thinking about it, you may try to fill up the entire space and your figures will become distorted. Here are two ways to solve the problem.

■ **Draw a smaller figure first**

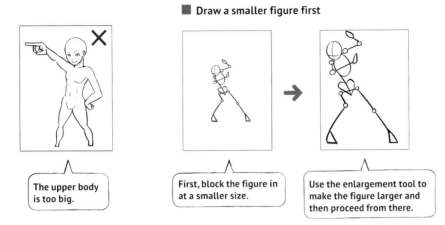

The upper body is too big.

First, block the figure in at a smaller size.

Use the enlargement tool to make the figure larger and then proceed from there.

■ **Change the canvas size as you go**

Another method is to alter the page or canvas size, extending it as you draw, then making adjustments.

Enlarge!

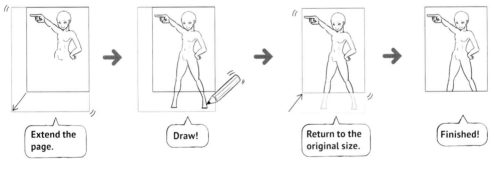

Extend the page.

Draw!

Return to the original size.

Finished!

---

**🖊 Digital Tools**

## Altering the size of illustration layers

From the menu bar, choose [Layer], then [Alter Shape] (you can also use [ctrl] + [T])

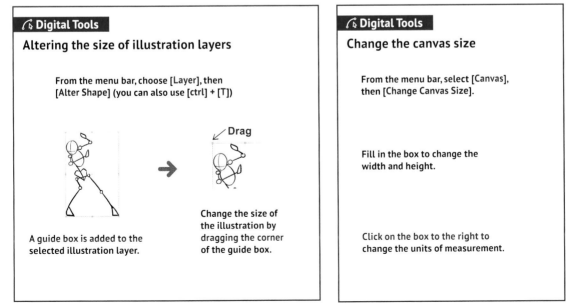

Drag

A guide box is added to the selected illustration layer.

Change the size of the illustration by dragging the corner of the guide box.

---

**🖊 Digital Tools**

## Change the canvas size

From the menu bar, select [Canvas], then [Change Canvas Size].

Fill in the box to change the width and height.

Click on the box to the right to change the units of measurement.

# Always use reference materials

Our memories tend to be a bit random and can be influenced by emotion, so they're not always reliable. When you're just starting out, using vague images from memory as your starting point is unlikely to lead to satisfactory results. Looking at reference materials as you draw will enable you to create a more accurate sketch and will improve your efficiency, as you won't need to waste time trying to remember how something looks or making errors in your drawing.

You can also ask someone to be a model!

# Making use of selection tools

Using selection tools is effective when correcting blocking-in or rough sketches. However, if you rely solely on these tools, you will never gain a deeper understanding of the human figure and it will take longer for you to improve your drawing skills. So use them only for correcting your drawings during the blocking-in and rough sketch stages.

■ Selection tool basics

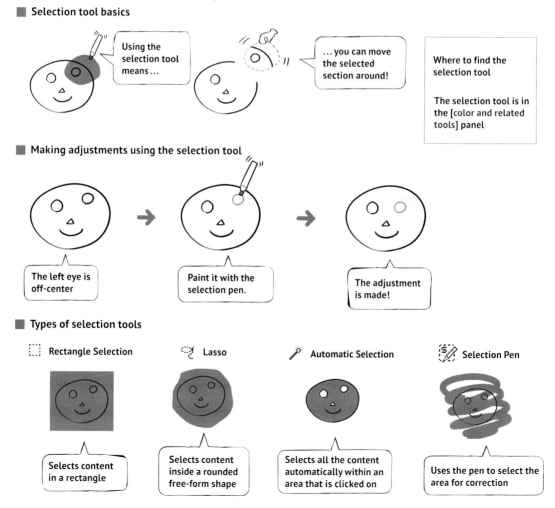

Using the selection tool means...

...you can move the selected section around!

Where to find the selection tool

The selection tool is in the [color and related tools] panel

■ Making adjustments using the selection tool

The left eye is off-center

Paint it with the selection pen.

The adjustment is made!

■ Types of selection tools

Rectangle Selection  Lasso  Automatic Selection  Selection Pen

Selects content in a rectangle

Selects content inside a rounded free-form shape

Selects all the content automatically within an area that is clicked on

Uses the pen to select the area for correction

PART 2

# Drawing Faces

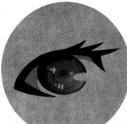

**Basic Ratios**

**Drawing Eyes**

**Drawing Eyebrows**

**Drawing Noses**

**Drawing Mouths**

**Drawing Lips**

**Drawing Teeth**

**Drawing Ears**

**Drawing Hair**

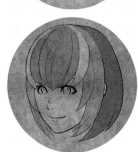

# Basic Ratios

There are certain basic principles for drawing faces, whether male or female. Here, we get an understanding of the various fundamental ratios of human faces before drawing them from various angles.

## Ratios in a face viewed from the front

These are the ratios you will need to master in order to sketch a face from the front.

The distance between the eyes should be the width of half an eye to one eye.

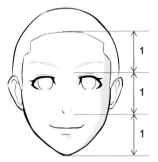

The distance from hairline to eyelid, eyelid to below the nose and below the nose to the chin should be the same.

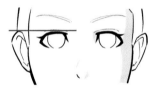

Ears and eyes are at the same level.

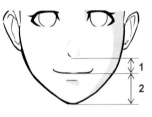

The distance from the nose to mouth is half the distance from the mouth to bottom of the chin.

nose~mouth : mouth~chin = 1:2

---

### 🔍 Critical Point

**Degrees of distortion**

The degree to which a face is distorted depends on how much detail is given to its parts and how effectively the shadows created by the bone structure and hollows are replicated. It's important to decide on the style of drawing you want and to what extent you want to distort it.

■ **Examples of distortion**

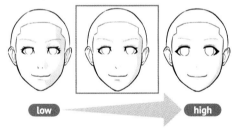

low → high

---

### ✒ Helpful Hint

**Parts that look more realistic with shadows added**

It's standard practice to add shadows to the sides of the nose and between the lips and chin.

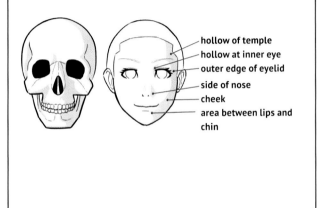

- hollow of temple
- hollow at inner eye
- outer edge of eyelid
- side of nose
- cheek
- area between lips and chin

# Ratios in a face viewed in profile

In order to sketch a face in profile, these are the basic ratios you'll need.

**The distance between the eyes and ears is twice the width of an eye seen in profile.**

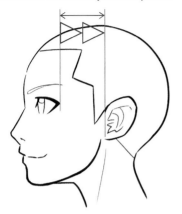

**The end of the curve of the chin is roughly in line with the mouth.**

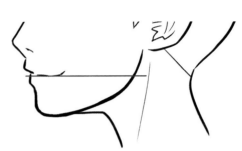

**The top of the ears and eyes are the same level.**

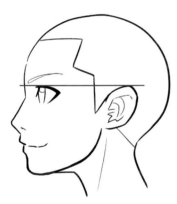

**The distance from the forehead to the front of the ear and from the front of the ear to the back of the head is the same.**

1    1

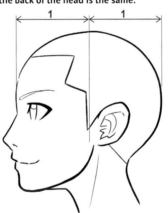

## Shape of the head

When viewed from the side, the head is oval in shape.

It's not a perfect circle.

**The mouth and nose both protrude from the outline of the face in profile.**

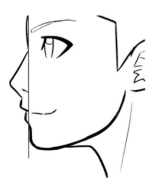

### ✐ Helpful Hint

**E line**

The line connecting the nose and chin is called the E line (esthetic line). If the lips fit within this line, the profile is well-proportioned.

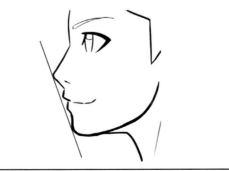

# Drawing faces from the front

## 1 Draw a circle and add in lines through the center

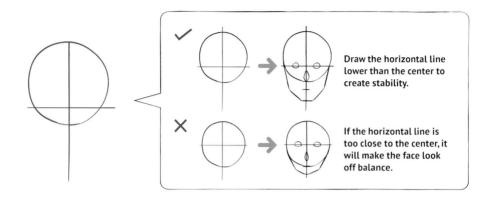

Draw the horizontal line lower than the center to create stability.

If the horizontal line is too close to the center, it will make the face look off balance.

## 2 Draw vertical lines on both edges of the circle

**For men**

The length of the face

**For women**

The diameter : face length = 3:2

## 3 Join the vertical lines

This square forms the foundation for the outline of the face.

## 4 Draw the nose

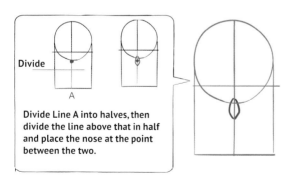

Divide

A

Divide Line A into halves, then divide the line above that in half and place the nose at the point between the two.

### Q Critical Point

#### The nose is a reference point

Deciding in advance where to place the nose makes it easier to draw faces seen from an angle. It's not true only for the nose—draw the face by starting with the parts in the center and then extending out to achieve a good balance more easily.

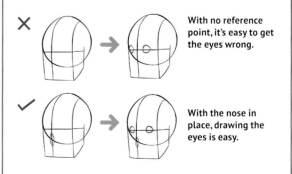

With no reference point, it's easy to get the eyes wrong.

With the nose in place, drawing the eyes is easy.

## 5 Draw the eyes

For how to decide the positioning of the eyes, see "Drawing Eyes" on page 28.

For how to decide the positioning of the eyes, see "Drawing Eyes" on page 28.

**Q Critical Point**

### The relationship between the face and the width of the eyes

The distance between the eyes is from about half to one eye's width.

From the outer corners of the eyes to the edge of the face is about half an eye's width.

## 6 Draw the mouth

Refer to the face ratios on page 18 to work out where to place the mouth.

Refer to the face ratios on page 18 to work out where to place the mouth.

## 7 Draw two vertical lines to ensure symmetry

Draw these in a separate layer so they can be erased immediately.

Decide the width of the chin by using two vertical lines.

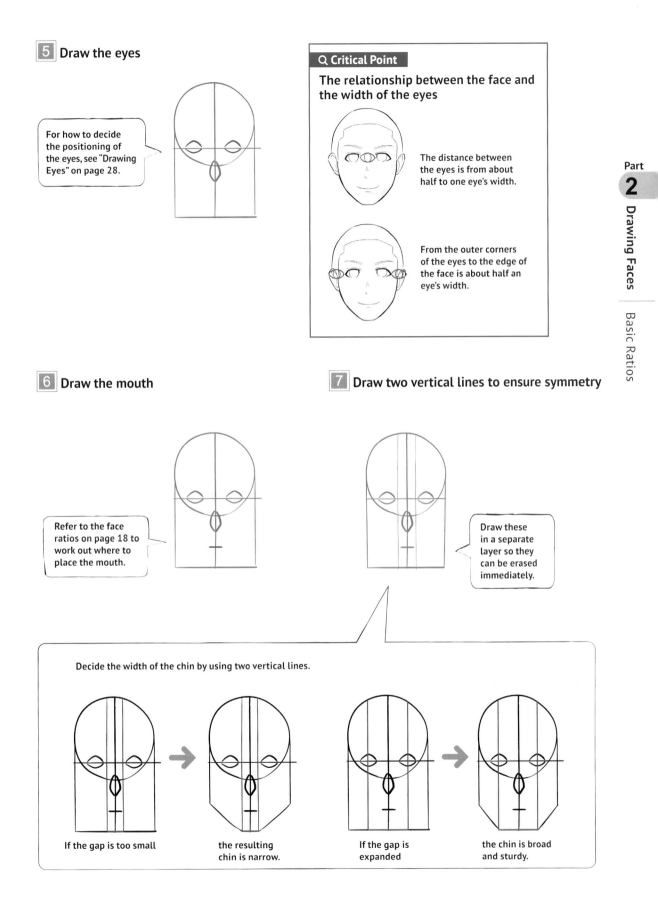

If the gap is too small | the resulting chin is narrow.

If the gap is expanded | the chin is broad and sturdy.

**8** Draw a horizontal line at about the line of the cheeks

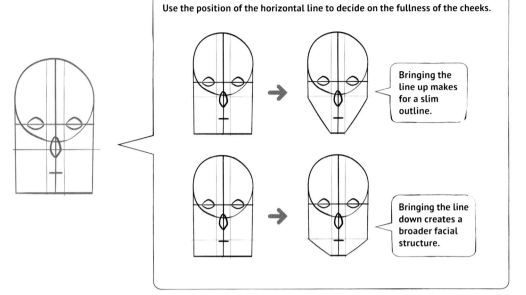

Use the position of the horizontal line to decide on the fullness of the cheeks.

Bringing the line up makes for a slim outline.

Bringing the line down creates a broader facial structure.

**9** Create the facial outline by joining the line from the cheeks to the chin

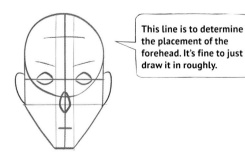

Make sure left and right are the same so the outline is symmetrical.

**10** Draw in the brows and ears

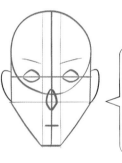

The brows are crucial parts of the face for determining expression. Refer to "Drawing Eyebrows" on page 36 to create a defined shape.

**11** Draw in the hairline to complete the sketch

This line is to determine the placement of the forehead. It's fine to just draw it in roughly.

**12** Use the sketch as a guide to create the rough drawing

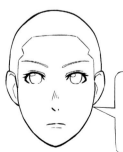

Draw in the eyes, nose and other parts in the areas previously decided and proceed with the rough drawing.

# Drawing faces from an angle

## 1 Draw a circle with a line through it

This line indicates the direction in which the face is turning.

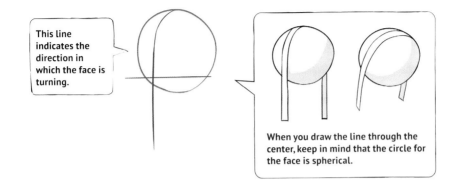

When you draw the line through the center, keep in mind that the circle for the face is spherical.

## 2 Draw vertical lines on both sides of the circle

The length of the two lines is the same as in "Drawing faces from the front" on page 20.

Using the shorter line, A, as a guide makes it easier to set the length of the face.

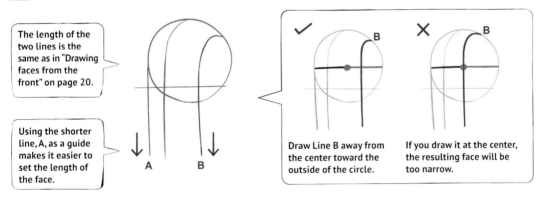

Draw Line B away from the center toward the outside of the circle.

If you draw it at the center, the resulting face will be too narrow.

## 3 Join the two lines

Draw the face as if it had fabric draped over it.

This square becomes the face.

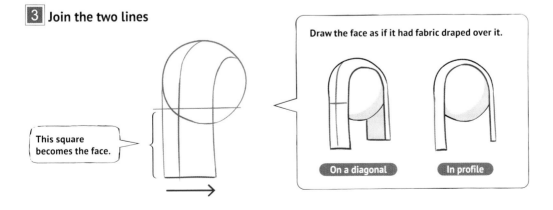

On a diagonal

In profile

### 4 Decide on the position of the nose

### 5 Draw the nose

Determining where to put the nose is the same as for "Drawing faces from the front" on page 20.

For noses on an angle, see "Drawing Noses" on page 37.

Decide on the positioning and fill it in.

### 6 Draw the eyes

Shift the eyes to the opposite direction to that which the face is turned to set them into the face (i.e., if the face is directed to the left, move the eyes to the right).

This creates dimension in the face.

If you don't first decide the point from where the nose starts, it will be hard to create dimension and it will simply look odd.

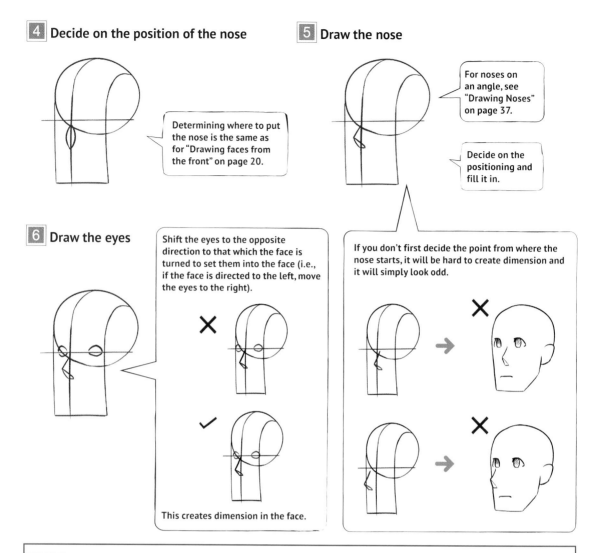

---

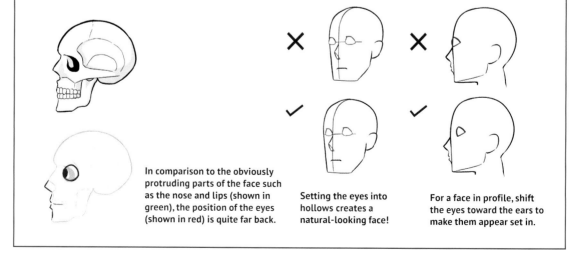

**Q Critical Point**

#### The reason for setting back the eyes

Of all the parts of the face, the eyes are the most set back. If you draw the eyes in the same position as you would for a face viewed from the front, they will appear to protrude like a popeyed goldfish's.

In comparison to the obviously protruding parts of the face such as the nose and lips (shown in green), the position of the eyes (shown in red) is quite far back.

Setting the eyes into hollows creates a natural-looking face!

For a face in profile, shift the eyes toward the ears to make them appear set in.

**7** Draw the area around the chin and the mouth

Draw a vertical line from where Line A starts, intersecting the diameter line a quarter of the way in. This line determines the facial outline.

Draw the mouth using the ratio nose – mouth : mouth – chin = 1:2

**8** Draw in vertical and horizontal guide lines to determine the size of the chin, facial outline and so on

Draw lines so that they intersect with the ones drawn in Step **7**.

Drawing the three reference lines is the same as for "Drawing faces from the front" on page 20.

**9** Draw the cheeks and chin

Use the vertical lines drawn in Step **7** as a guide.

The finished result shouldn't fit inside the facial lines

too thin!

**10** Draw the brows and ears

**11** Draw the head to complete the sketch

Make adjustments so that the entire face fits within a circle.

**12** Clean things up to complete the rough drawing

Using the completed sketch as a base, draw in the parts of the face.

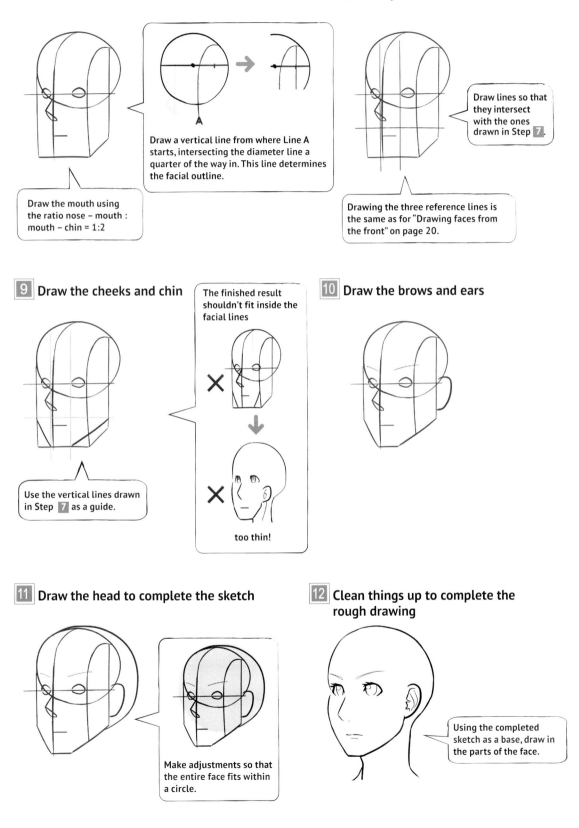

# Drawing faces in profile

## 1 Draw a circle and a straight line next to it to determine the size of the face

The circle will form the size of the face, so use this as a guide.

With a neck in place, it's easy to determine the size of the circle.

Length for lines in the face

**For men**

3

2

Diameter of circle : length of face is 3:2

**For women**

men / women

Slightly shorter than men

## 2 Draw the nose

Leave a little space underneath the nose.

✓

✗

Use "Ratios in a face viewed in profile" on page 19 as a guide when drawing.

If you join the nose to the vertical line it will be too large.

## 3 Draw the mouth and chin

Draw the mouth and chin slightly away from the line of the face.

---

### 🔍 Critical Point

#### Be aware of the E line!

Use the E line (see page 19) as a guide for drawing the mouth and chin:

✗          ✗          ✗

The trick is to make the chin protrude slightly!

If the mouth protrudes too far from the line, it will look like an octopus mouth.

If the chin protrudes too far, the face will look ape-like.

If the chin doesn't protrude at all, the face will appear to be looking downward.

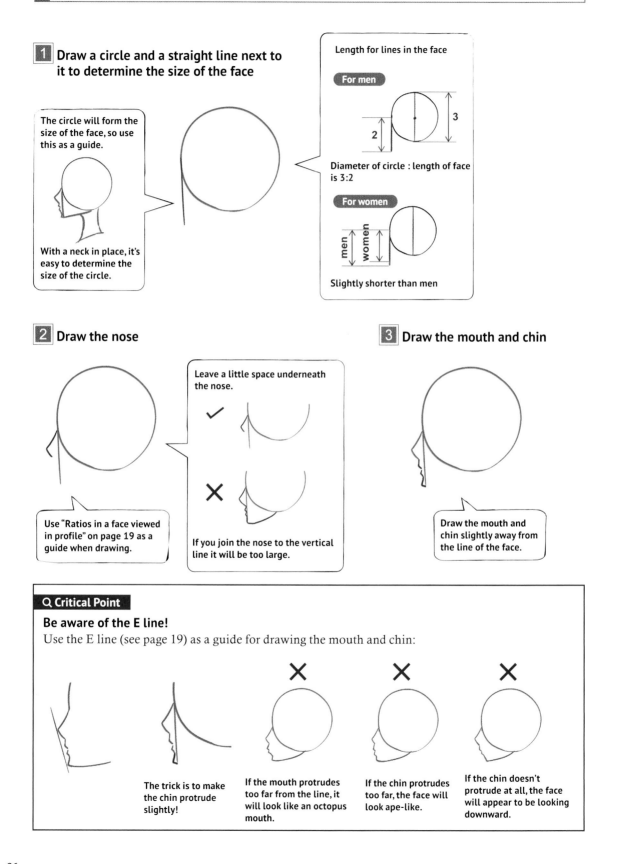

**4** Draw a vertical line through the center of the circle

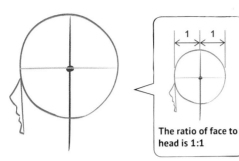

The ratio of face to head is 1:1

**5** Draw a horizontal line from the corner of the mouth to create the chin

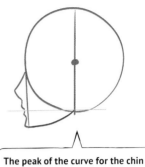

The peak of the curve for the chin is where the vertical line from Step **4** and the horizontal line from Step **5** intersect.

**6** Draw the eyes

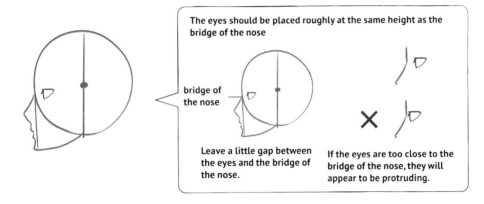

The eyes should be placed roughly at the same height as the bridge of the nose

bridge of the nose

Leave a little gap between the eyes and the bridge of the nose.

If the eyes are too close to the bridge of the nose, they will appear to be protruding.

**7** Draw the eyebrow and ear to complete the sketch

Draw the brow nearly to the center of the face.

**8** Neaten things up to complete the rough drawing

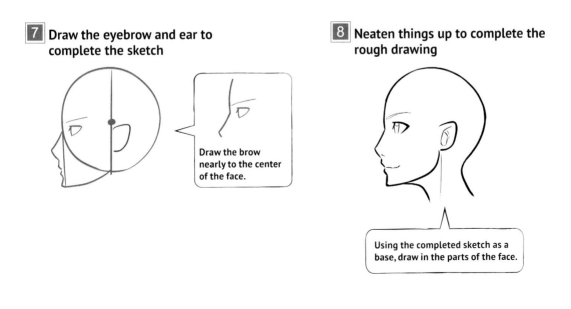

Using the completed sketch as a base, draw in the parts of the face.

# Drawing Eyes

The eyes are the most important part of the face. They are so vital, it is not an exaggeration to say that the quality of the face depends on how well the eyes are drawn.

## Composition of the eye

The eyes are a part of the body that can vary considerably depending on how realistic a drawing is. There are also some parts of the eye that are omitted in illustrations. The five parts and areas that are most frequently included are the following:

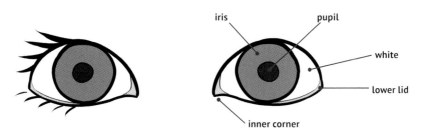

## Degrees of distortion

Select which parts of the eyes you will include depending on the drawing style used.

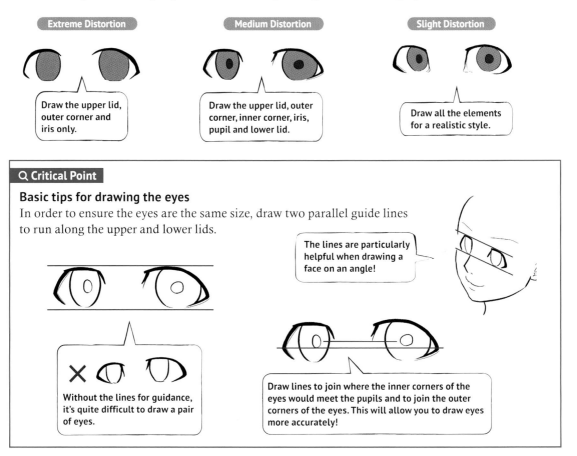

**Extreme Distortion**

Draw the upper lid, outer corner and iris only.

**Medium Distortion**

Draw the upper lid, outer corner, inner corner, iris, pupil and lower lid.

**Slight Distortion**

Draw all the elements for a realistic style.

### Q Critical Point

**Basic tips for drawing the eyes**

In order to ensure the eyes are the same size, draw two parallel guide lines to run along the upper and lower lids.

The lines are particularly helpful when drawing a face on an angle!

Without the lines for guidance, it's quite difficult to draw a pair of eyes.

Draw lines to join where the inner corners of the eyes would meet the pupils and to join the outer corners of the eyes. This will allow you to draw eyes more accurately!

# Drawing eyes from the front

**1** Draw a line for blocking-in

Divide into thirds.

**2** Draw guide lines above and below the main line

Leave roughly the same amount of space on either side of the main line.

**3** Use the guide lines to draw the upper lids

Make the lids slightly larger to create a cute look.

**4** Draw the lower lids

Do the same thing here: Make the lids slightly larger for a cute look.

**5** Draw in the irises to complete the sketch

Ratios in the eye

1  3  1

The ratio of the white of the eye to the iris is 1:3:1

**6** Clean things up to complete the rough drawing

Draw in the lids, irises and other parts of the eye that you have decided to include.

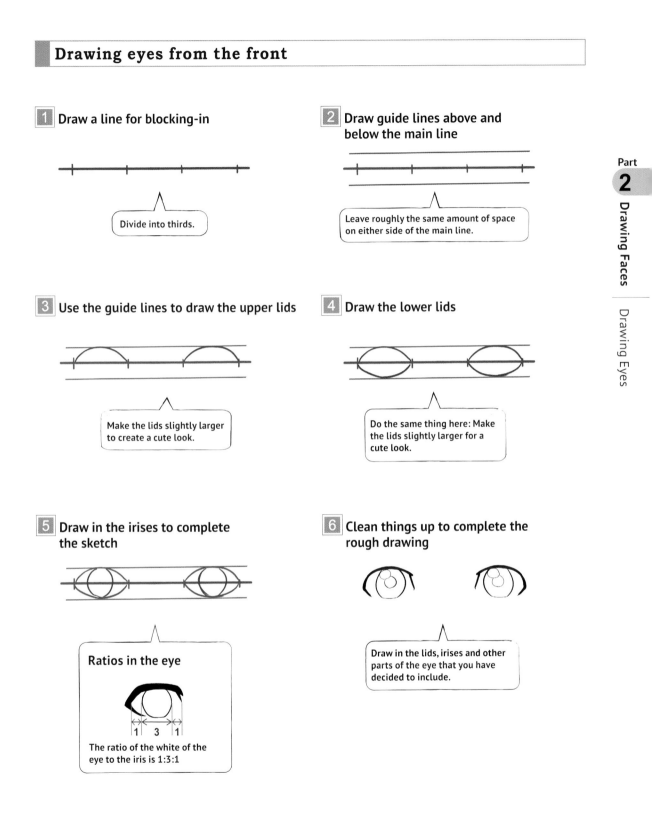

# Drawing eyes from an angle

**1** Block-in the face

Use "Drawing faces from an angle" on page 23 as a reference

**2** Draw guide lines above and below the eyes

**3** Block-in the width ratios for the eyes

**4** Use guide lines to draw in the upper and lower lids

**5** Draw in the irises to complete the rough sketch

If the face is on a diagonal, the eye becomes oval in shape.

**6** Clean things up to complete the rough drawing

Using the sketch as a base, fill in the lids and a rough sketch of the eyes.

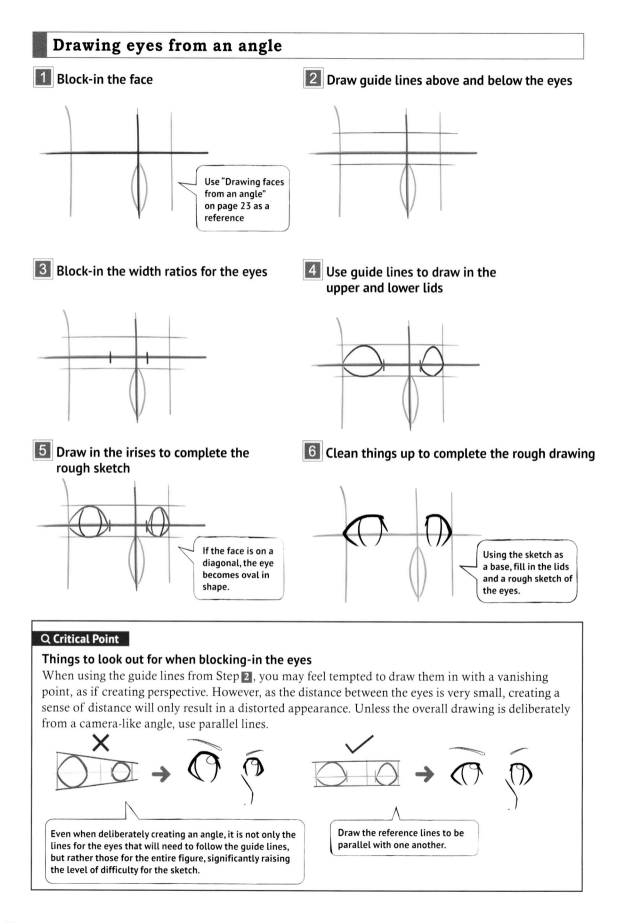

## Q Critical Point

### Things to look out for when blocking-in the eyes

When using the guide lines from Step **2**, you may feel tempted to draw them in with a vanishing point, as if creating perspective. However, as the distance between the eyes is very small, creating a sense of distance will only result in a distorted appearance. Unless the overall drawing is deliberately from a camera-like angle, use parallel lines.

Even when deliberately creating an angle, it is not only the lines for the eyes that will need to follow the guide lines, but rather those for the entire figure, significantly raising the level of difficulty for the sketch.

Draw the reference lines to be parallel with one another.

### 🔍 Critical Point

**How to sketch eyes of various shapes**

Initially using squares to block in the eyes for a sketch makes it hard to go wrong.

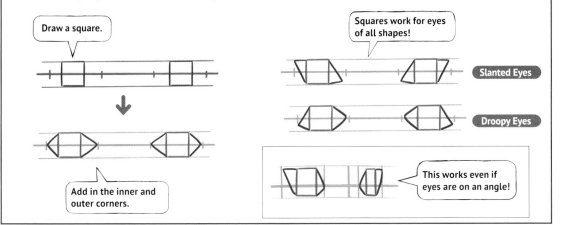

Draw a square.

Add in the inner and outer corners.

Squares work for eyes of all shapes!

Slanted Eyes

Droopy Eyes

This works even if eyes are on an angle!

### 🔍 Critical Point

**How to block-in eyes seen from angles above and below**

When drawing eyes viewed from above, below and so on, shifting the guide lines will make for easier execution.

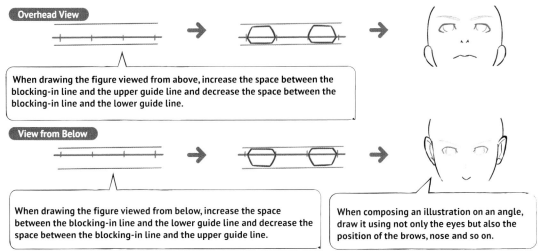

Overhead View

When drawing the figure viewed from above, increase the space between the blocking-in line and the upper guide line and decrease the space between the blocking-in line and the lower guide line.

View from Below

When drawing the figure viewed from below, increase the space between the blocking-in line and the lower guide line and decrease the space between the blocking-in line and the upper guide line.

When composing an illustration on an angle, draw it using not only the eyes but also the position of the brows, nose and so on.

### 🍃 Helpful Hint

**How to bring out dimension in the eyes**

Try thinking of the eyes as spheres with lids attached. If you think of the shape of the eyes as segments cut out from spheres, it will make it easier to draw them from difficult angles.

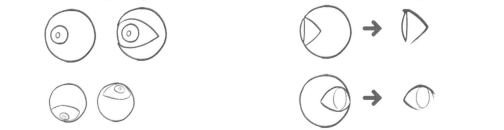

# Adding Color to the Eyes

## Coloring steps

For the eyes in particular, there are various ways of adding color. Here, we look at some examples. Divide the elements used into pupil, iris and highlights to create your own designs.

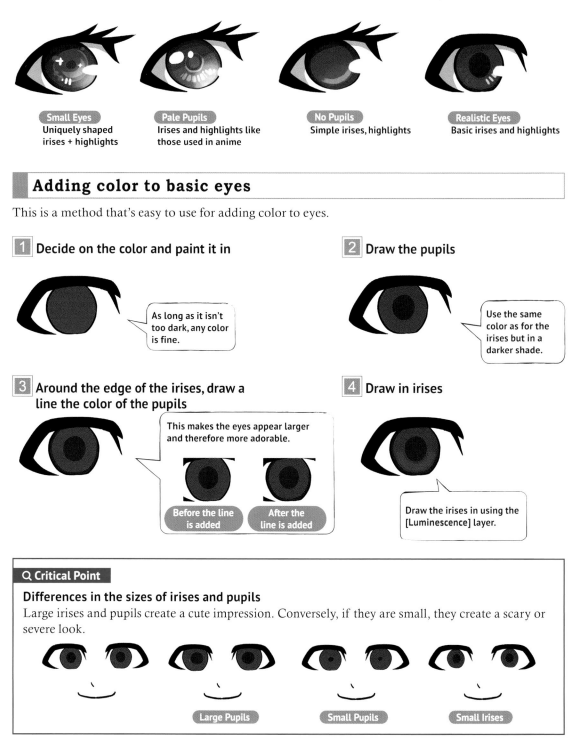

**Small Eyes**
Uniquely shaped irises + highlights

**Pale Pupils**
Irises and highlights like those used in anime

**No Pupils**
Simple irises, highlights

**Realistic Eyes**
Basic irises and highlights

## Adding color to basic eyes

This is a method that's easy to use for adding color to eyes.

**1** Decide on the color and paint it in

As long as it isn't too dark, any color is fine.

**2** Draw the pupils

Use the same color as for the irises but in a darker shade.

**3** Around the edge of the irises, draw a line the color of the pupils

This makes the eyes appear larger and therefore more adorable.

Before the line is added

After the line is added

**4** Draw in irises

Draw the irises in using the [Luminescence] layer.

### Q Critical Point

**Differences in the sizes of irises and pupils**
Large irises and pupils create a cute impression. Conversely, if they are small, they create a scary or severe look.

Large Pupils

Small Pupils

Small Irises

## 5 Add shadows to the eyes

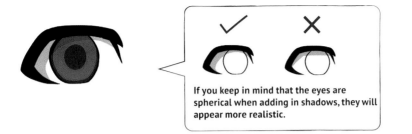

If you keep in mind that the eyes are spherical when adding in shadows, they will appear more realistic.

---

**⌂ Digital Tools**

### How to use the [Multiplication] layer

Using the [Multiplication] tool makes it easier to add shadow.

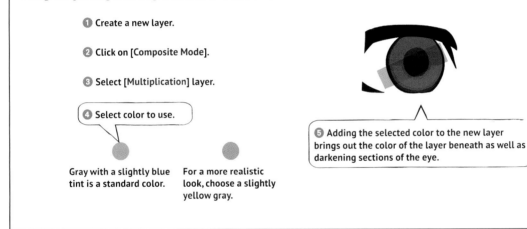

❶ Create a new layer.

❷ Click on [Composite Mode].

❸ Select [Multiplication] layer.

❹ Select color to use.

❺ Adding the selected color to the new layer brings out the color of the layer beneath as well as darkening sections of the eye.

Gray with a slightly blue tint is a standard color.

For a more realistic look, choose a slightly yellow gray.

---

**⌂ Digital Tools**

### How to use the [Luminescence] layer

Using the [Luminescence] layer when coloring the iris creates brightly sparkling, attractive eyes.

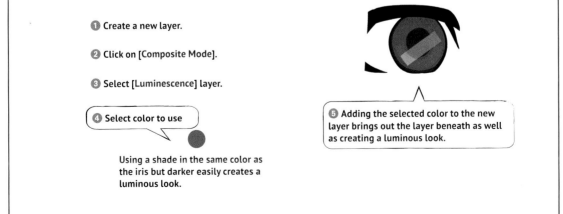

❶ Create a new layer.

❷ Click on [Composite Mode].

❸ Select [Luminescence] layer.

❹ Select color to use

❺ Adding the selected color to the new layer brings out the layer beneath as well as creating a luminous look.

Using a shade in the same color as the iris but darker easily creates a luminous look.

**6** Add a sparkling effect

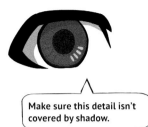

> Make sure this detail isn't covered by shadow.

**7** Add highlights to complete the eye!

---

**🖋 Helpful Hint**

**The difference between sparkle and highlights**
The sparkle in the iris is something like a pattern. Highlights, on the other hand, are light reflecting off the eye, and are not a pattern.

Even in darkness, the iris can be seen, but highlights are not visible.

---

## Adding color to various types of eyes

Here, we look at how to add color to the various types of eyes previously shown.

**1** Choose the eye color and draw the pupils

**2** Draw a colored line around the edge of the pupil

**3** Draw the iris

**4** Add details to the iris

**5** Draw shadows

**6** Add highlights and you're done!

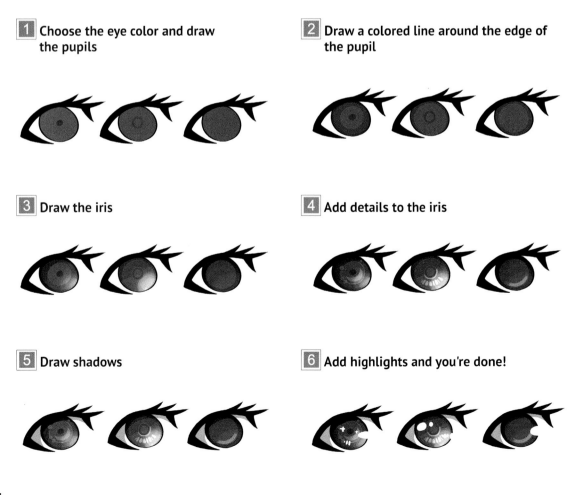

34

# Drawing eyelashes

Use guide lines that extend diagonally from the outer corner of the eye and around the lid when drawing eyelashes that call for a natural appearance.

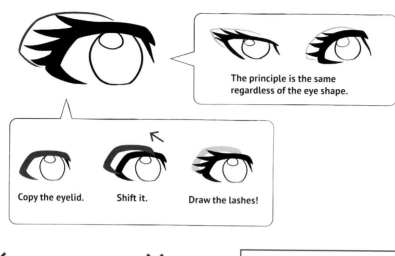

The principle is the same regardless of the eye shape.

Copy the eyelid.　Shift it.　Draw the lashes!

✕

If the lashes are too fine and detailed, they will appear fake.

✕

If they are around the entire eye, it will look like overly heavy makeup.

---

**🔍 Critical Point**

### Eyelashes in profile

For faces nearly in profile, draw eyelashes near the outer corner of the eyes.

---

# Various types of eyelashes

**Regular**

Often the eyelashes are indicated by thickening the line of the eyelids.

**Feminine**

No lashes grow in the corner section between the upper and lower lids.

Make the lower lashes fine and short for a natural look.

**Masculine**

Fine lashes make for a masculine look.

**Single Lash**

Draw a single lash to cover the gap between the upper and lower lids.

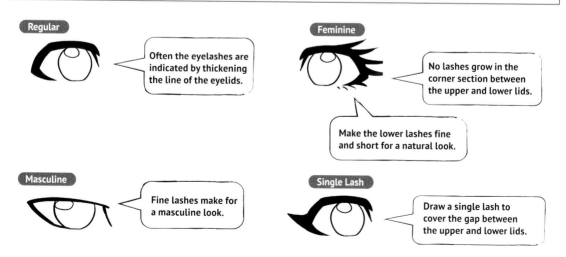

# Drawing Eyebrows

The eyebrows are crucial parts of the face when creating expression and are also key to evoking a sense of dimension in the face, so take particular care when sketching them.

## The structure of eyebrows

The position of the head of the brow has a big influence on the character's expression and personality.

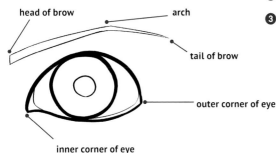

head of brow

arch

tail of brow

outer corner of eye

inner corner of eye

## Drawing the eyebrows

Draw guide lines from the sides of the nostrils the wings of the nose to determine the shape.

**1** The head of the brow starts at the extension of the line from the sides of the nostrils to the inner corner of the eye.
**2** The arch should be at the extension of the line running from the sides of the nostrils through the pupil.
**3** The tail of the brow should be at the extension of the line from the corner of the mouth to the outer corner of the eye.

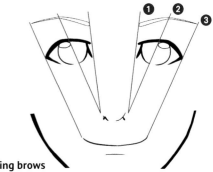

### ■ If you haven't drawn the wings of the nose

Even when you are not drawing the wings of the nose, decide roughly where they should be to help you draw the brows.

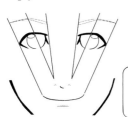

### ■ Things to watch out for when drawing brows

When drawing brows, make sure to draw them with the eyes looking straight ahead. Even if the eyes are not meant to be looking to the front, block them in as if they were in order to draw the brows.

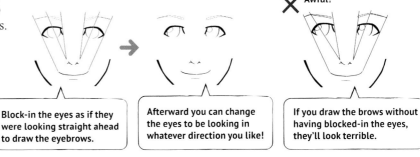

✗ **Awful!**

Block-in the eyes as if they were looking straight ahead to draw the eyebrows.

Afterward you can change the eyes to be looking in whatever direction you like!

If you draw the brows without having blocked-in the eyes, they'll look terrible.

---

**🔍 Critical Point**

### Eyebrows and facial dimension

The line from the arch to the tail of the brows lies on the outer section of the face. This is an important point when creating a sense of dimension.

Put simply, it's something like this:

Drawn realistically, the face looks like this:

When distorting the face, as long as the eyebrows start at the line from the sides of the nostrils to the inner corners of the eye, it doesn't matter so much if you don't follow the other lines.

The nose has a tendency to get too small, so draw straight lines through the inner corners of the eyes to use as a reference.

# Drawing Noses

The nose is often omitted or merely alluded to when drawing the face, as it is extremely difficult to fill in and balance. But don't skip the details of a well-rendered nose and make sure to properly include it in your sketch.

## The structure of the nose

The most commonly drawn parts of the nose are the bridge and the tip. Drawing in the sides of the nostrils tends to make for an aged appearance so they are not often depicted.

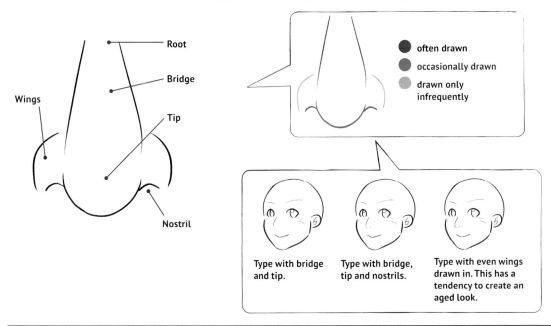

- often drawn
- occasionally drawn
- drawn only infrequently

Type with bridge and tip.

Type with bridge, tip and nostrils.

Type with even wings drawn in. This has a tendency to create an aged look.

---

**Q Critical Point**

### The nose is a must for creating dimension in the face

Unlike the eyes, mouth and other parts of the face that so richly express changes in emotion, the nose is completely unnecessary when drawing a character. So some people use lines or dots to indicate it, while others don't draw it at all, and yet it still manages to be expressed as a part of the face. Having said that, if drawn carelessly, the nose can ruin the sketch. Make sure to sketch it in properly with a sense of dimension in mind.

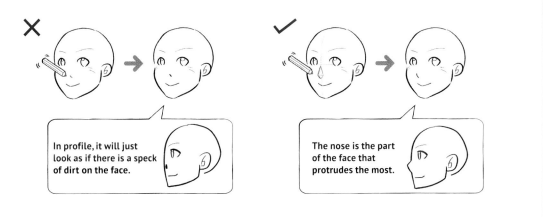

In profile, it will just look as if there is a speck of dirt on the face.

The nose is the part of the face that protrudes the most.

## Drawing noses

**1** Draw an isosceles triangle

**2** Draw a second isosceles triangle

**3** Draw a line out from the center of the triangles

**4** Use that line as a base to create another triangle

**5** Join the apexes of each triangle

**6** Attach it to the face

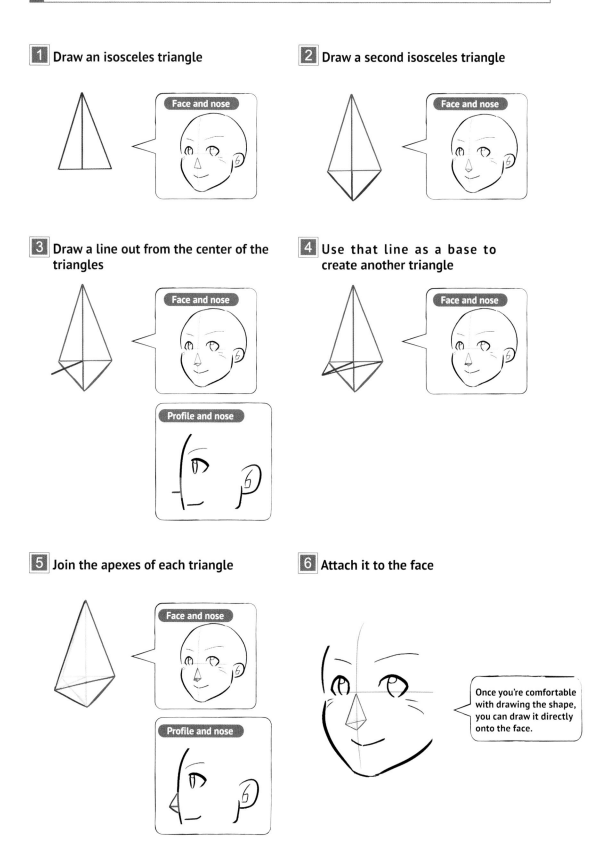

Face and nose

Profile and nose

Once you're comfortable with drawing the shape, you can draw it directly onto the face.

**7** Delete unnecessary lines to complete the sketch

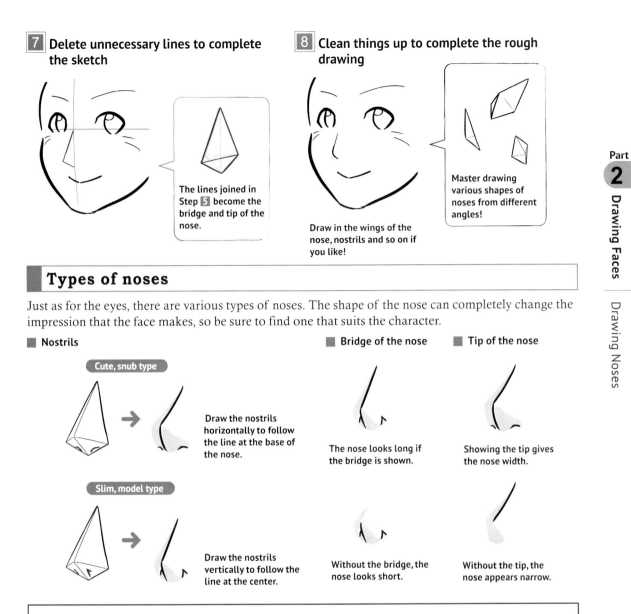

The lines joined in Step **5** become the bridge and tip of the nose.

**8** Clean things up to complete the rough drawing

Draw in the wings of the nose, nostrils and so on if you like!

Master drawing various shapes of noses from different angles!

## Types of noses

Just as for the eyes, there are various types of noses. The shape of the nose can completely change the impression that the face makes, so be sure to find one that suits the character.

■ Nostrils

Cute, snub type

Draw the nostrils horizontally to follow the line at the base of the nose.

Slim, model type

Draw the nostrils vertically to follow the line at the center.

■ Bridge of the nose

The nose looks long if the bridge is shown.

Without the bridge, the nose looks short.

■ Tip of the nose

Showing the tip gives the nose width.

Without the tip, the nose appears narrow.

---

**Q Critical Point**

### Nose shapes from various angles

The shape of the nose changes significantly depending on the angle. Memorize the shapes so you can draw the nose from different angles.

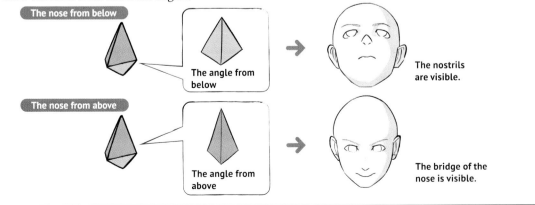

The nose from below

The angle from below

The nostrils are visible.

The nose from above

The angle from above

The bridge of the nose is visible.

# Drawing Mouths

After the eyes, the mouth is the most important part of the face for showing emotion. The method for understanding dimension in the mouth is the same as for the eyes, so if you master one or the other, it's easy to apply those lessons learned when you're drawing.

## Structure of the mouth

Just as for the eyes, there are various methods for altering the mouth. Think about whether you will draw the lips, teeth and so on as you experiment with creating your own drawing style.

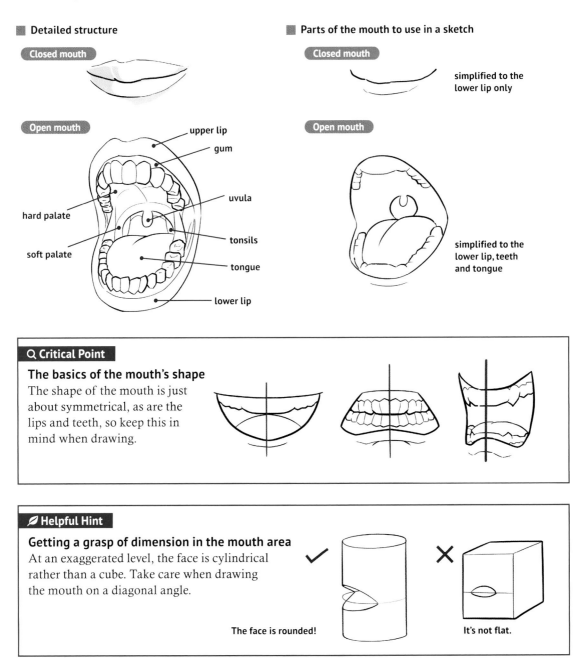

■ Detailed structure

**Closed mouth**

■ Parts of the mouth to use in a sketch

**Closed mouth**

simplified to the lower lip only

**Open mouth**

upper lip
gum
uvula
tonsils
tongue
lower lip
hard palate
soft palate

**Open mouth**

simplified to the lower lip, teeth and tongue

---

**Q Critical Point**

**The basics of the mouth's shape**
The shape of the mouth is just about symmetrical, as are the lips and teeth, so keep this in mind when drawing.

---

**✑ Helpful Hint**

**Getting a grasp of dimension in the mouth area**
At an exaggerated level, the face is cylindrical rather than a cube. Take care when drawing the mouth on a diagonal angle.

✓ The face is rounded!

✗ It's not flat.

# Drawing mouths

**1** Draw a horizontal line to show the position of the mouth

Follow the blocking-in for the face to draw a line for the mouth. Make sure that if the face is being viewed from front, both sides of the mouth are equal.

If the mouth is closed, you can follow this line to simply draw it (and the lips) and you're done!

**2** Decide on the approximate size of the mouth by drawing an oblong to enclose the horizontal line

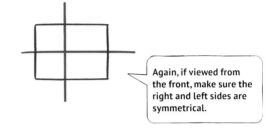

Again, if viewed from the front, make sure the right and left sides are symmetrical.

**3** Draw triangles on both sides of the mouth to determine the shape and complete the sketch

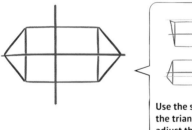

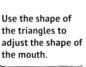

Use the shape of the triangles to adjust the shape of the mouth.

**4** Clean things up to complete the rough drawing

Fill in the teeth, lips, tongue and other parts you want to show and complete the rough sketch.

---

**Q Critical Point**

### The position of the open mouth
Make sure the mouth is not too high on the face.

Perfect positioning            Too high

Even when the mouth is open, aim for a ratio of nose – mouth: mouth – chin = 1:2

The lips are not included in this ratio

---

**✐ Helpful Hint**

### Draw semicircles
Once you've got used to the processes in Steps **2** and **3**, move on to being able to draw semicircles.

This will let you draw a more natural-looking mouth in a shorter time!

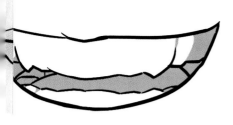

# Drawing Teeth

When drawing the mouth, don't forget about the teeth! A general understanding of their structure will give you a better grasp of their particular dimensions.

## Structure of the teeth

■ Detailed structure

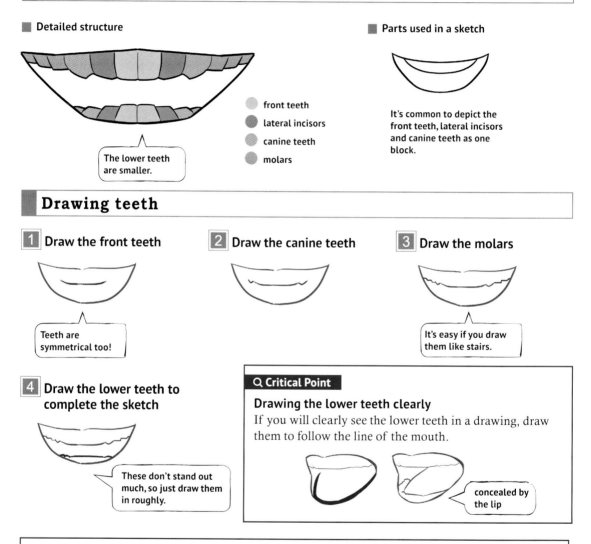

The lower teeth are smaller.

- ● front teeth
- ● lateral incisors
- ● canine teeth
- ● molars

■ Parts used in a sketch

It's common to depict the front teeth, lateral incisors and canine teeth as one block.

## Drawing teeth

### 1 Draw the front teeth

Teeth are symmetrical too!

### 2 Draw the canine teeth

### 3 Draw the molars

It's easy if you draw them like stairs.

### 4 Draw the lower teeth to complete the sketch

These don't stand out much, so just draw them in roughly.

### Q Critical Point

**Drawing the lower teeth clearly**
If you will clearly see the lower teeth in a drawing, draw them to follow the line of the mouth.

concealed by the lip

### Q Critical Point

**Things to watch for when filling in teeth**
It depends on your style of drawing, but teeth drawn in neatly so that each one is clear can look realistic and a bit gross, so either leave out the gap between each tooth or use only faint lines to indicate where they are.

✕

Too real

In most situations only the top six teeth are visible

# Drawing Ears

The ears are sometimes concealed by hair or aren't visible due to the angle of the face, so they're a part of the body that's drawn less often. Still, understanding their placement on the head will help you draw them more realistically.

## Structure of the ear

■ Detailed structure

From the front

- helix
- antihelix
- tragus
- antitragus
- earlobe

■ Parts used in a sketch

If the helix and tragus along with the inner part of the antihelix are indicated, the sketch will look ear-like.

From behind

The helix, lobe and back of the ear are visible.

### 🔍 Critical Point

#### The ears viewed from behind

face

The ears are attached to the head, not to the face.

## Size of the ears

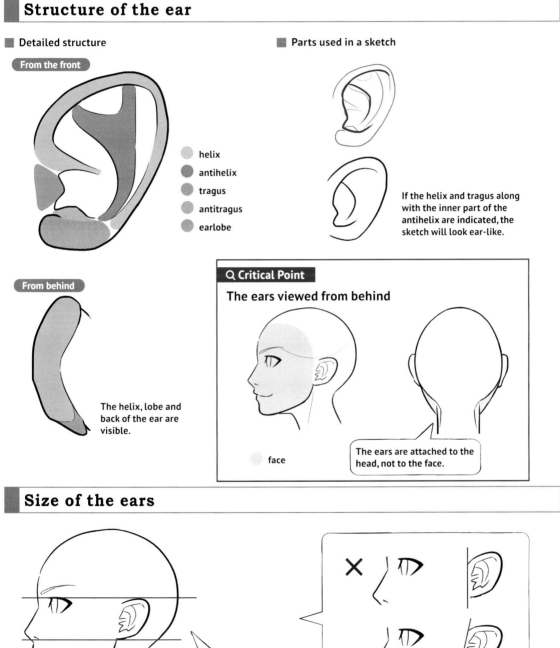

The ears are the same size as the length from eyes to nose.

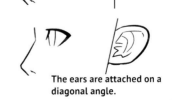

The ears are attached on a diagonal angle.

# Drawing Hair

The hair is of such importance when drawing a character that it's said to be second only to the eyes. Hair can be unkempt with a mind of its own, sleek and well-groomed or somewhere in-between. It really puts the finishing touches on your manga creation!

## Structure of the hair

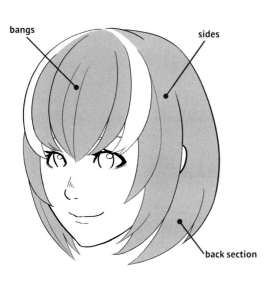

bangs

sides

back section

bangs = to the outer corners of the eyes

sides = from the outer corners of the eyes to the ears

back section = from behind the ears to the back of the head

**Q Critical Point**

**Hair to bridge the gap between the bangs and the sides**

If you fill in the gap between the bangs and the sides with hair to connect them, it will make for a more natural result.

## Draw neat lines

Careful, clean lines are the key to drawing attractive hair. There are tricks to this and of course practice helps, too, but here we look at things to watch out for.

✗

It doesn't matter how cute the face is, it will be ruined with messy hair!

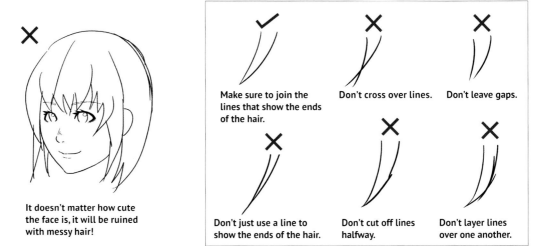

Make sure to join the lines that show the ends of the hair.

Don't cross over lines.

Don't leave gaps.

Don't just use a line to show the ends of the hair.

Don't cut off lines halfway.

Don't layer lines over one another.

# Drawing hair

**1** Decide on the volume of hair and sketch in a guide line

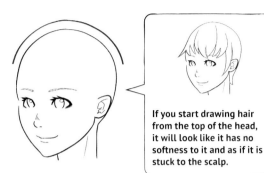

If you start drawing hair from the top of the head, it will look like it has no softness to it and as if it is stuck to the scalp.

**2** Decide on the position for the hair whorl

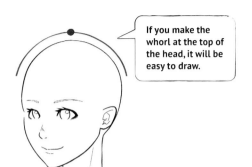

If you make the whorl at the top of the head, it will be easy to draw.

**3** Draw in guide lines flowing from the whorl

Be conscious of the whorl even where it is hidden by the head.

Some sections split away.

**4** Draw hair to fall in bundles

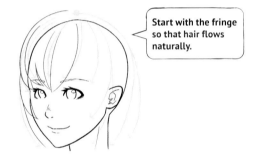

Start with the fringe so that hair flows naturally.

**5** The rough sketch is complete!

🔍 **Critical Point**

### Thinking about hairstyles

Whether hair has quirks or is short, the basic principles for drawing it are the same.

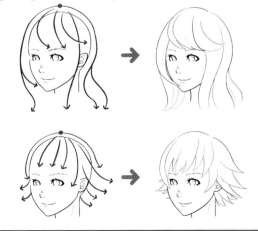

## Drawing long hair

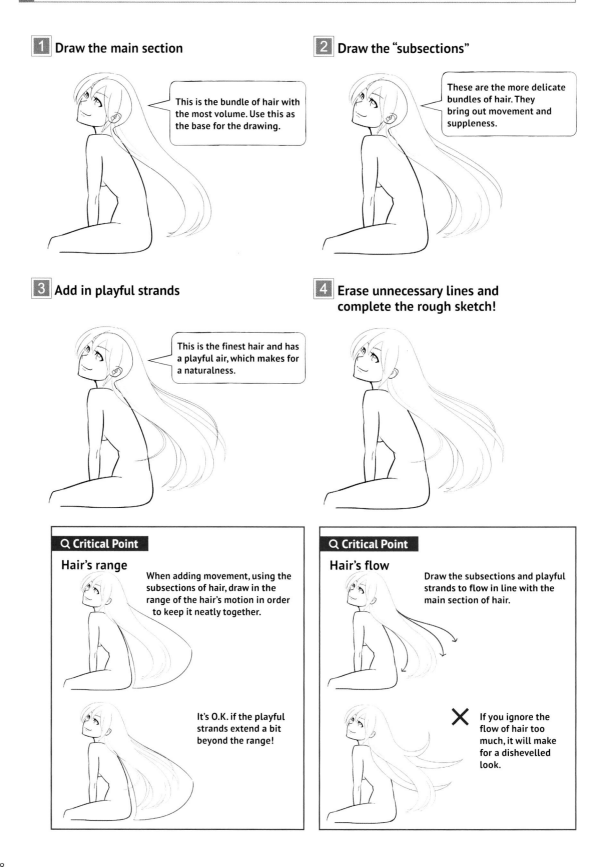

### 1 Draw the main section

This is the bundle of hair with the most volume. Use this as the base for the drawing.

### 2 Draw the "subsections"

These are the more delicate bundles of hair. They bring out movement and suppleness.

### 3 Add in playful strands

This is the finest hair and has a playful air, which makes for a naturalness.

### 4 Erase unnecessary lines and complete the rough sketch!

---

**Q Critical Point**

**Hair's range**

When adding movement, using the subsections of hair, draw in the range of the hair's motion in order to keep it neatly together.

It's O.K. if the playful strands extend a bit beyond the range!

---

**Q Critical Point**

**Hair's flow**

Draw the subsections and playful strands to flow in line with the main section of hair.

If you ignore the flow of hair too much, it will make for a dishevelled look.

# Drawing hair that is tied back

**1** Draw the bangs, side and back sections of hair

**2** Decide where the hair will be tied

> The lines indicating the hair at the back go toward where hair is fastened.

**3** Draw the main section

**4** Draw the subsection

> **X**
>
> Don't draw the playful strands as they make it too difficult to discern the hairstyle.

**5** Erase unnecessary lines and complete the rough sketch!

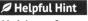

**✍ Helpful Hint**

### Hair's surface and underside

There is a surface and underside to hair. If you can keep this in mind, it will allow you to advance your drawing skills.

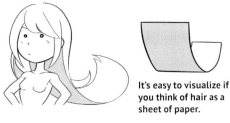

It's easy to visualize if you think of hair as a sheet of paper.

# Basics for the ends of the hair

## 1 Amount of ends in the bangs

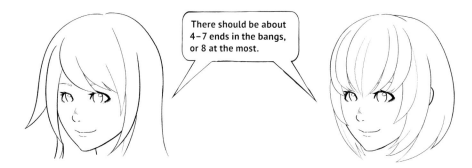

There should be about 4–7 ends in the bangs, or 8 at the most.

## 2 Types of hair ends

Variation in the hair ends adds visual variety, creating a natural hairstyle. Depending on the type of ends, they can be used in various places.

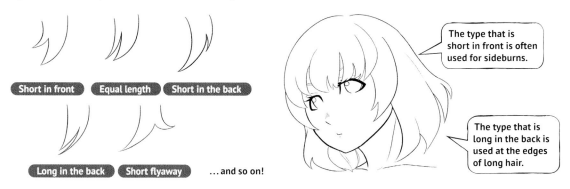

Short in front     Equal length     Short in the back

Long in the back     Short flyaway     …and so on!

The type that is short in front is often used for sideburns.

The type that is long in the back is used at the edges of long hair.

## 3 Things to watch out for when drawing the ends of bangs

✕ Don't draw hair without drawing guide lines first, as the hair will turn out like a wig.

✕ If the bangs are too detailed, hair will look dry and unkempt.

✕ If all the ends are the same thickness, hair will look fake.

Decide on the position for the whorl of the hair and draw guide lines in first, then draw the ends.

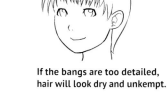

Vary the size of the ends randomly to create a natural finish.

# Drawing the hairline

## 1 Draw the line for the forehead

The face viewed in profile.

## 2 Decide the location for the temples

The temples extend from the forehead line to just below the eyebrows.

## 3 Draw the sideburns

Draw in a right angle.

**1 2**

Draw a line a third of the way from the outer corner of the eye to the end of the jawline.

**1 2**

Even if the angle changes, the principle is the same!

## 4 Connect the line with the ears to complete the rough sketch!

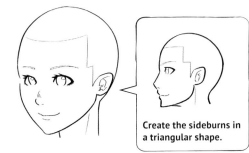

Create the sideburns in a triangular shape.

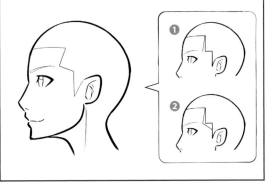

### ✐ Helpful Hint

**How to draw more realistic sideburns**
If you draw the right-angled section from Step **3** on a diagonal, it will look more realistic.

**1**

**2**

## Types of hairlines

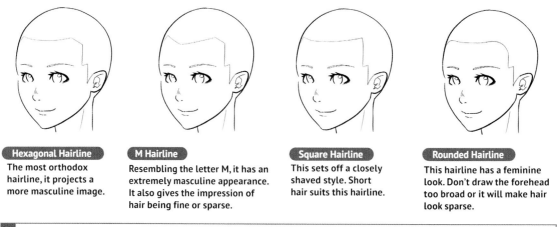

**Hexagonal Hairline**
The most orthodox hairline, it projects a more masculine image.

**M Hairline**
Resembling the letter M, it has an extremely masculine appearance. It also gives the impression of hair being fine or sparse.

**Square Hairline**
This sets off a closely shaved style. Short hair suits this hairline.

**Rounded Hairline**
This hairline has a feminine look. Don't draw the forehead too broad or it will make hair look sparse.

## Things to watch out for when drawing the hairline

If the hairline is irregular, characters will look like they are going bald, so while you are still learning, draw the hairline in first to create a guide.

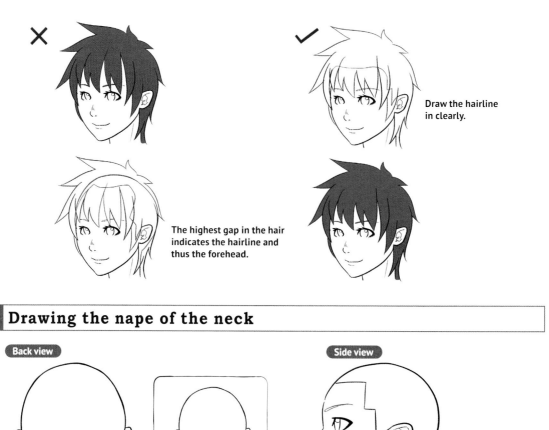

Draw the hairline in clearly.

The highest gap in the hair indicates the hairline and thus the forehead.

## Drawing the nape of the neck

**Back view**

The nape of the neck is in nearly the same position as the circle drawn for the head.

**Side view**

Draw a diagonal line from below the ear to the base of the skull where the head and neck meet.

## Drawing blunt bangs

**1** Draw the bangs long

**2** Cut them

**3** Finished!

## Drawing braids

**1** Layer the hearts

**2** Close off the tops of the hearts

Make the right side larger.

**3** Cut off the lower left sides

**4** Clean up the sketch and you're done!

---

**Q Critical Point**

**Heart shapes**
Variations can be created by altering the shape of the hearts.

Long hearts create loose braiding.

Gradually decrease the size to bring out volume!

---

## Drawing slicked-back hair

**1** Draw guide lines at the crown and sides to follow the shape of the head

**2** Follow the guide lines to draw radial lines

**3** Draw lines along the sides

**4** Clean up the sketch

The lines at the sides should run diagonally downward, irrespective of the guide lines.

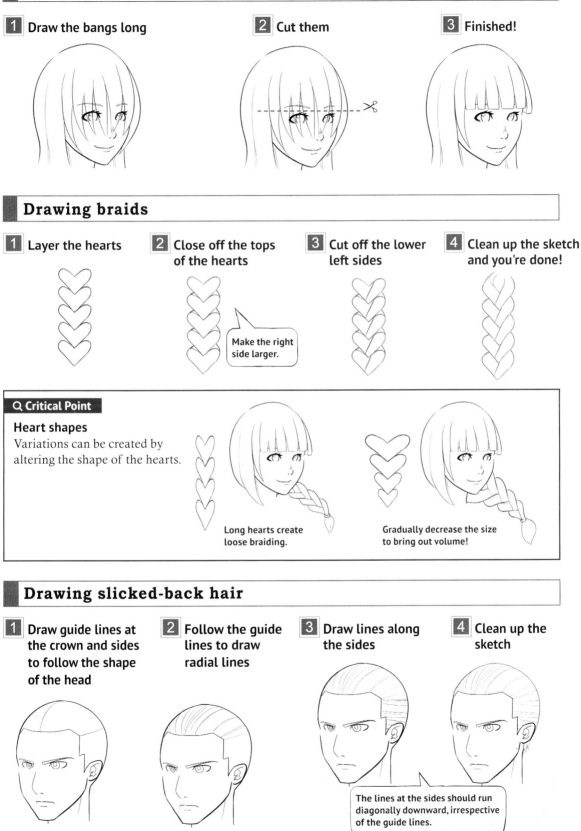

# Adding color to hair

## 1 Highlights are extremely important when coloring hair

The secret to coloring hair is to add its shine (highlights). It's a simpler way to draw attractive hair than adding shadows.

It's necessary to consider the hair's dimension and texture, meaning it can take a bit of effort.

Quickly adding a highlight creates a glossy look. The hair seems to shine, giving it an attractive appearance!

Add the highlight in the middle of the head's curve!

---

### 🖊 Digital Tools

**Use special layers to add highlights**

Use the layer with special effects to cut out the effort of choosing color and to create glossy-looking hair.

❶ Click on the [Composite Mode] menu from the center of the layer panel.

❷ Choose the type of layer.

❸ I recommend [Luminescence] or [Screen]!

● Base Color

**[Luminescence] Layer**

The color applied in the highlighted area combines with the color in the lower layer to create a brighter shade. It makes for a vivid effect.

**[Screen] Layer**

Similarly, the color applied as a highlight combines with the color in the lower layer to create a brighter shade, but the result is not as vivid as that of the [Luminescence] layer.

---

## 2 Types of highlight

There are various types of highlights too. Choose the one that's your favorite.

**Realistic Type**

There's a lot of fine detail in this type, which is often used in manga and the like.

**Dot Type**

This gives the hairstyle an airy look. It's often used in cute anime illustrations.

**Line Type**

This creates the look of smooth, shiny hair and is often used in anime.

**Blurred Type**

Often used in thickly layered "*atsunuri*" illustrations and realistic drawing styles.

# Drawing faces from various angles

When creating your illustrations, you'll want to draw characters from various angles, but this is an area where many people have trouble, as a change of angle can mess up the sketch. Here, we look at the tricks to sketching from above and below. Keep in mind that these are methods to use in the initial sketch and cannot be employed in the rough drawing or line drawing stages.

## Drawing faces from above (bird's-eye view)

**1** Sketch the face from the front

**2** Block-in the face to work out the degree to which it is looking down

> A line in the middle helps with balance!

**3** Shift the face to correspond with the blocking-in

> Shift the hairline also.

> ✕
>
> Make sure the mouth doesn't get lost under the nose and facial outline!

**4** Shift the nose farther down

> Take care that the mouth doesn't get lost as you shift the nose.

> Shift the nose to achieve an approximate ratio of nose to mouth : mouth to chin = 1:1

**5** Shift the ears up

> When the head tilts up or down, the ears look different, so shift them accordingly.

**6** Draw the neck

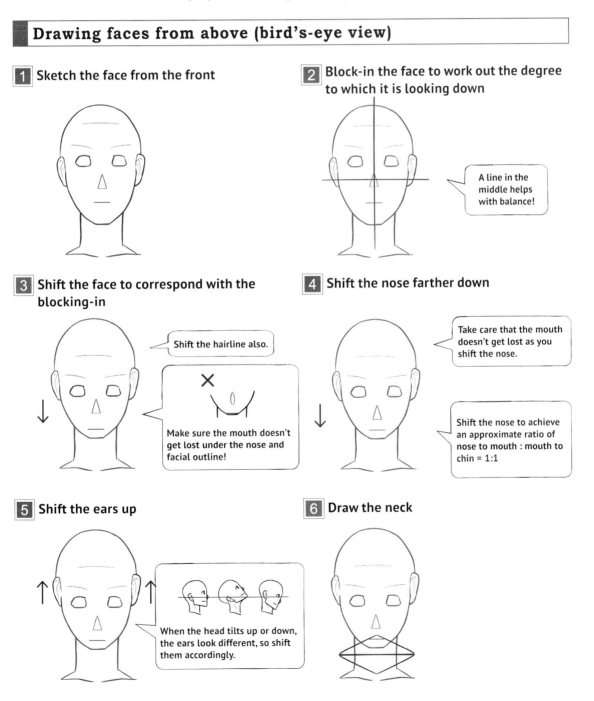

**7** Clean up the eyes, nose and mouth to complete the sketch

For the eyes, refer to "How to block-in eyes seen from angles above and below" on page 31.

**8** Fill in the face to finish off the rough drawing

The processes in this chapter are techniques that are only for use in sketching. If you use them at the rough drawing or line drawing stage, you'll get odd results, so take care to use them as intended.

---

**Q Critical Point**

### How to draw noses and mouths from above

**How to draw the mouth**

The mouth forms the Japanese character 「ひ」.

ひ→

Draw the extending "wings" straight.

If you use a U shape, the character appears to be smiling.

If you use the ひ shape with the wings turned down, it will look like the character is grimacing.

**How to draw the nose**

Add in the lower protrusion.

If you leave in only the protruding section after erasing everything else, the nose will appear small. I recommend this for female characters!

---

## Drawing faces from below

**1** Sketch the face from the front, deciding the degree to which the face is directed upward in order to block it in

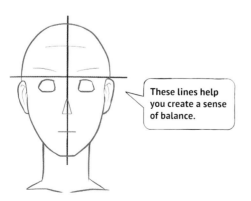

These lines help you create a sense of balance.

**2** Follow the blocking-in to shift the face

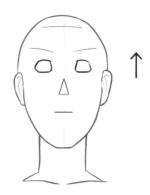

### 3 Shift the nose and mouth

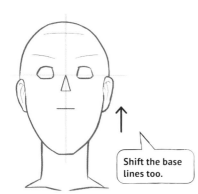

Shift the base lines too.

### 4 Draw the chin

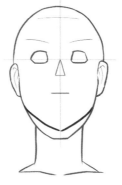

Here!

The starting point for the chin is nearly the same as the starting point for the chin used when drawing the face.

### 5 Shift the ears down to complete the sketch

Lower them to around the jawline.

### 6 Fill in the face to finish off the rough sketch!

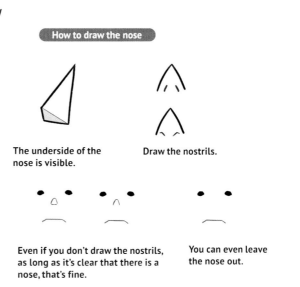

Join the jawline so it works in smoothly with the neck.

Reuse the original line for the chin as the shadow on the neck.

---

**Q Critical Point**

## How to draw noses and mouths from below

**How to draw the mouth**

When drawing the mouth from below, use the ʊ character upside down.

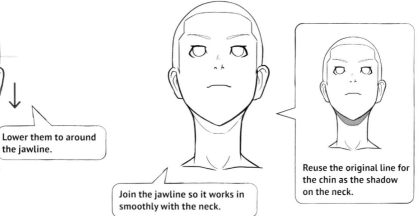

Extend the wing section out horizontally.

If there are no wings, the character will appear to be grimacing.

**How to draw the nose**

The underside of the nose is visible.

Draw the nostrils.

Even if you don't draw the nostrils, as long as it's clear that there is a nose, that's fine.

You can even leave the nose out.

## Drawing faces from below on an angle

**1** Draw the face in profile

**2** Draw lines for blocking in

Draw lines at the crown of the head, below the eyes and under the chin.

**3** Copy the face and shift it

Follow the blocking-in lines to shift the face.

**4** Erase the unnecessary lines from the original

Erase up to the blocking-in lines for the eyes.

This line for the head is extremely important.

**5** Draw the outline of the face

**6** Erase unnecessary lines from the copied face

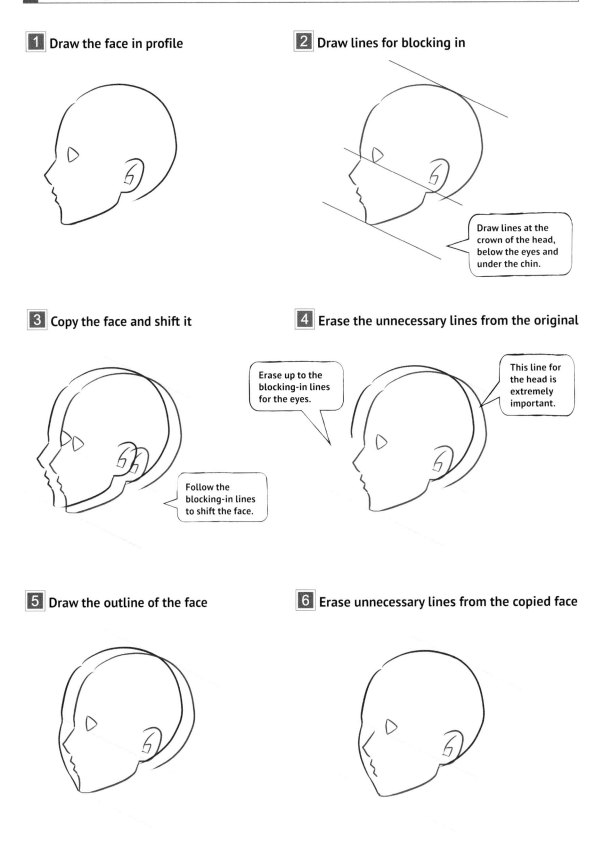

### 7 Draw in the eye

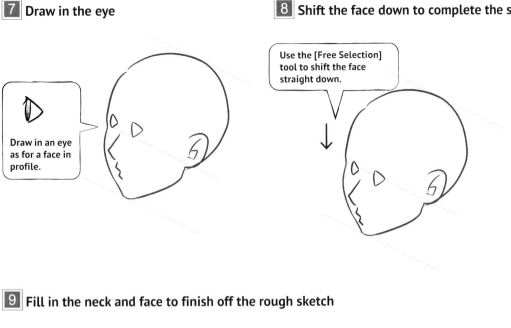

Draw in an eye as for a face in profile.

### 8 Shift the face down to complete the sketch

Use the [Free Selection] tool to shift the face straight down.

### 9 Fill in the neck and face to finish off the rough sketch

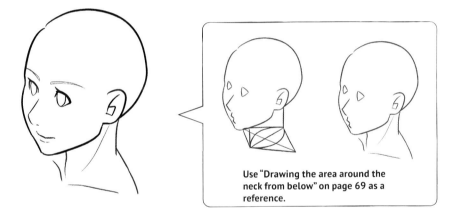

Use "Drawing the area around the neck from below" on page 69 as a reference.

---

🖉 **Helpful Hint**

**Draw faces that are nearly in profile**

Apply this technique and you'll be able to draw faces from the side, even on tricky angles.

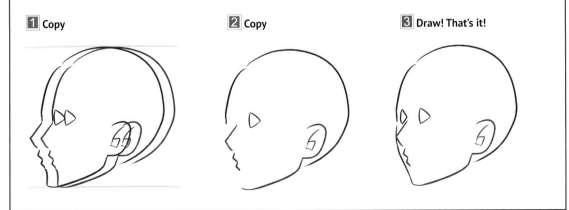

**1** Copy

**2** Copy

**3** Draw! That's it!

## Drawing faces from above on an angle

This is practically the same principle used for drawing faces from below on an angle.

**1** Draw the face in profile and add blocking-in lines

This is the opposite to the face viewed from below.

**2** Copy the face

**3** Erase unnecessary lines

Erase to the nose.

**4** Draw the outline of the face

**5** Erase unnecessary lines and draw in the eye

Follow the blocking-in.

**6** Shift the face up

**7** Draw the section under the chin

**8** Fill in the neck and face to finish off the rough drawing

**Q Critical Point**

### How to draw the nose and mouth on an angle

Use the ひ character shape even when the face is on an angle, following the blocking-in lines.

just right ✓        "ひ" wobbly ✗

Rather than creating an inverse triangle for the underside of the nose, keep it flat so as not to ruin the sketch.

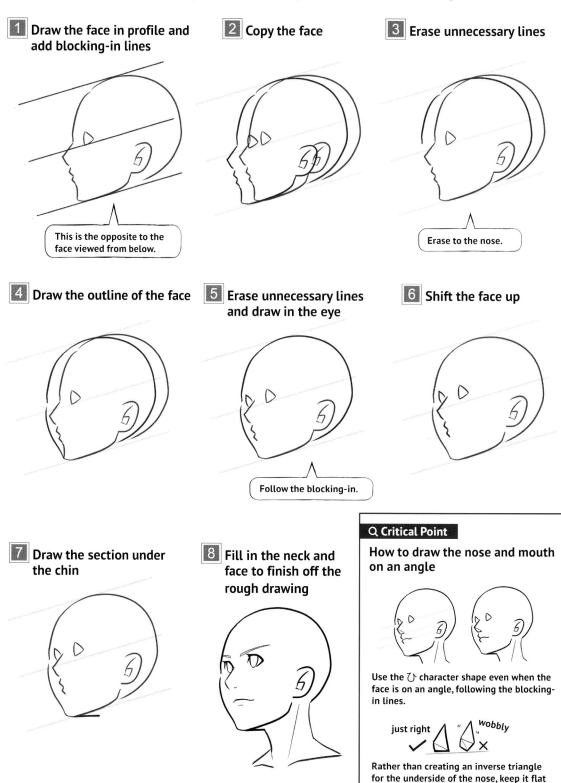

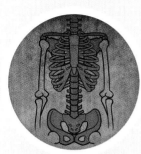

## PART 3

# Drawing Torsos

**Basic Ratios**

**Drawing Necks**

**Drawing Chests**

**Drawing Breasts**

**Drawing Shoulders**

**Drawing Abdominal Muscles**

**Drawing Backs**

**Drawing Hip Joints**

**Drawing Buttocks**

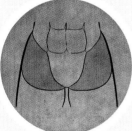

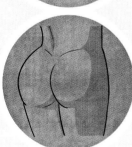

# Basic Ratios

Here, we will go through blocking-in the torso, the step before sketching and the step that involves drawing in the bones that form the core of the body. This stage helps determine the entire balance of the body, so keep practicing in order to be able to do the blocking-in from various angles.

## The structure of the skeleton

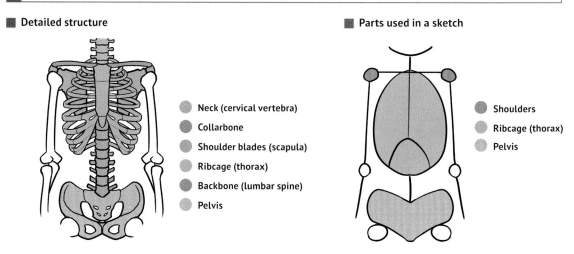

■ Detailed structure

- Neck (cervical vertebra)
- Collarbone
- Shoulder blades (scapula)
- Ribcage (thorax)
- Backbone (lumbar spine)
- Pelvis

■ Parts used in a sketch

- Shoulders
- Ribcage (thorax)
- Pelvis

## Ratios in the torso

In order to block-in the torso, learn the following three ratios.

neck : backbone = 1:2

the same

The ribcage and the pelvis are the same width.

Divide the ribcage at a 2:1 ratio.

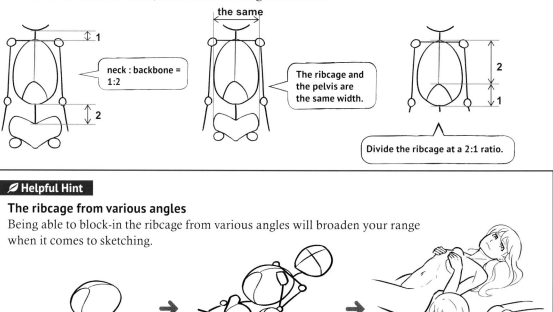

### ✎ Helpful Hint

**The ribcage from various angles**
Being able to block-in the ribcage from various angles will broaden your range when it comes to sketching.

Use the center line and the curved line below to express dimension.

Use the ribcage as a reference to draw in the head, pelvis and so on.

The finished rough drawing!

# How to block-in

## 1 Draw the head and ribcage

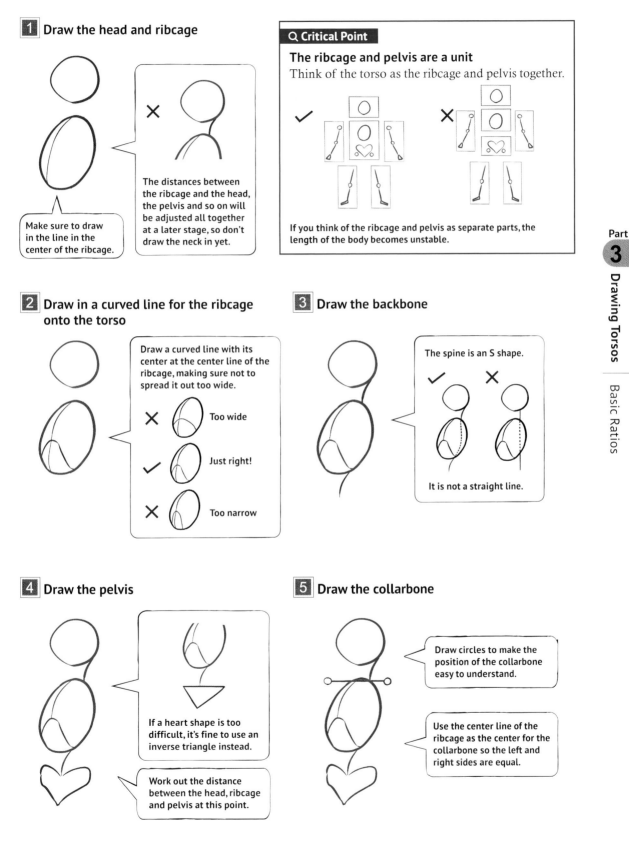

Make sure to draw in the line in the center of the ribcage.

The distances between the ribcage and the head, the pelvis and so on will be adjusted all together at a later stage, so don't draw the neck in yet.

### 🔍 Critical Point

**The ribcage and pelvis are a unit**
Think of the torso as the ribcage and pelvis together.

If you think of the ribcage and pelvis as separate parts, the length of the body becomes unstable.

## 2 Draw in a curved line for the ribcage onto the torso

Draw a curved line with its center at the center line of the ribcage, making sure not to spread it out too wide.

✕ Too wide

✓ Just right!

✕ Too narrow

## 3 Draw the backbone

The spine is an S shape.

✓  ✕

It is not a straight line.

## 4 Draw the pelvis

If a heart shape is too difficult, it's fine to use an inverse triangle instead.

Work out the distance between the head, ribcage and pelvis at this point.

## 5 Draw the collarbone

Draw circles to make the position of the collarbone easy to understand.

Use the center line of the ribcage as the center for the collarbone so the left and right sides are equal.

## 6 Draw in the hip joints straight down from the shoulders

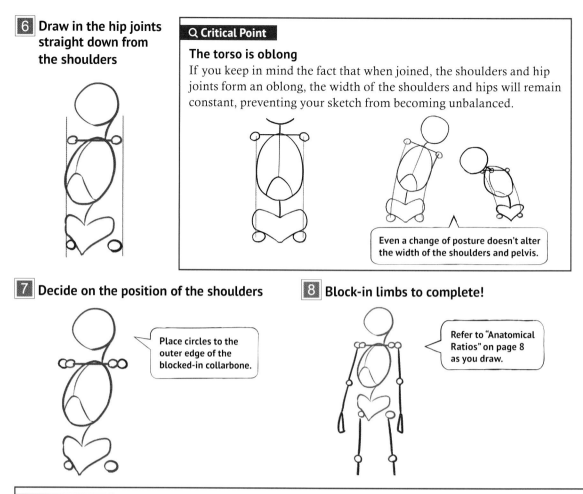

**Q Critical Point**

### The torso is oblong

If you keep in mind the fact that when joined, the shoulders and hip joints form an oblong, the width of the shoulders and hips will remain constant, preventing your sketch from becoming unbalanced.

> Even a change of posture doesn't alter the width of the shoulders and pelvis.

## 7 Decide on the position of the shoulders

> Place circles to the outer edge of the blocked-in collarbone.

## 8 Block-in limbs to complete!

> Refer to "Anatomical Ratios" on page 8 as you draw.

**Q Critical Point**

### Blocking-in the shoulders

If you use the blocking-in technique for the collarbone as well as for the shoulders, the shoulder width will become very narrow. Broaden the width of the shoulders by placing blocking-in lines for the shoulder joints to the outer edge of the collarbone.

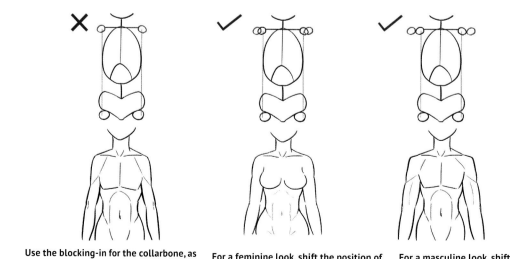

Use the blocking-in for the collarbone, as the blocking-in for the shoulders creates a cramped look.

For a feminine look, shift the position of the shoulders about half a circle's width out from the collarbone.

For a masculine look, shift the shoulders by a whole circle.

**🔍 Critical Point**

## Blocking-in the backbone

Visualize a supple curved line that joins the neck to the pelvis to block-in the backbone.

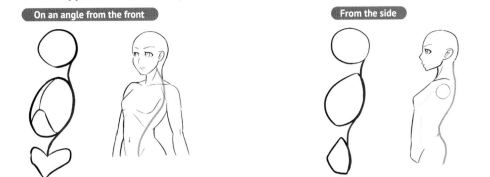

On an angle from the front

From the side

**🖉 Helpful Hint**

## How to block-in the backbone as the first step

When drawing a difficult pose, blocking-in the backbone will make it easier.

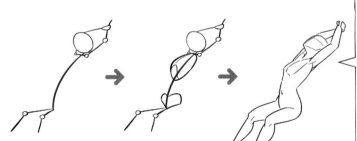

For a nearly front-on angle, place the backbone at the center to block-in the ribcage and pelvis.

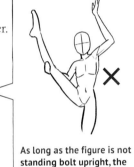

As long as the figure is not standing bolt upright, the backbone should be curved.

If the figure is exactly side-on, don't allow the backbone to pass through the ribcage.

Place the ribcage so that it is touching the edge of the backbone.

For a nearly side-on angle, draw the ribcage to one side of the backbone.

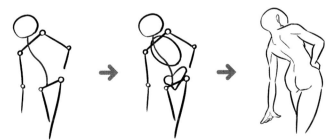

When drawing the back view of a figure viewed from above, the backbone is the only reference at the blocking-in and sketching stage, so this makes it particularly important.

When drawing a figure viewed from behind, drawing the backbone first is especially helpful when sketching.

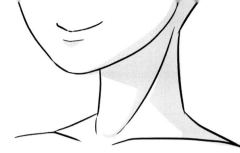

# Drawing Necks

The neck is simple to draw in compositions such as portraits, but when depicting the entire body, it's also important for setting the balance between the head and torso.

## The structure of the neck

### Detailed structure

**Front view**

**Side view**

**Back view**

| | Sternocleidomastoid |
| --- | --- |
| | Sternohyoid |
| | Trapezius |
| | Other muscles |
| | Bone |

### Ratios for the neck

**Front view**

The sternocleidomastoid is the main part of the neck, while the sternohyoid's role is to bring out dimension with its protruding sinews rather than to function as a muscle.

**Side view**

**Back view**

The trapezius can be simplified to two triangles on either side of the neck and an inverse triangle below the neck.

### Ratios for the neck

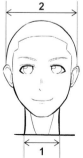

2

1

The average thickness for the neck. Width of head : width of neck = 2:1

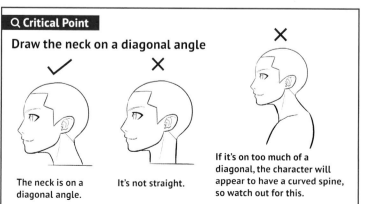

**Q Critical Point**

### Draw the neck on a diagonal angle

✓ ✗ ✗

The neck is on a diagonal angle.

It's not straight.

If it's on too much of a diagonal, the character will appear to have a curved spine, so watch out for this.

# Drawing the neck

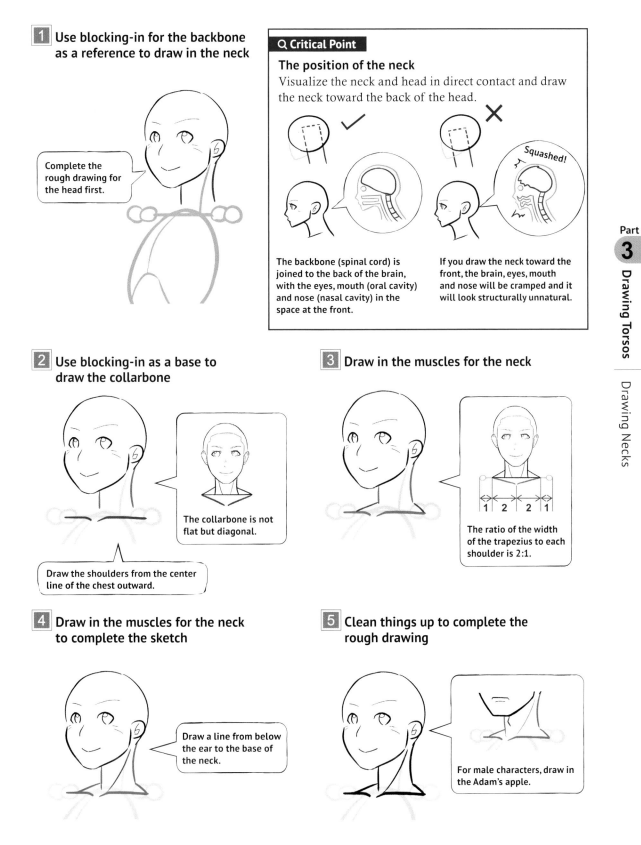

**1** Use blocking-in for the backbone as a reference to draw in the neck

Complete the rough drawing for the head first.

### 🔍 Critical Point

**The position of the neck**

Visualize the neck and head in direct contact and draw the neck toward the back of the head.

✓ ✗

Squashed!

The backbone (spinal cord) is joined to the back of the brain, with the eyes, mouth (oral cavity) and nose (nasal cavity) in the space at the front.

If you draw the neck toward the front, the brain, eyes, mouth and nose will be cramped and it will look structurally unnatural.

**2** Use blocking-in as a base to draw the collarbone

The collarbone is not flat but diagonal.

Draw the shoulders from the center line of the chest outward.

**3** Draw in the muscles for the neck

The ratio of the width of the trapezius to each shoulder is 2:1.

1 2 2 1

**4** Draw in the muscles for the neck to complete the sketch

Draw a line from below the ear to the base of the neck.

**5** Clean things up to complete the rough drawing

For male characters, draw in the Adam's apple.

# Drawing the underside of the chin

The underside of the chin gets an unusual amount of emphasis and attention when the face is directed upward. It's worth understanding its structure in its role connecting the face and neck.

## 1 The structure of the underside of the chin

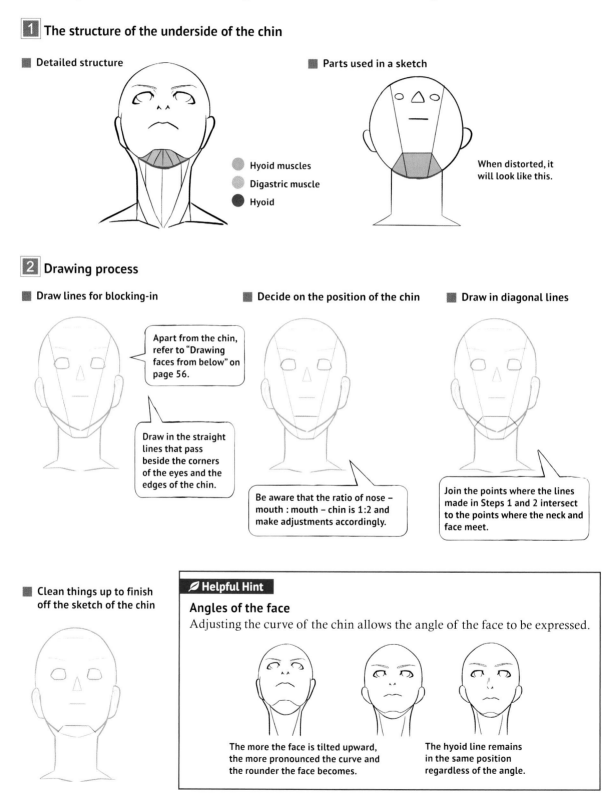

■ Detailed structure

■ Parts used in a sketch

- ● Hyoid muscles
- ● Digastric muscle
- ● Hyoid

When distorted, it will look like this.

## 2 Drawing process

■ Draw lines for blocking-in

Apart from the chin, refer to "Drawing faces from below" on page 56.

Draw in the straight lines that pass beside the corners of the eyes and the edges of the chin.

■ Decide on the position of the chin

Be aware that the ratio of nose – mouth : mouth – chin is 1:2 and make adjustments accordingly.

■ Draw in diagonal lines

Join the points where the lines made in Steps 1 and 2 intersect to the points where the neck and face meet.

■ Clean things up to finish off the sketch of the chin

**🖉 Helpful Hint**

### Angles of the face
Adjusting the curve of the chin allows the angle of the face to be expressed.

The more the face is tilted upward, the more pronounced the curve and the rounder the face becomes.

The hyoid line remains in the same position regardless of the angle.

# Drawing the area around the neck from underneath

**1** Sketch the face

Refer to "Drawing faces from above on an angle" on page 60 as you draw.

**2** Block-in the neck

✕

Make sure the neck isn't positioned too far forward.

**3** Draw in a horizontal line from where the ear meets the chin

**4** Join the end of the chin to the point where the neck meets the horizontal line drawn in Step **3**

This triangle forms the underside of the chin.

**5** Draw the muscles for the collarbone and neck

The method of drawing the neck muscles remains the same.

**6** Erase unnecessary lines and clean up the sketch to complete!

Draw in an Adam's apple or other details if you like.

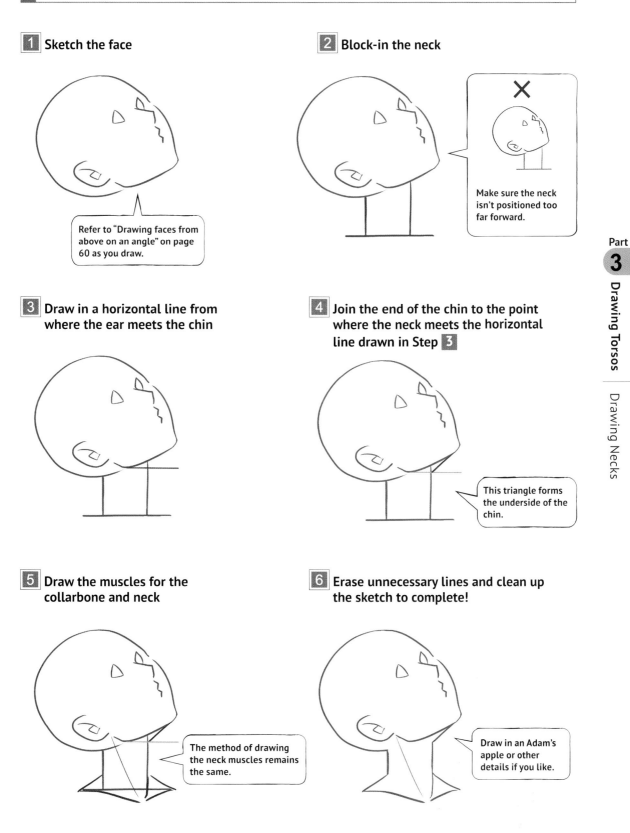

# Drawing the area around the neck from above

## 1 The neck viewed from above

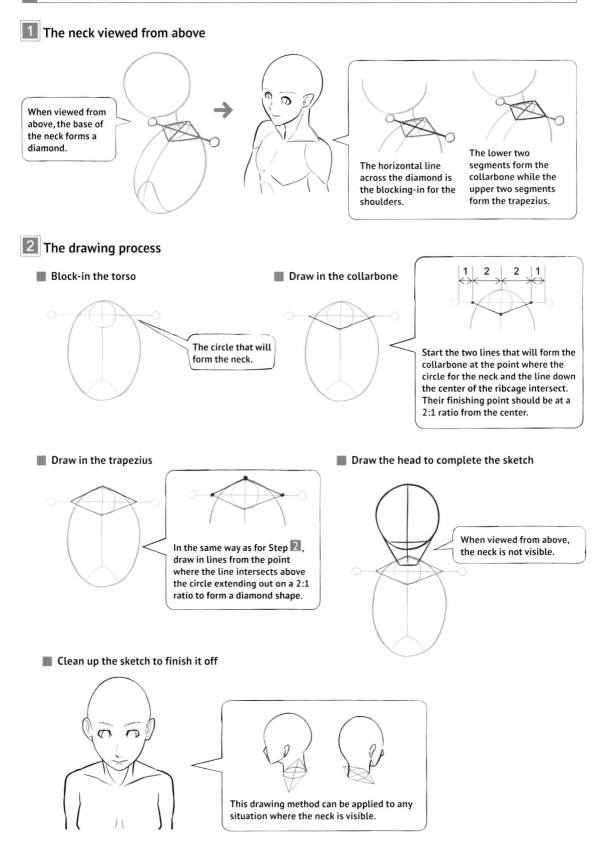

When viewed from above, the base of the neck forms a diamond.

The horizontal line across the diamond is the blocking-in for the shoulders.

The lower two segments form the collarbone while the upper two segments form the trapezius.

## 2 The drawing process

### Block-in the torso

The circle that will form the neck.

### Draw in the collarbone

1   2   2   1

Start the two lines that will form the collarbone at the point where the circle for the neck and the line down the center of the ribcage intersect. Their finishing point should be at a 2:1 ratio from the center.

### Draw in the trapezius

In the same way as for Step 2, draw in lines from the point where the line intersects above the circle extending out on a 2:1 ratio to form a diamond shape.

### Draw the head to complete the sketch

When viewed from above, the neck is not visible.

### Clean up the sketch to finish it off

This drawing method can be applied to any situation where the neck is visible.

# Separating layers and colors

Many people get stuck like this at the sketching stage when drawing poses and body parts that are overlapping in complicated ways.

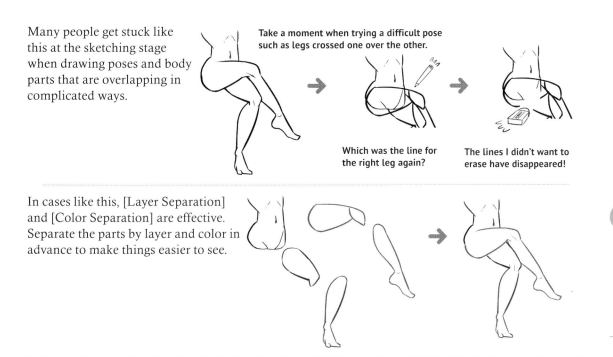

Take a moment when trying a difficult pose such as legs crossed one over the other.

Which was the line for the right leg again?

The lines I didn't want to erase have disappeared!

In cases like this, [Layer Separation] and [Color Separation] are effective. Separate the parts by layer and color in advance to make things easier to see.

---

### 🔍 Critical Point

## Layer basics

Layers refer to transparent canvas—similar to sheets of tracing paper. Use them and get to know how to make use of their features to avoid confusion when sketching.

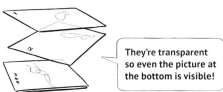

They're transparent so even the picture at the bottom is visible!

■ **Layers are a stack of transparent paper.**

By using multiple layers, mistakes such as accidentally erasing or adding sections other than those needing correction can be avoided.

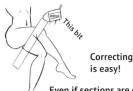

This bit

Correcting is easy!

Select only the layer that you want to correct! (Make changes only to this canvas.)

Even if sections are deleted with the eraser, there is no change to the layers that are not selected!

---

■ **Each layer can be managed separately.**

Just like shifting sheets of paper, the selected layer can be moved without affecting the others and it is also possible to temporarily stop displaying unnecessary layers.

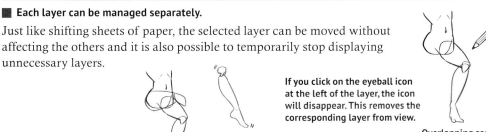

You can shift only the parts that you want!

Making adjustments is easy!

If you click on the eyeball icon at the left of the layer, the icon will disappear. This removes the corresponding layer from view.

Overlapping sections are easy to draw too!

# Drawing Chests

For male characters, large pectoral muscles indicate strength or an athletic leaning, while breasts highlight shape and physical definition in your female characters.

## Structure of the chest

■ Detailed structure

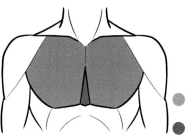

● Greater pectoral muscle
● Sternum

■ Parts used in a sketch

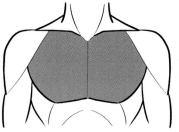

The sternum is reduced to a line.

## Using the sternum to block-in

When drawing the chest, the sternum is used for blocking-in. It's an important section for creating a sketch as it determines the direction of the upper body.

You can even do difficult poses with the face, upper and lower body facing in different directions!

Even on a difficult angle and when the character has breasts, make sure to block-in using the sternum.

### Q Critical Point

#### The shape of the pectorals

The muscles in the chest (greater pectoral muscle) are attached to the bones of the arm. Therefore, when the arms are raised, the pectorals are pulled up with them and their shape changes.

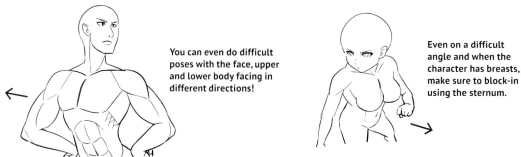

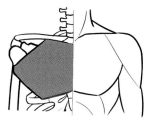

The section indicated by the green line is attached to other parts of the body so it does not alter even if the arm is raised.

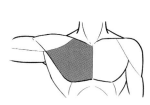

The muscle is drawn up by the arm and stretches horizontally.

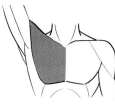

When pulled up, the muscle contracts and the surface area is reduced.

# Drawing the chest

**1** Create blocking-in to draw the pectorals

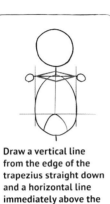

Draw a vertical line from the edge of the trapezius straight down and a horizontal line immediately above the curve of the ribcage.

**2** Draw a cross through the blocking-in from Step **1** with the upper points at the edges of the blocked-in collarbone

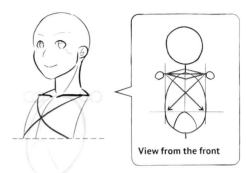

View from the front

**3** Use curved lines to join the edges of the blocked-in collarbone to the lower points of the cross

**4** Draw in the center of the pectorals

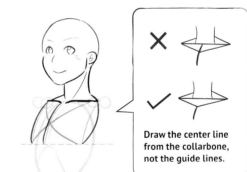

Draw the center line from the collarbone, not the guide lines.

**5** Draw in the bottom line of the pectorals to complete the sketch

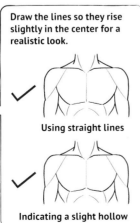

Draw the lines so they rise slightly in the center for a realistic look.

Using straight lines

Indicating a slight hollow

**6** Clean things up to complete the rough drawing

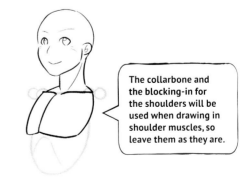

The collarbone and the blocking-in for the shoulders will be used when drawing in shoulder muscles, so leave them as they are.

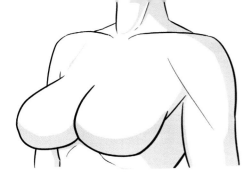

# Drawing Breasts

For your female characters, sketching in the breasts is pretty simple, but there's a lot to consider in regard to shape and positioning.

## Structure of the breasts

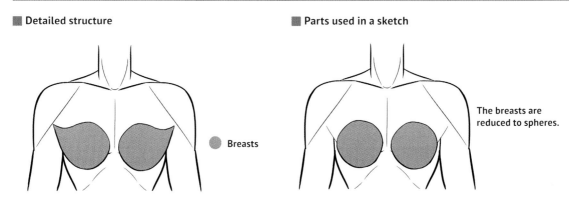

■ Detailed structure

■ Parts used in a sketch

● Breasts

The breasts are reduced to spheres.

## Breast size

Alter the size of the blocked-in circle to adjust the breast size.

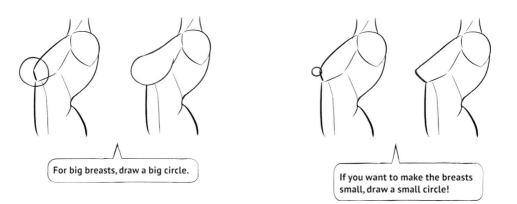

For big breasts, draw a big circle.

If you want to make the breasts small, draw a small circle!

---

**🔍 Critical Point**

### Draw the chest before you draw the breasts!

The female breasts are not chest muscles that have changed shape. This might seem obvious, but surprising numbers of people draw only the breasts without having drawn the pectoral muscles, and this can ruin the sketch. Draw both the pectorals and the breasts to improve the accuracy of your sketch.

Without blocking-in, it's easy for the sketch to go off-balance!

Draw the chest in first, then the breasts, for a reliable sketch.

# Drawing the breasts

**1** Draw circles on the chest to block-in the breasts

**2** Draw around the circles to create the breasts

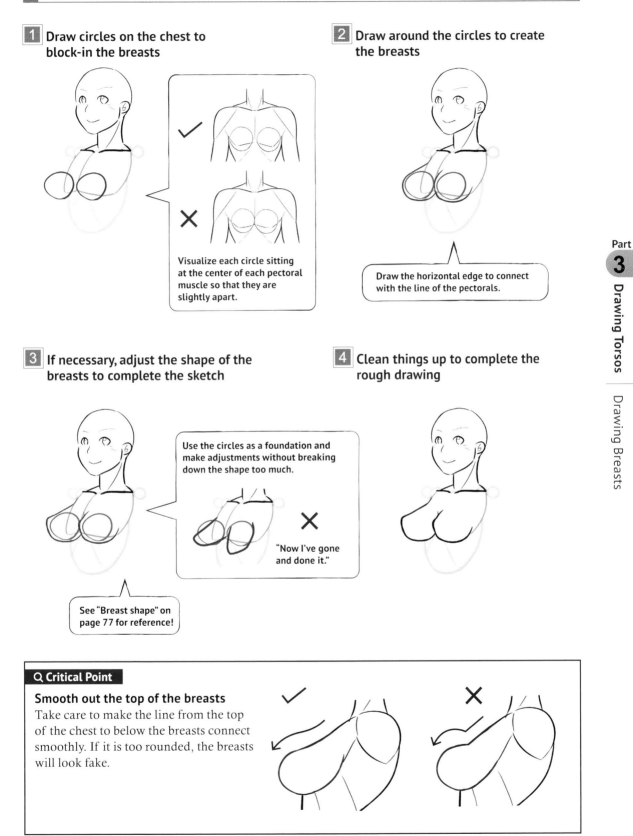

Visualize each circle sitting at the center of each pectoral muscle so that they are slightly apart.

Draw the horizontal edge to connect with the line of the pectorals.

**3** If necessary, adjust the shape of the breasts to complete the sketch

**4** Clean things up to complete the rough drawing

Use the circles as a foundation and make adjustments without breaking down the shape too much.

"Now I've gone and done it."

See "Breast shape" on page 77 for reference!

## Q Critical Point

### Smooth out the top of the breasts

Take care to make the line from the top of the chest to below the breasts connect smoothly. If it is too rounded, the breasts will look fake.

# Drawing the décolletage

The décolletage is the area from the neck to the chest, a part of the body that creates attractiveness in a woman's upper torso. Make sure to leave room for drawing it in.

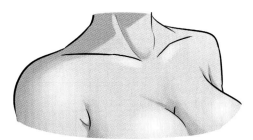

**Things to watch out for when adding color to the décolletage**

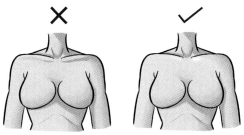

Using too dark a color to shade the collarbone will make the character look too thin. Add lighter highlights for a healthy look.

**The relationship between the décolletage and the breast position**

The breasts are attached to the lower half of the pectoral muscles. If you draw them in above the pectorals, the décolletage will disappear and the drawing will look off-balance.

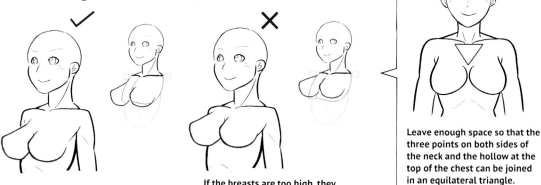

If the breasts are too high, they will look unnatural.

Leave enough space so that the three points on both sides of the neck and the hollow at the top of the chest can be joined in an equilateral triangle.

---

**Q Critical Point**

### Expressing softness

When drawing the breasts, using a shape like the Japanese character ハ to draw in the lower section will highlight their softness, although depending on the figure's posture and shape, it may not be possible to create this shape.

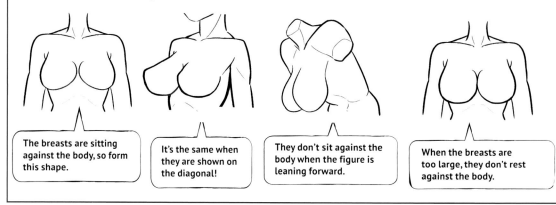

The breasts are sitting against the body, so form this shape.

It's the same when they are shown on the diagonal!

They don't sit against the body when the figure is leaning forward.

When the breasts are too large, they don't rest against the body.

# Breast shape

Draw your character's breasts to suit your taste and to reflect her defining traits.

## ■ Semicircle

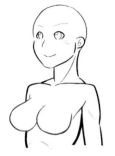 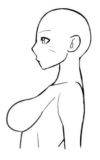

This shape resembles a hemisphere, like a bowl, and is generally perceived to be the ideal shape. If the breasts get too big, their weight will cause them to droop and, without something like a bra to support them, it is difficult to maintain their hemispherical form.

## ■ Triangular

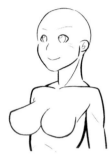 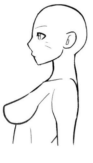

There is no roundness to the top part of the breasts, and in profile they appear triangular. The nipples pointing upward are also a characteristic of this shape. Even without making the breasts themselves too big, it's possible to emphasize the undersection.

## ■ Teardrop-Shaped

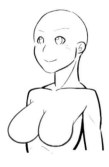 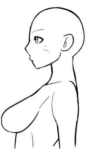

The breasts form a shape like a teardrop. If the breasts are of a certain size, they tend to assume this shape. Take care when drawing them so they don't appear to droop.

## ■ Bell-Shaped

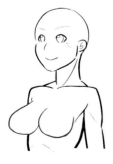 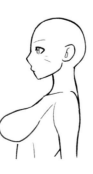

The breasts thrust forward in the shape of a bell. As the nipple area is emphasized, the breasts appear more voluptuous than their actual size.

# Breast size

Size is an important factor when drawing breasts. However, physique and shape also play a part in determining breast size. Here, we look at the range of cup sizes.

**Q Critical Point**

### Measuring cup size
The cup size is the difference between the underbust and bust measurements. Both measurements take in the area around the bust.

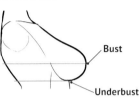

If the difference between the two measurements is 4 inches (10 cm), the cup size is A; 5 inches (12.5 cm) is a B cup; 6 inches (15 cm) is a C cup and so on with the cup size rising by 1-inch (2.5-cm) increments.

### A Cup
There is no fullness in the breasts and the structure is similar to that of males. However the chest is not as broad as on a man, so a fine pen can be used to draw the breasts.

### B Cup
The breasts stand out more than for the A cup, however they are still small and when viewed from the front, they do not extend beyond the sides of the body.

### C Cup
There is a roundness and fullness to the breasts and they extend beyond the width of the body. They stand out as being feminine but are still small.

### ■ D Cup

A size larger than a C cup, breasts of this size are quite big but not so large as to meet in the middle.

### ■ E-F Cups

Breasts of this size would be described as large and are noticeable even when the figure is clothed. At this size the breasts start to be larger than the pectoral muscles, and even without a bra, cleavage forms.

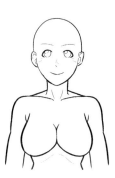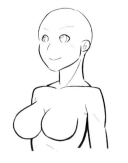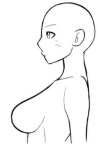

### ■ G-H Cups

Breasts of this size are heavy and do not retain their shape easily without support. At this size, they have a tendency to become teardrop-shaped.

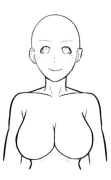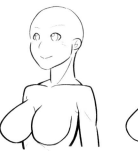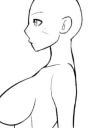

### ■ I-J Cups

Even larger than a G-H cup, breasts of this size become saggy due to their weight. They can be drawn in the same way as for G-H cups, but a size larger. Breasts of sizes larger than this can be drawn in the same way.

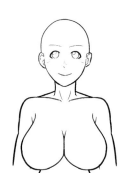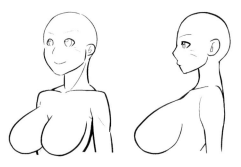

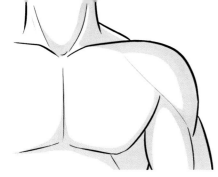

# Drawing Shoulders

Apart from having a complicated structure to begin with, the shoulders are the most difficult part of the upper body to draw due to the arms, which can move freely and add another level of complexity and flow. Having an understanding of the structure of the shoulder joint and muscles is invaluable.

## Structure of the shoulder

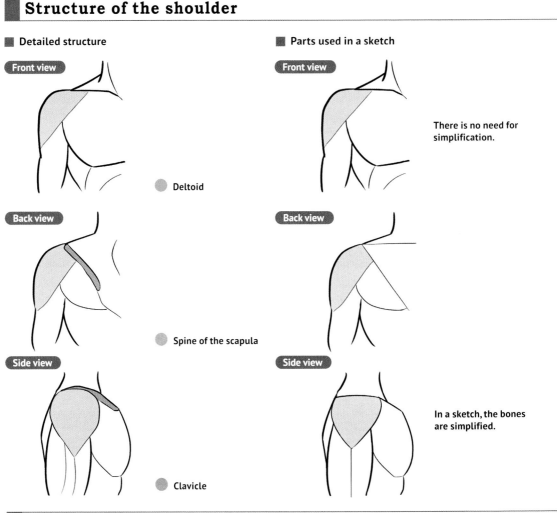

■ Detailed structure

**Front view**

● Deltoid

**Back view**

● Spine of the scapula

**Side view**

● Clavicle

■ Parts used in a sketch

**Front view**

There is no need for simplification.

**Back view**

**Side view**

In a sketch, the bones are simplified.

## Ratios in the shoulder

The ratio between the deltoids and shoulder width become important when sketching in the size of the deltoids. As the deltoids are important parts of the body for determining the size of the pectoral muscles and arms, it's a good idea to learn this ratio.

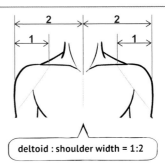

deltoid : shoulder width = 1:2

# Drawing the shoulders

**1** **Block-in the shoulders**

In order for the shoulder width not to appear awkward, shift the circles for the shoulder joints using the blocking-in for the torso (pages 63–4) as a reference.

**2** **Draw in the shoulder line from the edge of the blocking-in for the collarbone**

Make sure the left and right shoulders line up.

**3** **Join the lines to form the deltoids and complete the sketch**

As you draw, keep in mind that when viewed from the front, the ratio of deltoid : shoulder width should be 1:2.

**4** **Clean things up to finish the rough sketch**

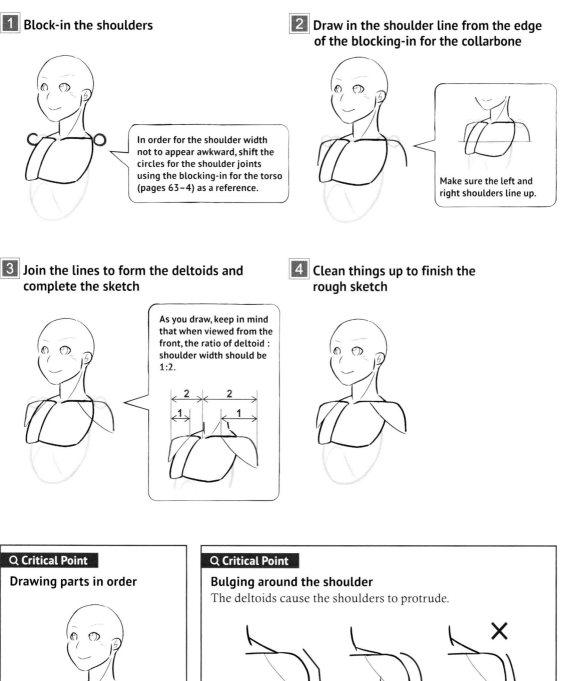

---

**Q Critical Point**

### Drawing parts in order

The arms will get in the way when you draw the torso and other parts of the body, so draw them in last.

**Q Critical Point**

### Bulging around the shoulder

The deltoids cause the shoulders to protrude.

Men's muscles make their shoulders jut out.

Women's shoulders have a roundness.

They should not be flat.

# The shape of the shoulder muscles (deltoids)

The shoulders move freely, so if you learn the shape of the deltoids and can draw them from any angle, it will make things easy.

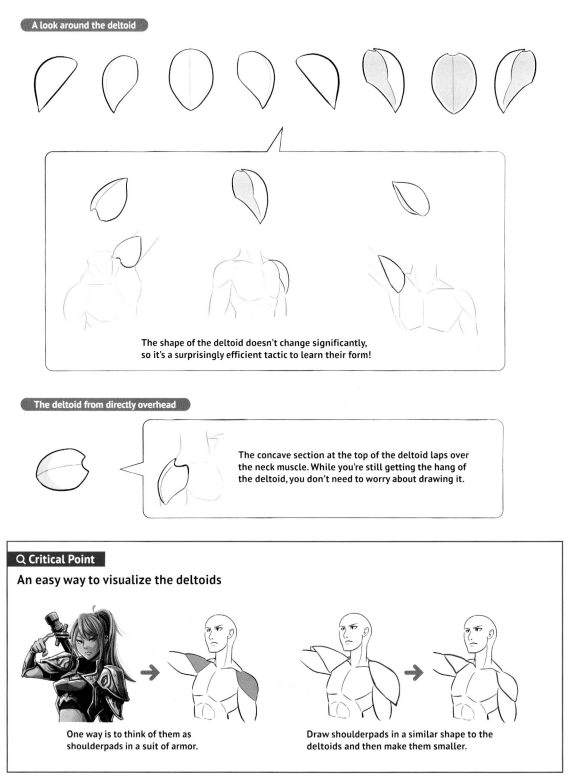

**A look around the deltoid**

The shape of the deltoid doesn't change significantly, so it's a surprisingly efficient tactic to learn their form!

**The deltoid from directly overhead**

The concave section at the top of the deltoid laps over the neck muscle. While you're still getting the hang of the deltoid, you don't need to worry about drawing it.

**Q Critical Point**

## An easy way to visualize the deltoids

One way is to think of them as shoulderpads in a suit of armor.

Draw shoulderpads in a similar shape to the deltoids and then make them smaller.

# Connecting the shoulders to other parts

## 1 Connecting the shoulder muscles and how to capture their shape

The shoulder muscles (deltoids) sit over the pectoral muscles.

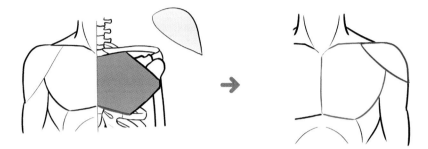

## 2 Connecting the deltoids, chest and back

When drawing a pose where the arm is raised, it's easiest to think of the deltoids and pectorals as a package. The deltoids are muscles that are connected to both the pectoral muscles and the rotator cuff (back muscles). Depending on the angle, they will appear to be connected to the pectoral muscles or the rotator cuff, but in either case they will be similar to a triangle in shape.

The deltoid and surrounding muscles resemble a triangle when grouped together.

## 2 Connections when viewed from above

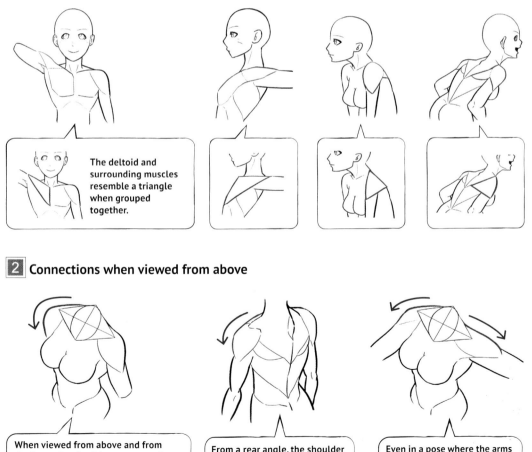

When viewed from above and from the front, the shoulder appears to be connected to the trapezius so it can be expressed as a single curved line.

From a rear angle, the shoulder appears to be attached to the chest muscles.

Even in a pose where the arms are raised, the drawing method is the same.

# Connections in the bones of the shoulder

The collarbone, scapula and humerus are all connected, and when the arm is raised the collarbone moves to follow it. This is the same when muscles are attached.

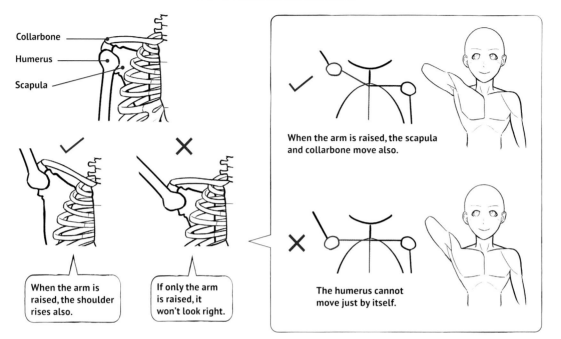

Collarbone
Humerus
Scapula

When the arm is raised, the shoulder rises also.

If only the arm is raised, it won't look right.

When the arm is raised, the scapula and collarbone move also.

The humerus cannot move just by itself.

---

**Q Critical Point**

### Further stabilizing the sketch

As explained above, the collarbone rises when the arm is raised, but when putting this into practice, the blocking-in for the collarbone often gets stretched out horizontally, throwing the sketch off balance. Draw the blocking-in lines clearly to prevent the sketch from being ruined.

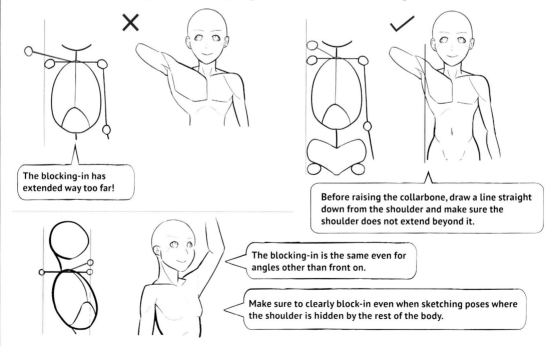

The blocking-in has extended way too far!

Before raising the collarbone, draw a line straight down from the shoulder and make sure the shoulder does not extend beyond it.

The blocking-in is the same even for angles other than front on.

Make sure to clearly block-in even when sketching poses where the shoulder is hidden by the rest of the body.

# How the shoulder muscles move

Here, muscle movement in the arms is grouped according to angle. Use this as a reference when sketching.

## 1 Raising the arms to the front (front view)

■ Raising the right arm to the front

■ Raising the left arm to the front

- Deltoid
- Biceps
- Triceps

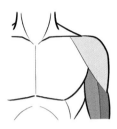

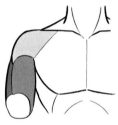

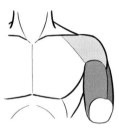

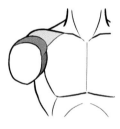

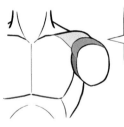

The shoulder is actually concealed by the hand and forearm so is hardly visible.

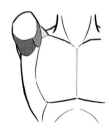

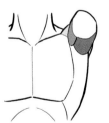

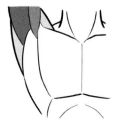

The deltoid is barely visible as it is hidden by the upper arm.

## 2 Raising the arm to the front (back view)

## 3 Raising the arm to the front (side view)

■ Raising the left arm to the front    ■ Raising the right arm to the front

■ Raising the left arm to the front    ■ Raising the right arm to the front

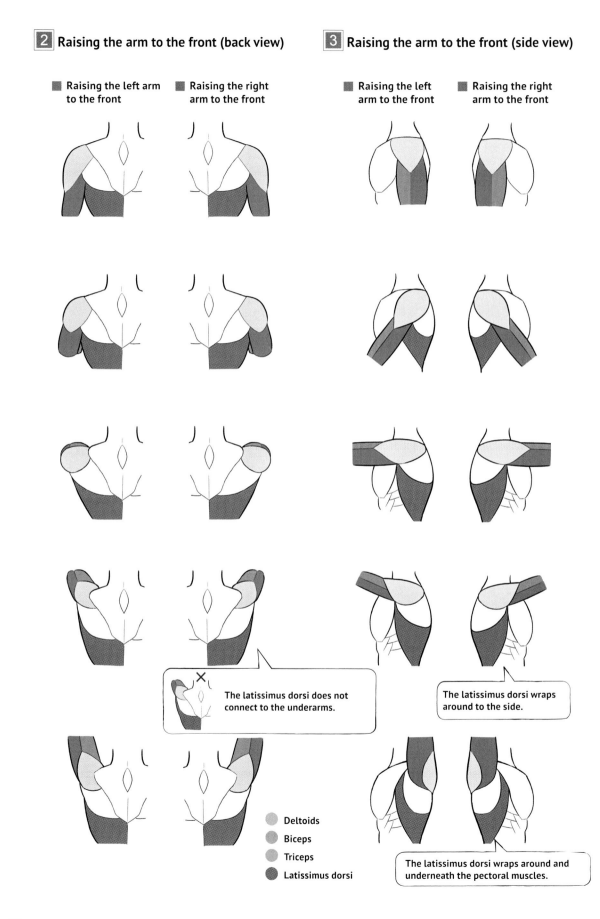

The latissimus dorsi does not connect to the underarms.

The latissimus dorsi wraps around to the side.

- ● Deltoids
- ● Biceps
- ● Triceps
- ● Latissimus dorsi

The latissimus dorsi wraps around and underneath the pectoral muscles.

86

# 4 Raising the arm to the side (front view)

# 5 Raising the arm to the side (back view)

■ Raising the right arm to the side

■ Raising the left arm to the side

■ Raising the left arm to the side

■ Raising the right arm to the side

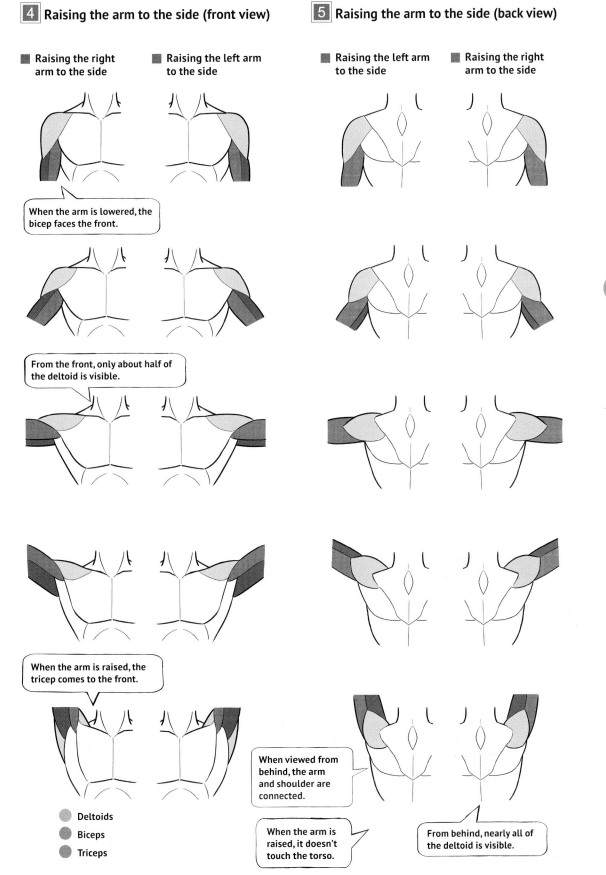

When the arm is lowered, the bicep faces the front.

From the front, only about half of the deltoid is visible.

When the arm is raised, the tricep comes to the front.

When viewed from behind, the arm and shoulder are connected.

When the arm is raised, it doesn't touch the torso.

From behind, nearly all of the deltoid is visible.

- ● Deltoids
- ● Biceps
- ● Triceps

# Drawing Abdominal Muscles

Abs are important in determining where the front and sides of the body meet. Mastering this area gives your sketches the stability they need.

## The structure of the abdominal muscles

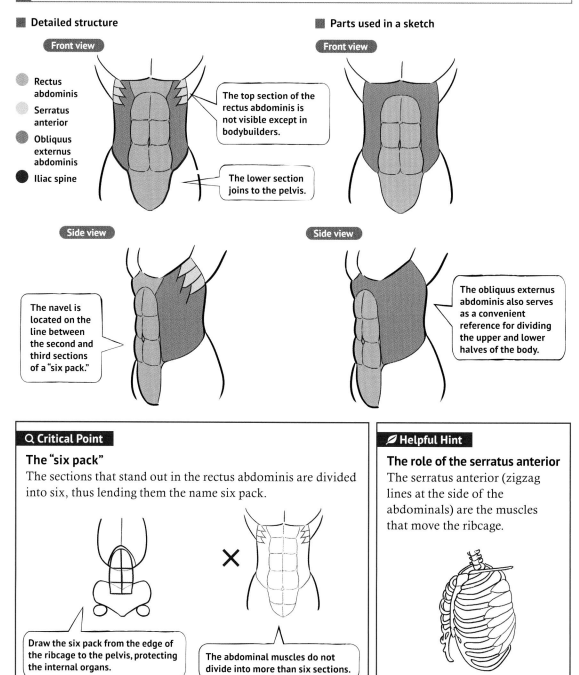

■ **Detailed structure**

**Front view**

- Rectus abdominis
- Serratus anterior
- Obliquus externus abdominis
- Iliac spine

The top section of the rectus abdominis is not visible except in bodybuilders.

The lower section joins to the pelvis.

**Side view**

The navel is located on the line between the second and third sections of a "six pack."

■ **Parts used in a sketch**

**Front view**

**Side view**

The obliquus externus abdominis also serves as a convenient reference for dividing the upper and lower halves of the body.

---

**🔍 Critical Point**

**The "six pack"**

The sections that stand out in the rectus abdominis are divided into six, thus lending them the name six pack.

✕

Draw the six pack from the edge of the ribcage to the pelvis, protecting the internal organs.

The abdominal muscles do not divide into more than six sections.

**🖋 Helpful Hint**

**The role of the serratus anterior**

The serratus anterior (zigzag lines at the side of the abdominals) are the muscles that move the ribcage.

# Drawing the abdominal muscles

**1** Draw the center line

Extend the line from the lower edge of the pectoral muscles down to the base of the pelvis.

Internal organs

Internal organs are packed inside the body. Keep this in mind and use a curved line to draw the center line in.

**2** Draw straight lines down from the pectoral muscles

It's easy to work out the position of the center when the chest sketch is complete.

**3** Join the lines at the base of the pelvis

## Q Critical Point

### The boundary between the front and sides of the body

The lines drawn straight down from the nipples divide the front and sides of the body (they also separate the abdominal muscles from the oblique muscles).

They serve as a guide line when adding shadow, so make good use of them!

## Q Critical Point

### The reason for joining the abdominal muscle lines

Connecting the lines that run down from the nipples to the base of the pelvis means that when you draw the abdominal muscles on a diagonal angle, the sketch will remain stable.

When the lines are joined, it is easy to stabilize the sketch.

If the lines are not joined, it is difficult to create stability in the area where the chest and hips join and the sketch is easily thrown off balance.

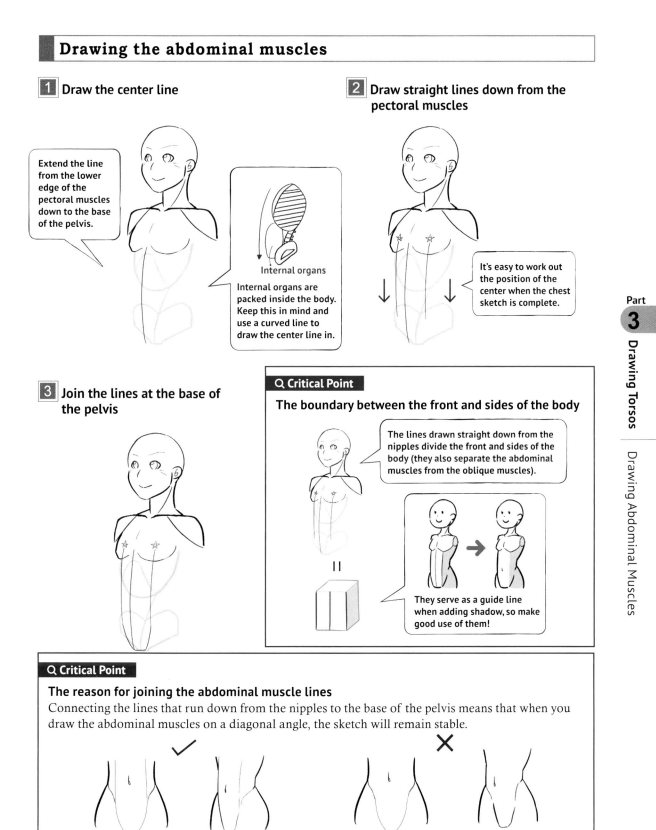

## 4 Draw the abdominal muscles

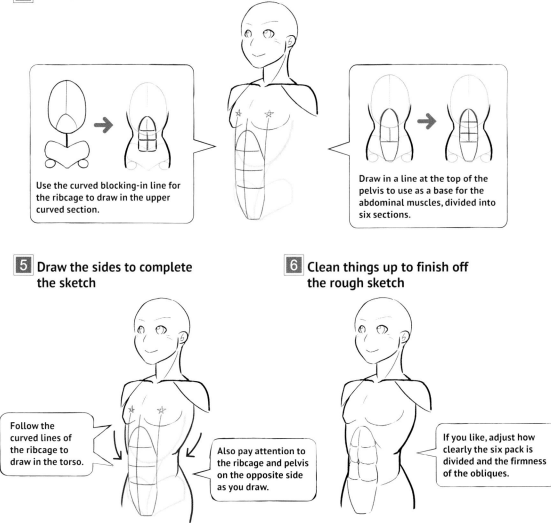

Use the curved blocking-in line for the ribcage to draw in the upper curved section.

Draw in a line at the top of the pelvis to use as a base for the abdominal muscles, divided into six sections.

## 5 Draw the sides to complete the sketch

## 6 Clean things up to finish off the rough sketch

Follow the curved lines of the ribcage to draw in the torso.

Also pay attention to the ribcage and pelvis on the opposite side as you draw.

If you like, adjust how clearly the six pack is divided and the firmness of the obliques.

---

### 🍃 Helpful Hint

### How the abdominal muscles develop

After a series of crunches or some kind of workout regimen, the abdominal muscles gradually begin to stand out. Here, we show that process.

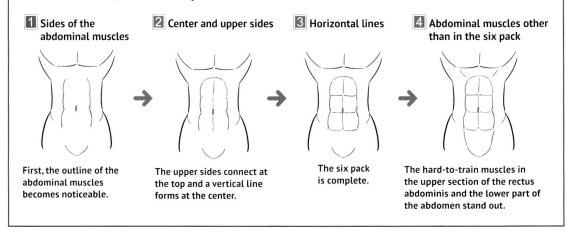

**1 Sides of the abdominal muscles**

**2 Center and upper sides**

**3 Horizontal lines**

**4 Abdominal muscles other than in the six pack**

First, the outline of the abdominal muscles becomes noticeable.

The upper sides connect at the top and a vertical line forms at the center.

The six pack is complete.

The hard-to-train muscles in the upper section of the rectus abdominis and the lower part of the abdomen stand out.

# Drawing abdominal muscles in women

**1** Draw in the center line and extend lines from the center of the pectorals straight down

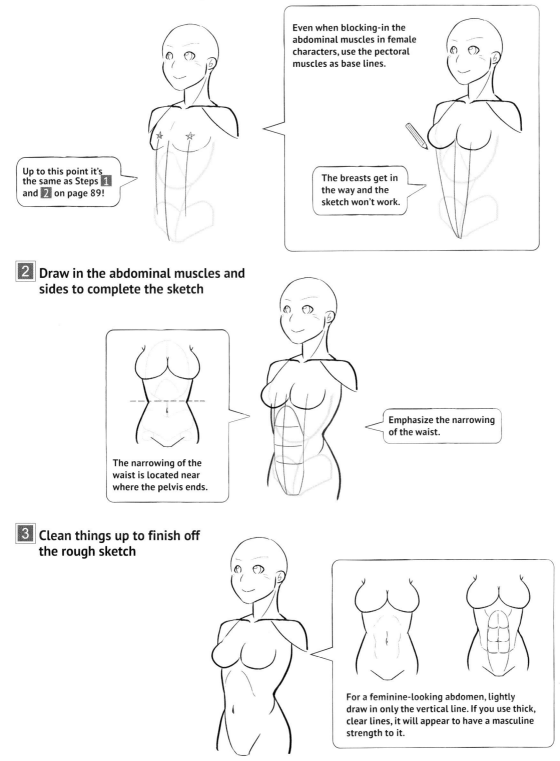

Even when blocking-in the abdominal muscles in female characters, use the pectoral muscles as base lines.

Up to this point it's the same as Steps **1** and **2** on page 89!

The breasts get in the way and the sketch won't work.

**2** Draw in the abdominal muscles and sides to complete the sketch

Emphasize the narrowing of the waist.

The narrowing of the waist is located near where the pelvis ends.

**3** Clean things up to finish off the rough sketch

For a feminine-looking abdomen, lightly draw in only the vertical line. If you use thick, clear lines, it will appear to have a masculine strength to it.

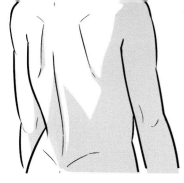

# Drawing Backs

With the backbone and scapulae, the back is a part of the body where bones are more prominent than muscles. In a regular physique, the parts that can be used for reference when drawing don't stand out that much, so the blocking-in of the backbone and ribcage becomes crucial.

## Structure of the back

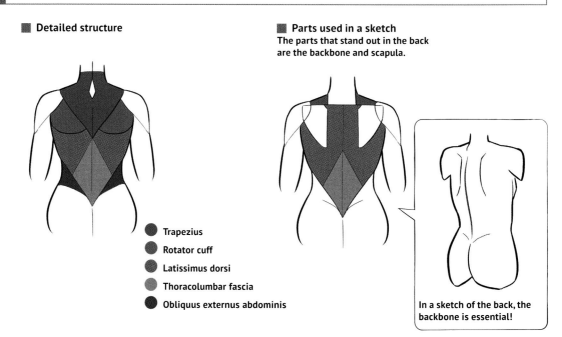

■ Detailed structure

■ Parts used in a sketch
The parts that stand out in the back are the backbone and scapula.

- Trapezius
- Rotator cuff
- Latissimus dorsi
- Thoracolumbar fascia
- Obliquus externus abdominis

In a sketch of the back, the backbone is essential!

---

### ✐ Helpful Hint

**The diamond in the back**
The diamond in the back, known as the thoracolumbar fascia, plays a big role as a guide for adding shadow.

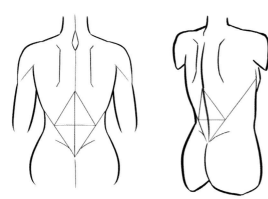

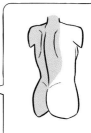

There are few reference points for sketching, and it is difficult to express dimension in the back, so the diamond is very helpful!

It's easy to add shadow!

Naturally, erase the diamond once the sketch is complete.

# Drawing the back

## 1 Draw the deltoids

Refer to page 81 for drawing the deltoids.

Draw in the scapulae using right-angled triangles.

## 2 Draw the scapulae

The width of a scapula is nearly the same as that of the neck.

The scapulae run from the shoulder line down to just below the halfway line of the ribcage.

## 3 Draw the latissimus dorsi

When drawing the latissimus dorsi, use the base line used to draw the scapulae as a starting point. The finishing point is where the backbone joins the pelvis.

## 4 Add in the top half (thoracolumbar fascia) to form a diamond

The starting point for the diamond is the base line for the scapulae. The finishing point is halfway between the ribcage and the pelvis.

## 5 Draw in the torso to complete the sketch

Use the base line drawn in Step 4 to create the narrowing at the waist.

## 6 Clean things up to finish off the rough sketch

Erase all the lines except for the inner edges of the scapulae and the backbone.

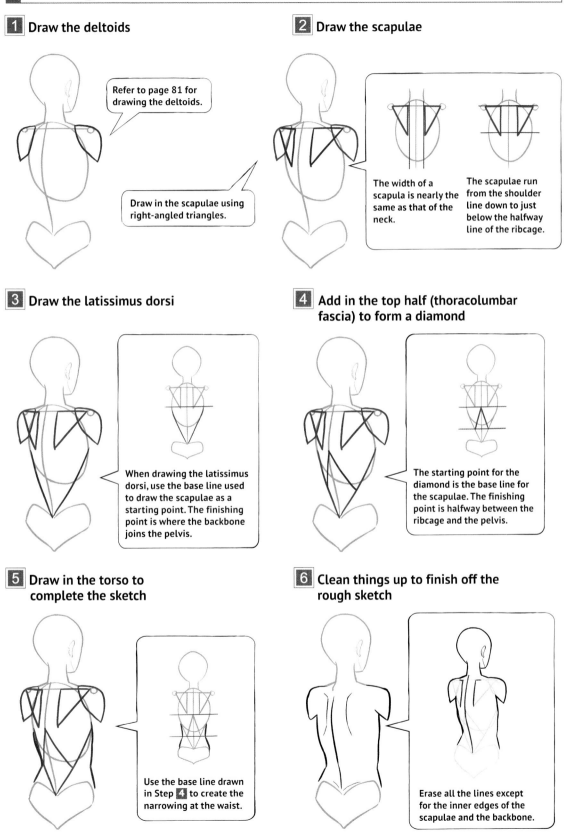

# Muscles in the back

When sketching the back, the bones are important for adding shadow and bringing out dimension, but it's also vital to understand the structure of the muscles. Pay particular attention to the rotator cuff (which is important because it connects to the deltoid) and the thoracolumbar fascia, which acts as the main guide for adding shadow.

### 1 Rotator cuff

The rotator cuff is the group of muscles that joins the scapula to the arm. It's made up of four muscles.

The deltoid sits on top of the rotator cuff.

It is a complex shape, so it's fine to reduce it to the shape above.

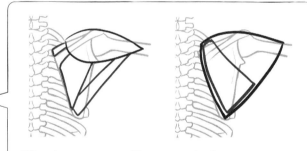

When the arm opens out, it's easy to render the rotator cuff together with the deltoid as a triangle.

### 2 Trapezius

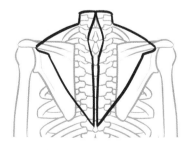

The trapezius is the group of muscles in the neck. It is quite a large and complicated shape.

There's no problem with you drawing it as a triangle.

## 3 Latissimus dorsi

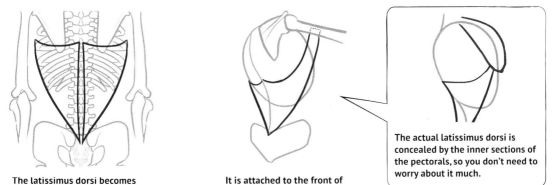

The latissimus dorsi becomes important when expressing dimension around the back.

It is attached to the front of the bones in the arm.

The actual latissimus dorsi is concealed by the inner sections of the pectorals, so you don't need to worry about it much.

---

**♛ Tips & Tricks**

### How the rotator cuffs, latissimus dorsi and trapezius overlap

The rotator cuff, latissimus dorsi and trapezius are layered in this order from inside out:

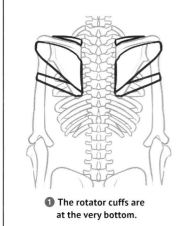
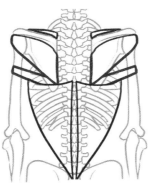
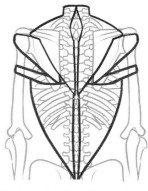

❶ The rotator cuffs are at the very bottom.

❷ The latissimus dorsi sits on top of them.

❸ The trapezius sits on the very top.

---

## 4 Thoracolumbar fascia

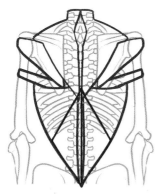

The thoracolumbar fascia takes the lead when it comes to shading and creating a more realistic-looking back. It's not actually a muscle, but a membrane that covers muscle.

## 5 Lateral muscles of the abdomen

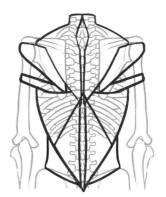

The lateral muscles are along the side of the waist and part of them can be seen when viewing the back. The point where they meet the latissimus dorsi is where the waist narrows.

# Scapula

This is the part that stands out most when drawing the back. It is fused with the shoulder joint.

### 1 Structure of the scapula

■ View from the front

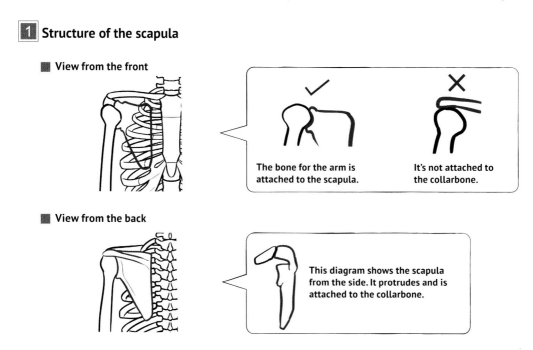

The bone for the arm is attached to the scapula.

It's not attached to the collarbone.

■ View from the back

This diagram shows the scapula from the side. It protrudes and is attached to the collarbone.

### 2 Arm movement and the scapula

When the arm is raised, the scapula moves, as does the collarbone.

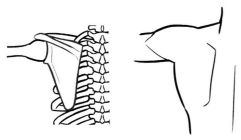

The scapula does not move significantly.

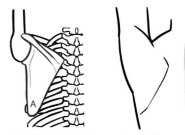

At the most, when the arm is raised Section A protrudes from the ribcage.

### 3 How the scapula rises up

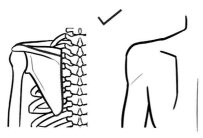

The section that lifts the skin up is the section of the scapula that protrudes.

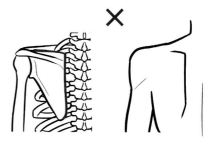

The silhouette of the scapula does not rise up.

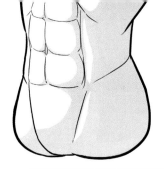

# Drawing Hip Joints

This part of the body is crucial for determining the position of the legs, especially their direction. Although the hip joints are difficult to draw, they're connected to the buttocks, so spend some time mastering them.

## Structure of the hip joints

■ Detailed structure

**Front view**

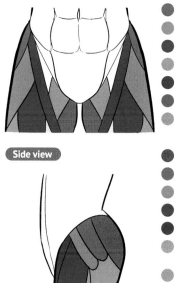

■ Parts used in a sketch

● Mesogluteus
● Tensor fasciae latae
● Musculus rectus femoris
● Tractus iliotibialis
● Sartorius
● Adductor longus
● Pectineus

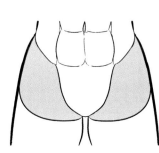

The hip joint section can be reduced to the parts that join the legs to the hips.

**Side view**

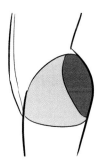

● Gluteus maximus
● Mesogluteus
● Tensor fasciae latae
● Sartorius
● Musculus rectus femoris
● Caput longum musculi bicipitis femoris
● Tractus iliotibialis
● Vastus lateralis

Leave the gluteus maximus in, but the other parts can be reduced to spherical hip joints.

---

**Q Critical Point**

### The hip joints' range of motion

When drawing the hip joints, it's easier if you imagine spheres set into the torso. You can also think of the hip joints' range of motion in terms of spheres with legs attached.

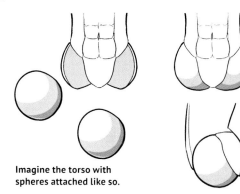

Imagine the torso with spheres attached like so.

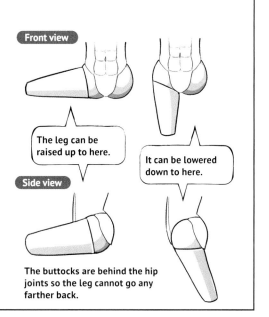

**Front view**

The leg can be raised up to here.

It can be lowered down to here.

**Side view**

The buttocks are behind the hip joints so the leg cannot go any farther back.

# Drawing the hip joints

## 1 Draw a circle (hip joints) below the pelvis

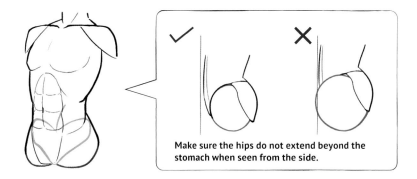

Make sure the hips do not extend beyond the stomach when seen from the side.

## 2 Clean things up and finish off the rough sketch

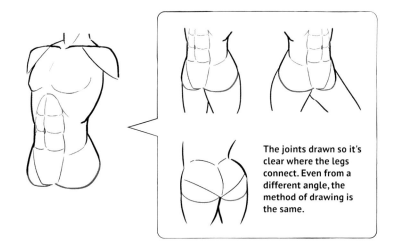

The joints drawn so it's clear where the legs connect. Even from a different angle, the method of drawing is the same.

---

**Q Critical Point**

### Things to watch out for when sketching the hip joints

Although you're only drawing circles, there are a few things to look out for. The hip joints are a key part of the lower body, so pay attention to detail.

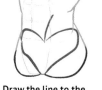

Draw the line to the center of the pelvis.

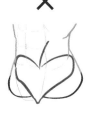

Make sure the two circles are the same height on each side.

## The V line where the abdominal muscles meet the legs

The line that joins the abdominal muscles (rectis abdominis) to the hip bone (iliac spine) is important when drawing the area around the hips. Here, the area is referred to as the abdominal V line.

### ▦ Men

### ▦ Abdominal V line

The abdominal V line is essential especially with muscular characters.

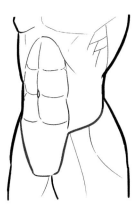

### ▦ Groin

The line where the legs join to the pelvis becomes the V line.

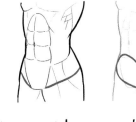

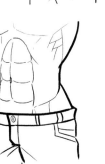

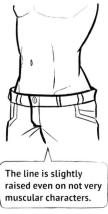

> Being able to see the abdominal V line in the gap between the waist and trousers is an option.

> The line is slightly raised even on not very muscular characters.

### ▦ Women

### ▦ Abdominal V line

In women, the abdominal V line does not stand out but is in shadow.

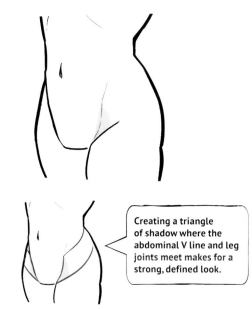

> Creating a triangle of shadow where the abdominal V line and leg joints meet makes for a strong, defined look.

### ▦ Groin

As with men, the line where the legs meet the pelvis is the V line.

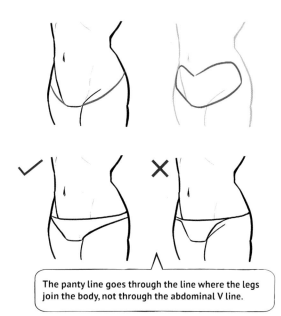

> The panty line goes through the line where the legs join the body, not through the abdominal V line.

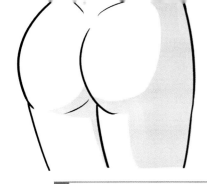

# Drawing Buttocks

Learn to draw this important area regardless of the character's gender. It's essential for more complicated poses and for action stances.

## Structure of the buttocks

■ Detailed structure

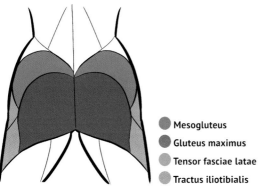

● Mesogluteus
● Gluteus maximus
● Tensor fasciae latae
● Tractus iliotibialis

■ Parts used in a sketch

Due to the fat in the buttocks, muscle doesn't easily stand out, so most of the muscles can be left out.

## The height of the buttocks and crotch

The buttocks are positioned lower than the crotch.

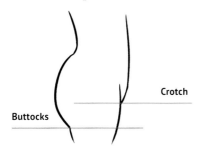

Buttocks

Crotch

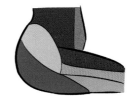

When a person is seated, the buttocks become a cushion.

---

**Q Critical Point**

### Recreate the roundness of the buttocks in poses

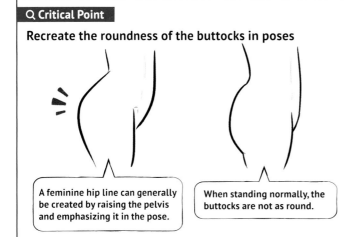

A feminine hip line can generally be created by raising the pelvis and emphasizing it in the pose.

When standing normally, the buttocks are not as round.

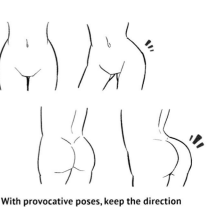

With provocative poses, keep the direction and positioning of the pelvis in mind.

# Drawing the buttocks

**1** Draw an oval over the blocking-in of the pelvis

The oval is the same height as the pelvis.

**2** Draw a matching oval on the other side

Make sure the heights are the same.

It doesn't matter if they overlap.

In order to bring out dimension in the lower body, place the second oval on the inside of the torso outline.

**Back view**

**Side view**

×

If the ovals are too big, the sense of volume will be lost.

**3** Draw the hip joints to complete the sketch

Think of the hip joints as being spherical.

**4** Clean things up to finish off the rough sketch

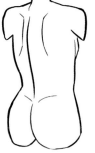

🔍 **Critical Point**

**Drawing the legs from the side of the buttocks**
Draw the legs starting at the red line of the hip joints drawn in Step **3**.

When drawing the leg farthest away, refer to page 145 so that it doesn't become too thin.

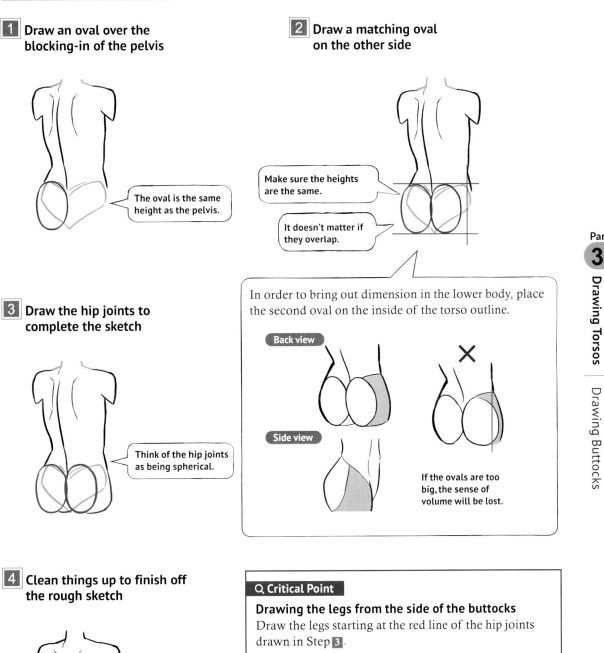

# Women's buttocks

## 1 Characteristics of women's buttocks

Make the ovals used in the sketch large in order to achieve softly rounded feminine buttocks.

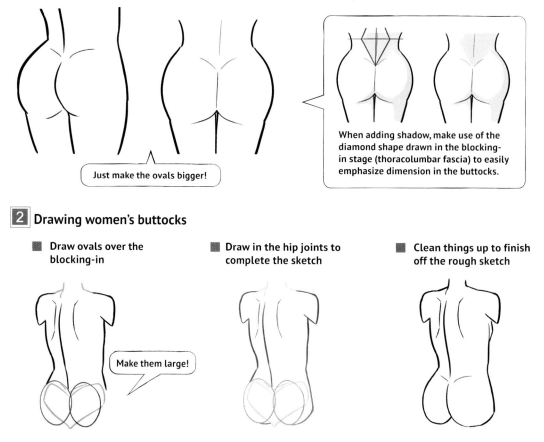

Just make the ovals bigger!

When adding shadow, make use of the diamond shape drawn in the blocking-in stage (thoracolumbar fascia) to easily emphasize dimension in the buttocks.

## 2 Drawing women's buttocks

■ Draw ovals over the blocking-in

■ Draw in the hip joints to complete the sketch

■ Clean things up to finish off the rough sketch

Make them large!

---

**Q Critical Point**

### The buttocks seen from the front

Usually, if the character is standing with her thighs pressed together, the buttocks cannot be seen from the front.

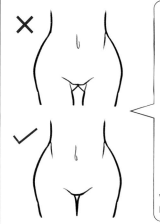

✗

✓

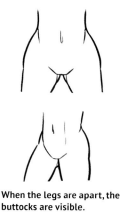

When the legs are apart, the buttocks are visible.

■ When wearing panties

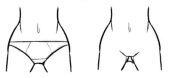

When viewed from the front, the buttocks are concealed by the panties.

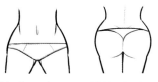

If the buttocks are not hidden by the panties, they will look like a thong.

# Men's buttocks

## 1 Characteristics of men's buttocks

Men's buttocks have less fat than women's buttocks, so the muscles are more obvious.

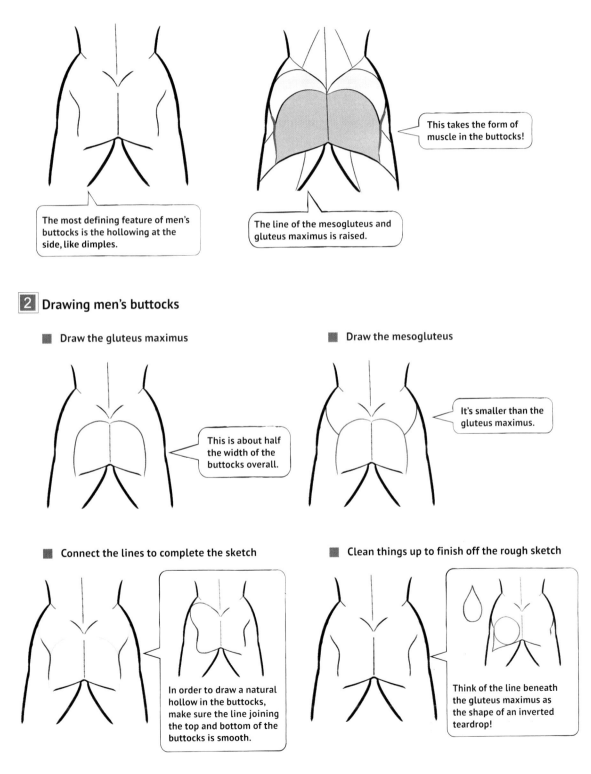

This takes the form of muscle in the buttocks!

The most defining feature of men's buttocks is the hollowing at the side, like dimples.

The line of the mesogluteus and gluteus maximus is raised.

## 2 Drawing men's buttocks

### Draw the gluteus maximus

This is about half the width of the buttocks overall.

### Draw the mesogluteus

It's smaller than the gluteus maximus.

### Connect the lines to complete the sketch

In order to draw a natural hollow in the buttocks, make sure the line joining the top and bottom of the buttocks is smooth.

### Clean things up to finish off the rough sketch

Think of the line beneath the gluteus maximus as the shape of an inverted teardrop!

# Men and Women: Drawing the Differences

When drawing men and women, there are various ways to distinguish each gender. Here, we look at male and female characteristics and how to incorporate them into your drawing.

## Basic facial differences

Generally, male and female faces have the following characteristics.

■ Male

■ Female

- Brows are thick and eyes are close together.
- Nose is large.
- Facial outline is angular, and the face is long.
- Neck is thick.

- Brows are fine, and eyes are set wide apart.
- Eyes are large, and eyelashes are noticeable.
- Nose is small and not drawn too clearly.
- Lips are full.
- Face has a full, rounded outline and is not as long as a male's.
- Neck is thin.

■ Male and female differences in symbols

Simplified, the differences between men and women can be expressed as follows.

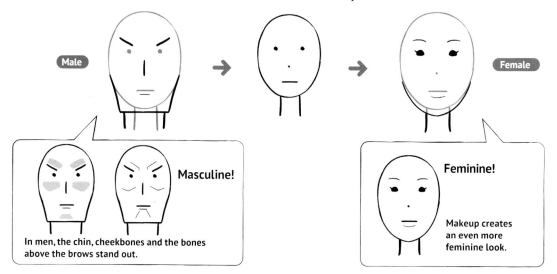

Male → Female

Masculine!

In men, the chin, cheekbones and the bones above the brows stand out.

Feminine!

Makeup creates an even more feminine look.

# The basics for children's faces

An artist can learn a lot from studying and drawing the faces of children and learning the distinguishing differences. Change the hairstyle and make boys' eyebrows thicker to distinguish the genders.

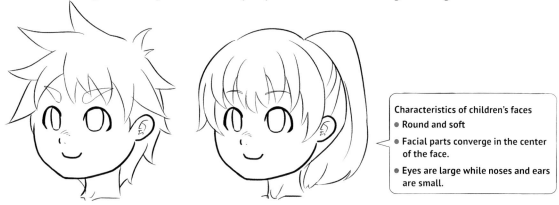

Characteristics of children's faces
- Round and soft
- Facial parts converge in the center of the face.
- Eyes are large while noses and ears are small.

## Q Critical Point

### Cuteness

The defining characteristics of children are also the defining characteristics for highlighting a character's cuteness, so they can be used for adults too. They're similar to feminine characteristics, and if applied to men, they tend to look feminine.

Bangs emphasize cuteness!

Cute!

Grown up!

# The basics for teenagers' faces

For girls and boys of middle-school age and older, even more differences start to emerge due to bone structure. Both boys' and girls' faces start to grow longer and the eyes become smaller. This is particularly true for boys.

Boys' facial outlines become slightly firmer, and the brows become thicker. Gender differences are marked by hairstyles.

## Q Critical Point

### Differentiate male from female via the facial outline!

For men, regardless of how feminine the elements of their face may be, the outline is firm and angular. For women, this applies too, in that they may have masculine aspects to their face but its outline will be soft and rounded.

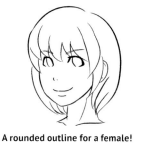

An angular outline for a male!

A rounded outline for a female!

## Differentiating men's and women's faces in more detail

Hairstyles and makeup suggest or accentuate femininity and masculinity, although the facial outline, nose, lips and other features remain the same shape.

### ■ Feminine males and masculine females

**Changeable parts**
● Hairstyle
● Brows
● Makeup (mascara, lipstick, etc.)

**Unchangeable parts**
● Eyes (eyelashes)
● Facial outline
● Nose
● Lips

A feminine man. Make the hairstyle, brows and makeup feminine but leave most of the other aspects male.

A masculine woman. Use the hairstyle and brows to express masculinity, and don't draw in makeup (blush, lipstick).

When emphasizing traits of the same gender, it is effective to focus on the aspects that cannot be changed.

### ■ Masculine man

Parts that create a more masculine appearance when emphasized
● Nose
● Facial outline

The addition of facial hair emphasizes masculinity.

### ■ Feminine woman

Parts that create a more feminine appearance when emphasized
● Eyelashes
● Lips

Accessories are also a feminine element. A mole is also a symbol of femininity.

When drawing androgynous characters, bring out the appeal of their androgyny by using facial features of the opposite gender within their own gender's facial outline.

### ■ Androgynous male

If the nose and facial outline are masculine, even if the remaining features are feminine the character will look like an attractive young man. Light color applied to the lips makes for a very sexy look.

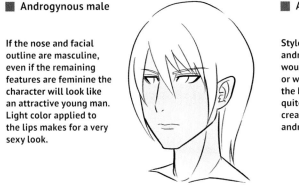

### ■ Androgynous female

Style the hair in an androgynous way that would suit either men or women and make the brows and nose quite masculine. This creates a sophisticated, androgynous charm.

# Differentiating male and female bodies

Here, we look at the differences between male and female physiques. Make sure to learn the usual characteristics of males and females, from the more general areas right down to the fine details, in order to incorporate them into your drawing.

## 1 Differences in physique

■ Men

■ Women

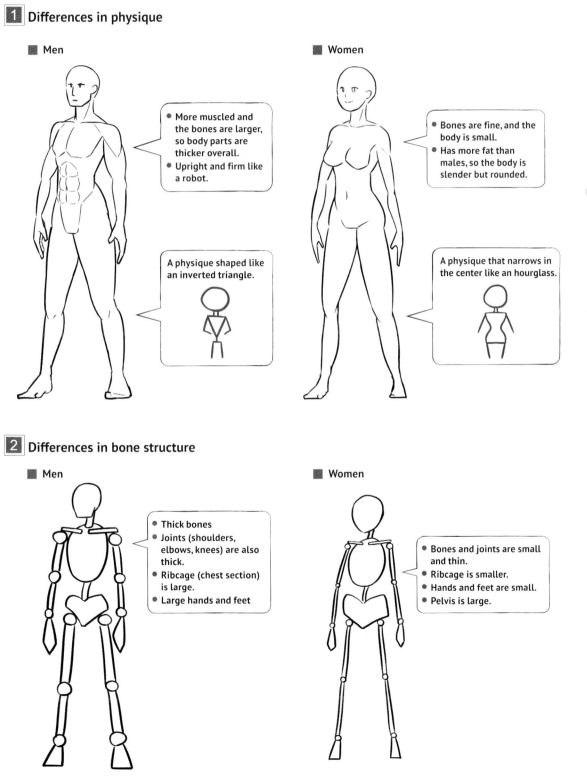

- More muscled and the bones are larger, so body parts are thicker overall.
- Upright and firm like a robot.

A physique shaped like an inverted triangle.

- Bones are fine, and the body is small.
- Has more fat than males, so the body is slender but rounded.

A physique that narrows in the center like an hourglass.

## 2 Differences in bone structure

■ Men

■ Women

- Thick bones
- Joints (shoulders, elbows, knees) are also thick.
- Ribcage (chest section) is large.
- Large hands and feet

- Bones and joints are small and thin.
- Ribcage is smaller.
- Hands and feet are small.
- Pelvis is large.

# Differences in body parts

## Neck

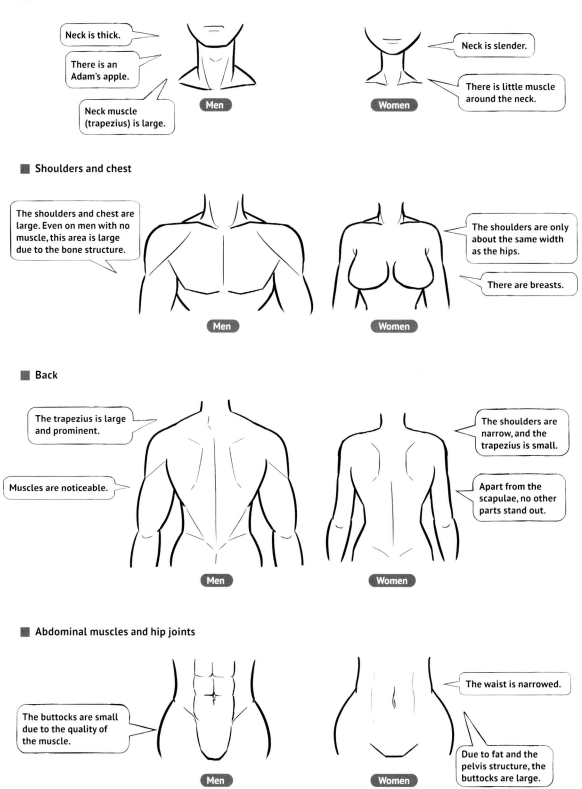

Neck is thick.

There is an Adam's apple.

Neck muscle (trapezius) is large.

Men

Neck is slender.

There is little muscle around the neck.

Women

## Shoulders and chest

The shoulders and chest are large. Even on men with no muscle, this area is large due to the bone structure.

Men

The shoulders are only about the same width as the hips.

There are breasts.

Women

## Back

The trapezius is large and prominent.

Muscles are noticeable.

Men

The shoulders are narrow, and the trapezius is small.

Apart from the scapulae, no other parts stand out.

Women

## Abdominal muscles and hip joints

The buttocks are small due to the quality of the muscle.

Men

The waist is narrowed.

Due to fat and the pelvis structure, the buttocks are large.

Women

## Arms

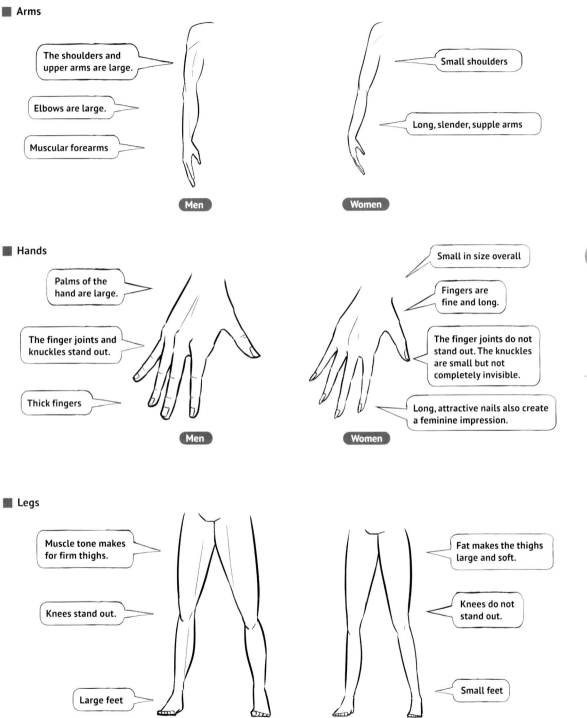

**Men**

The shoulders and upper arms are large.

Elbows are large.

Muscular forearms

**Women**

Small shoulders

Long, slender, supple arms

## Hands

**Men**

Palms of the hand are large.

The finger joints and knuckles stand out.

Thick fingers

**Women**

Small in size overall

Fingers are fine and long.

The finger joints do not stand out. The knuckles are small but not completely invisible.

Long, attractive nails also create a feminine impression.

## Legs

**Men**

Muscle tone makes for firm thighs.

Knees stand out.

Large feet

**Women**

Fat makes the thighs large and soft.

Knees do not stand out.

Small feet

## Differences between the physiques of teen boys and girls

For boys and girls of middle-school age, differences begin to emerge in the muscles of the neck and shoulders, and the joints in men are more noticeable. As with the face, differences become more marked with age.

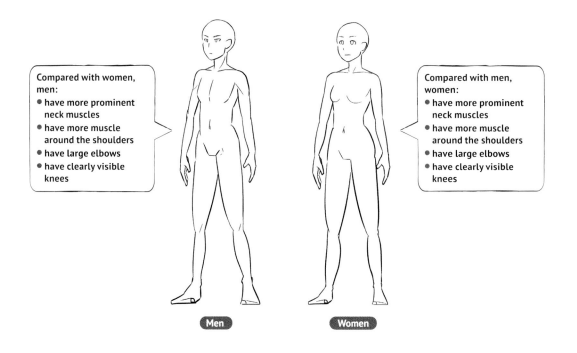

Compared with women, men:
- have more prominent neck muscles
- have more muscle around the shoulders
- have large elbows
- have clearly visible knees

Compared with men, women:
- have more prominent neck muscles
- have more muscle around the shoulders
- have large elbows
- have clearly visible knees

Men

Women

## Differences in children's physiques

One of the main differences between the physiques of girls and boys of around elementary-school age is in bone structure.

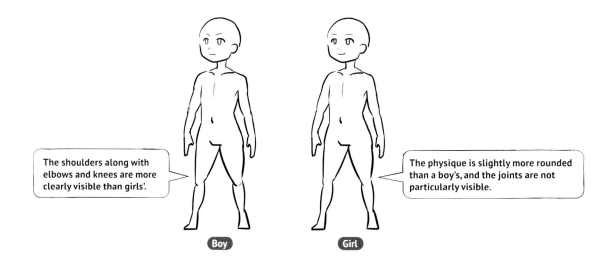

The shoulders along with elbows and knees are more clearly visible than girls'.

The physique is slightly more rounded than a boy's, and the joints are not particularly visible.

Boy

Girl

## 🖋 Helpful Hint

### Differentiating men's and women's physiques in more detail in drawing

#### ▣ Masculine (muscular) physiques
Muscle firms the physique, making it a defining feature of men's bodies.

> The muscularity is what stands out.

> All the muscles are large to a certain degree, but are not drawn as clearly as for men. Joints, limbs and pelvis (buttocks) are the same size as for women.

#### 🔍 Critical Point

**Male characteristics**
When drawing men, adding in body hair emphasizes masculinity.

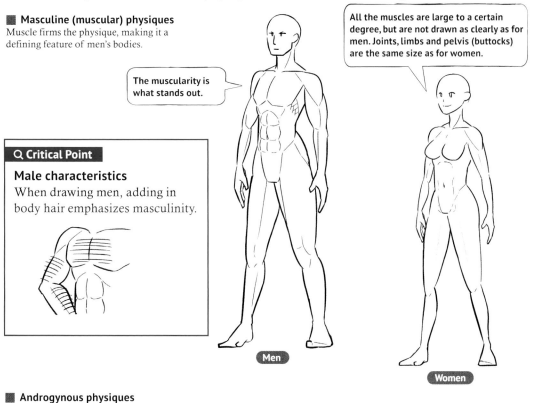

Men

Women

#### ▣ Androgynous physiques
In the case of androgynous physiques, there are fewer physical male and female characteristics, but even so, there are differences between males and females in regard to bone structure and body fat.

> The bones are fine and there is little muscle definition, similar to that of a woman. However, the joint size remains the same and there is little fat, so there is no roundness to the body.

> The breasts and buttocks become smaller and the body becomes less rounded, similar to a male physique. However, the bone structure is female and there is still more fat than for a man, so some roundness remains.

#### 🔍 Critical Point

**Female characteristic**
Breasts and buttocks can be enlarged for a more defined look.

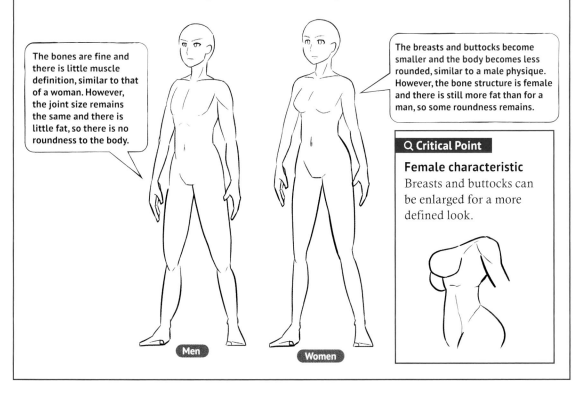

Men

Women

# Applying color to skin

Get a good grasp of the basics and techniques for adding color to skin to discover the type of painting that suits you best.

## Types of painting

In illustration, "painting" refers to adding color and dimension to objects through shading. Broadly categorized, there are four basic types of painting in digital illustration.

### ■ Placing

As the name suggests, this method involves placing the desired color where it is needed. As it's a preparatory step in creating a base shade, the thick pen is used to roughly fill in color. Note that if you attempt to complete the illustration using this method, it will look messy.

### ■ Erase

Use tools such as the eraser to remove color and adjust the drawing. It's a hundred times simpler and more accurate than placing the desired color on and painting it in.

### ■ Blend

Use a tool such as the watercolor pen to adjust the drawing and blend out obvious lines. This allows you to create neat, smooth shading between colors.

### ■ Add extra color

Adjust the shade by adding a different color on top. This is the technique used in "atsunuri." When you are able to add more and more colors, you will be able to achieve a smooth finish similar to that of color blending.

When you consider the various types of illustration, you may think that there are other methods of applying color, but they are all applications of the four shown here. Various nuances can be achieved by changing the pen setting and using texture to adjust the look of the illustration.

Watercolor pen + erasing

Texture + blending

# Applying color to skin

## 1 Paint in a base color

## 2 Create shadow

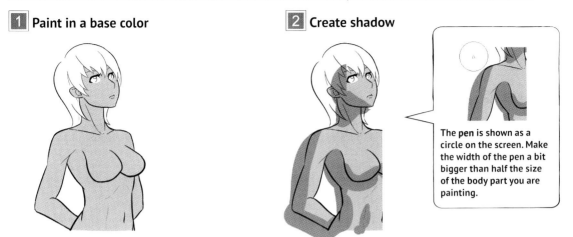

> The **pen** is shown as a circle on the screen. Make the width of the pen a bit bigger than half the size of the body part you are painting.

---

### 🔍 Critical Point

**Pen width for creating shadow**

A fine pen limits the area that can be painted, and as the field of vision is also limited in the process, it creates an odd effect. Use a thick pen to fill in color when creating shadow.

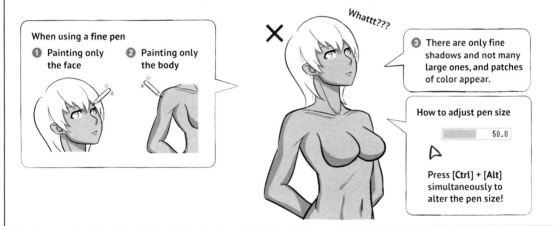

**When using a fine pen**

① Painting only the face

② Painting only the body

Whatt???

③ There are only fine shadows and not many large ones, and patches of color appear.

**How to adjust pen size**

50.0

Press [Ctrl] + [Alt] simultaneously to alter the pen size!

---

### 🖊 Digital Tools

**How to use "clipping" to stop worrying about color bleeding out**

Using the clipping function means you can erase any color that goes beyond the lines and allows you to work without having to worry about being precise when painting.

① Create a new layer one above the base-coat layer and check the box for "clip the underlying layer."

② When this is done, a red bar appears to the left of that layer.

Preparation is complete!

③ Regardless of how roughly you paint that layer, it won't go beyond the colored areas marked in the layer below!

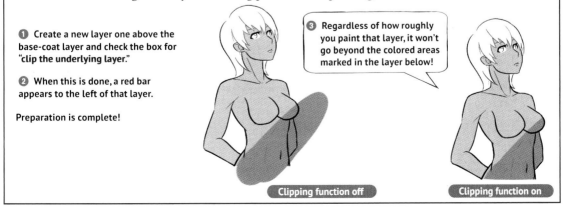

Clipping function off

Clipping function on

## 3 Use the same method to add highlights

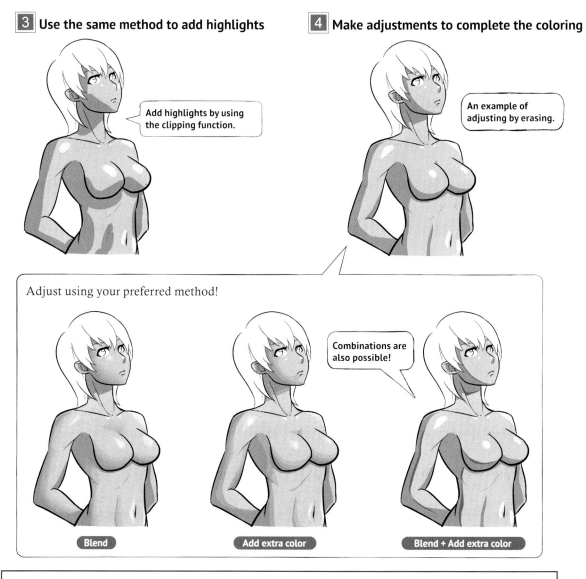

Add highlights by using the clipping function.

## 4 Make adjustments to complete the coloring

An example of adjusting by erasing.

Adjust using your preferred method!

Combinations are also possible!

**Blend**

**Add extra color**

**Blend + Add extra color**

---

🖉 **Helpful Hint**

### Techniques for adding extra color

When creating shadow, use different shades of color over several stages to increase the sense of dimension in the face.

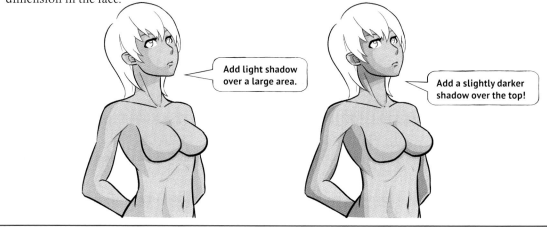

Add light shadow over a large area.

Add a slightly darker shadow over the top!

# Creating glowing skin

Adding a red tinge to the cheeks and so on creates the look of glowing skin and good circulation, and gives your character a healthful appearance.

## 1 Choose color and apply with airbrush

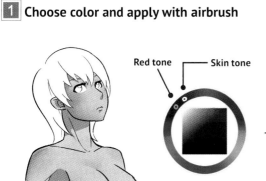

Red tone — Skin tone

Choose a color slightly redder than the skin tone and use the airbrush to apply in two strokes.

**A note about red tones**

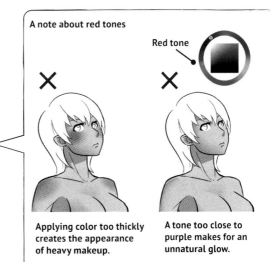

Red tone

Red tone

✕

✕

Applying color too thickly creates the appearance of heavy makeup.

A tone too close to purple makes for an unnatural glow.

## 2 Add highlights to complete color application

Use the fine pen to add highlights.

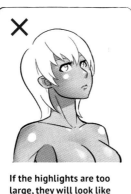

✕

If the highlights are too large, they will look like white paint, making for an odd appearance.

### 🔍 Critical Point

**Where to apply red tone**

Apart from the cheeks, a natural finish can be achieved by adding a redness to the nose, shoulders, knees, elbows and other protruding parts.

# Tips for creating shadow

## 1 Substitute 3D forms for body parts

It's possible to substitute 3D forms, such as cylinders, cubes and spheres, for any part of the body. Don't make it too complicated when creating shadow, and think of it as shading in these three 3D forms.

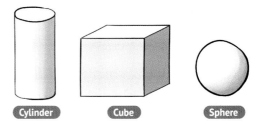

**Cylinder**    **Cube**    **Sphere**

■ **Androgynous physiques**
Substituting forms for body parts

The head is a sphere.

Arms and legs are cylinders.

The torso is a cylinder and two spheres.

■ **Tips for adding shadow to the head**
Add shadow to the head as for a sphere and adjust by erasing and blending.

If you think too much about the lips, nose and the hollows of the eyes, you'll become confused and the drawing will look strange.

■ **Tips for adding shadow to complicated body parts**
Combinations of 3D forms can also be substituted in for complicated parts such as the hands.

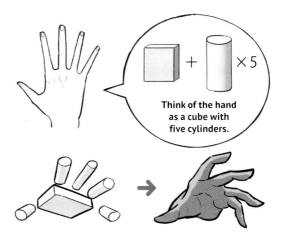

Think of the hand as a cube with five cylinders.

Keep the forms in mind when adding shadow!

## 2 Be aware of the light source

Shadows form when light hits a solid object. It may seem obvious, but in order for light to hit an object, it needs to have a source. To create consistent shading, it's important to keep in mind where the light is shining from.

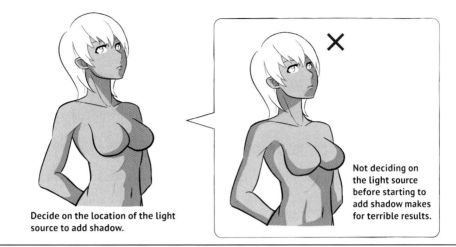

Light source

Decide on the location of the light source to add shadow.

Not deciding on the light source before starting to add shadow makes for terrible results.

### Q Critical Point

#### Things to note about the location of the light source

**Use one light source**
If you don't have any particular intention for the light source, make it either left or right.

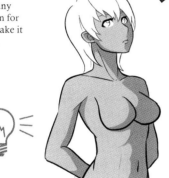

**Place the light source where it is easy to apply color**
How easy it is to apply color depends on the position of the light source. If it's in a difficult position, the coloring is likely to lack the intended sense of dimension.

**Light source locations that make shading difficult**
Locating the light source anywhere that's not directly to the left or right, such as above, below, at the front or at the back, makes it difficult to add shadow.

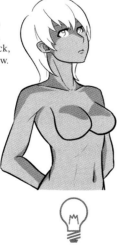

**More than two light sources**
Having more than two light sources makes it difficult to create shadow, so try it when you've had some practice. Decide on the main and the secondary source of light, and rather than adding shadows from the secondary source, use highlights instead.

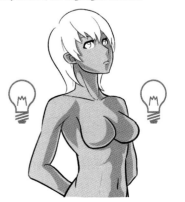

117

### 3 Use dark colors!

If the selected colors are too light, it'll look ineffective, as if no shadow had been added at all. Refer to the color palette and choose a color dark enough to make you think it might be excessive at first.

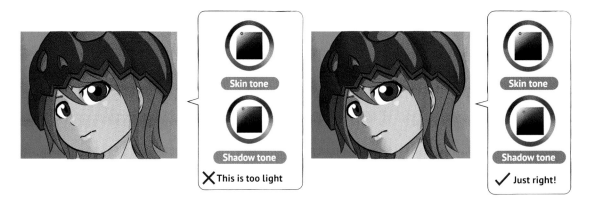

Skin tone

Shadow tone

✗ This is too light

Skin tone

Shadow tone

✓ Just right!

---

**⬠ Helpful Hint**

## Notes on using the blending tool when adding color

### ◼ Don't blur everything
If you blur all the parts of the shadow when blending it, the illustration will be unclear and seem to lack contrast.

✗ Too much blending

✓ Don't blend the shadows of objects that block light, such as body parts and clothing.

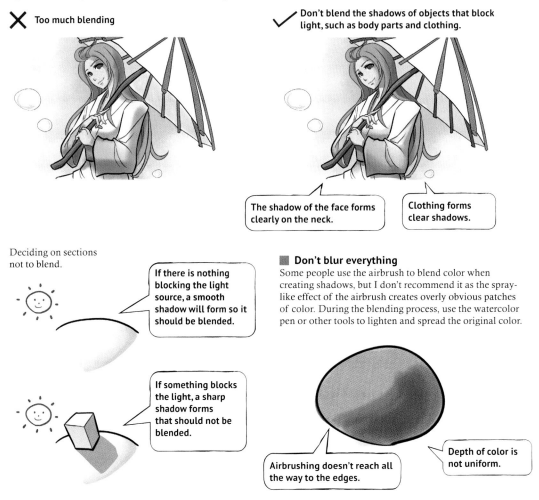

The shadow of the face forms clearly on the neck.

Clothing forms clear shadows.

Deciding on sections not to blend.

If there is nothing blocking the light source, a smooth shadow will form so it should be blended.

If something blocks the light, a sharp shadow forms that should not be blended.

### ◼ Don't blur everything
Some people use the airbrush to blend color when creating shadows, but I don't recommend it as the spray-like effect of the airbrush creates overly obvious patches of color. During the blending process, use the watercolor pen or other tools to lighten and spread the original color.

Airbrushing doesn't reach all the way to the edges.

Depth of color is not uniform.

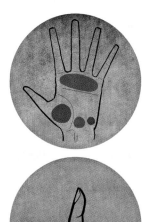

# Drawing Hands
# & Arms

**Basic Ratios—Hands**

**Drawing Fingers**

**Drawing Ratios—Arms**

**Drawing Elbows**

**Drawing Underarms**

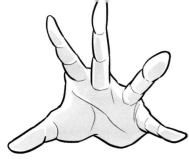

# Basic Ratios—Hands

With so many moving parts, hands can be hard to grasp. Start small, with a finger, then move on to the whole hand from there.

## Structure and ratios in the hand

### Don't blur everything

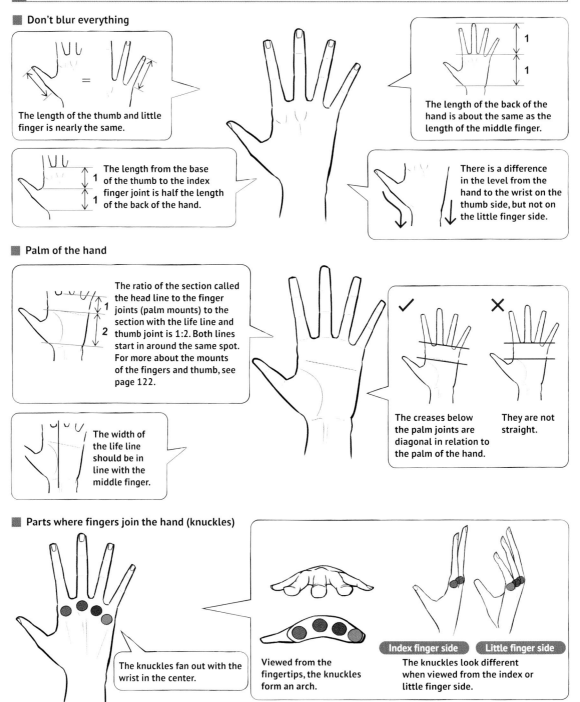

The length of the thumb and little finger is nearly the same.

The length from the base of the thumb to the index finger joint is half the length of the back of the hand.

The length of the back of the hand is about the same as the length of the middle finger.

There is a difference in the level from the hand to the wrist on the thumb side, but not on the little finger side.

### Palm of the hand

The ratio of the section called the head line to the finger joints (palm mounts) to the section with the life line and thumb joint is 1:2. Both lines start in around the same spot. For more about the mounts of the fingers and thumb, see page 122.

The width of the life line should be in line with the middle finger.

The creases below the palm joints are diagonal in relation to the palm of the hand.

They are not straight.

### Parts where fingers join the hand (knuckles)

The knuckles fan out with the wrist in the center.

Viewed from the fingertips, the knuckles form an arch.

**Index finger side**  **Little finger side**

The knuckles look different when viewed from the index or little finger side.

# Drawing an open hand

## 1 Draw an oblong

Make it slightly long.

## 2 Draw in the index, middle and ring fingers

Keep the bones and muscles of the hand in mind and draw the fingers radiating out from the palm of the hand.

## 3 Draw the bases for the index and little fingers

The index finger moves quite freely, so sketch it separately in order to express this.

Match the base for the little finger to the palm of the hand and adjust the shape to form a rectangle.

## 4 Draw the index and little fingers

## 5 Round out the joints of the three middle fingers to complete the sketch

If the curve is too large the fingers will be short, so watch out!

## 6 Draw the knuckles and ckean things up to finish off the rough drawing

For nails, see page 131.

When drawing the palm of the hand, draw in the lines below the palm mounts and alongside the thumb mount.

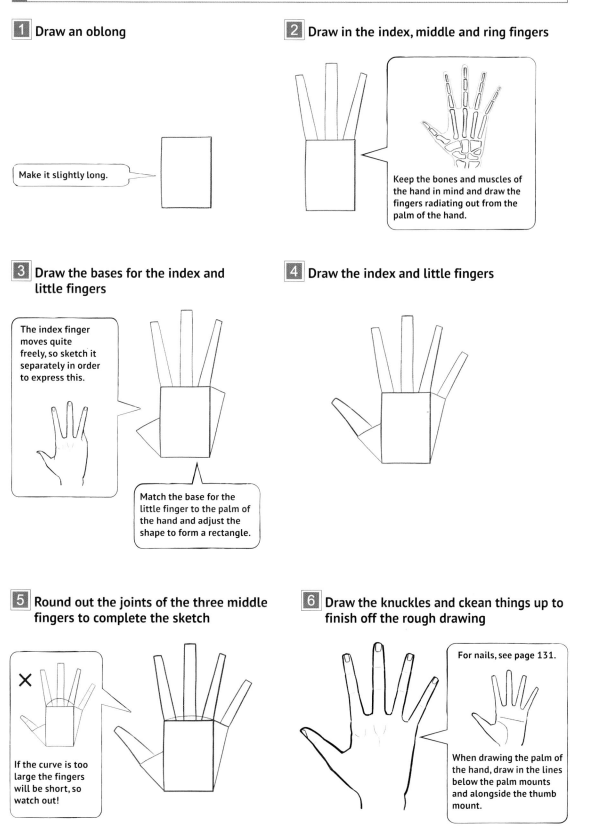

# Drawing the hand from various angles

There are four raised sections in the palm of the hand. Combining them acts as a guide when drawing the hand from more complicated angles.

■ **Structure of the palm of the hand**

● **Thumb mount** : the swelling located at the thumb joint

● **Palm mounts** : the swelling located beneath the four fingers

● **Hypothenar eminence** : the swelling on the little finger side of the hand opposite the thumb mount

● **Palm heel** : the section at the base of the palm

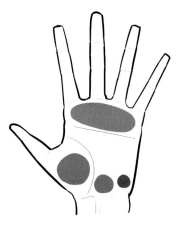

## 1 Create a triangle using the thumb and palm mounts

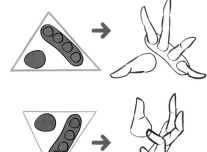

Once you have the image of the hand and fingers in mind, draw a triangle to form the foundation of the hand.

On the palm mounts, draw the four circles that will form the blocking-in for the fingers in such a way that each finger's position is clear.

**Q Critical Point**

**Palm Heel Position**
Draw the palm heel at the center of the base of the triangle. This is crucial as a base line when drawing the fingers.

## 2 Draw the fingers

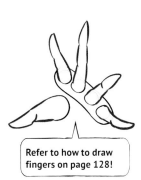

Refer to how to draw fingers on page 128!

## 3 Draw in the hypothenar eminence and make the palm of the hand square to complete the sketch!

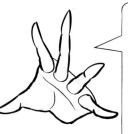

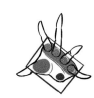

Create a square incorporating the thumb and palm mounts and hypothenar eminence.

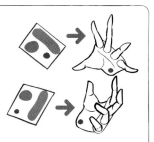

This applies when drawing the hand from various angles!

# Drawing a clenched fist (from the palm side)

**1** Draw a square and divide it in half horizontally

**2** Draw four fingers

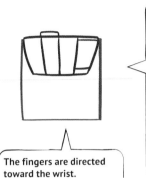 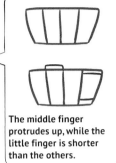

The fingers are directed toward the wrist.

The middle finger protrudes up, while the little finger is shorter than the others.

**3** Draw the tip of the thumb

The thumb should reach to just over the top of the ring finger. It should be about half the length of the fingers in width.

**4** Draw the outside edge of the thumb

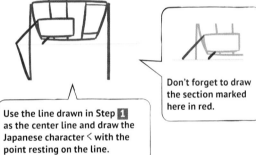

Use the line drawn in Step **1** as the center line and draw the Japanese character ＜ with the point resting on the line.

Don't forget to draw the section marked here in red.

**5** Draw in the foundation for the thumb (thumb mount) to complete the sketch

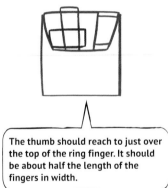

Make the curve extend out to about the middle finger.

**6** Clean things up to finish off the rough drawing

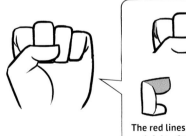

The red lines at the left and right of the fist are the first joints of the index and little fingers.

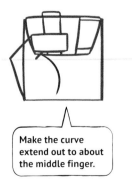

# Drawing a clenched fist (from the back-of-the-hand side)

**1** Draw a square and carve off the base section of the little-finger side

**2** Draw the knuckles

> The knuckle of the little finger is positioned lowest.

**3** Draw the fingers to complete the sketch

> Show the differences in level.

> The little finger is barely visible.

**4** Clean things up to finish off the rough drawing

> For men, draw in the knuckles of the index and middle fingers as the main features. For women, use the fine pen to draw in the middle knuckle only.

# Drawing a clenched fist (from above)

**1** Draw the fingers

> Draw the little finger shorter.

> Draw the index finger directed straight down, but draw the other fingers on a diagonal angle.

**2** Draw the knuckles

Middle

Index

Ring

Little

> Draw the middle finger in a high position and the little finger in a low position, with the index and ring fingers at the same height.

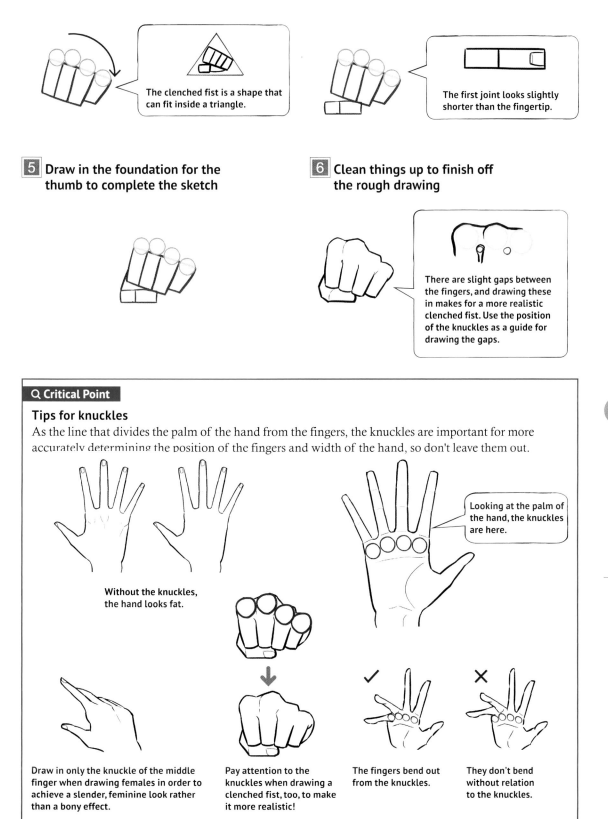

### 3 Tilt the hand toward the little-finger side

The clenched fist is a shape that can fit inside a triangle.

### 4 Draw the thumb

The first joint looks slightly shorter than the fingertip.

### 5 Draw in the foundation for the thumb to complete the sketch

### 6 Clean things up to finish off the rough drawing

There are slight gaps between the fingers, and drawing these in makes for a more realistic clenched fist. Use the position of the knuckles as a guide for drawing the gaps.

---

**Q Critical Point**

#### Tips for knuckles

As the line that divides the palm of the hand from the fingers, the knuckles are important for more accurately determining the position of the fingers and width of the hand, so don't leave them out.

Looking at the palm of the hand, the knuckles are here.

Without the knuckles, the hand looks fat.

Draw in only the knuckle of the middle finger when drawing females in order to achieve a slender, feminine look rather than a bony effect.

Pay attention to the knuckles when drawing a clenched fist, too, to make it more realistic!

✓ The fingers bend out from the knuckles.

✗ They don't bend without relation to the knuckles.

# Drawing the wrist

## 1 Basics for the wrist

### ■ Palm-of-the-hand side

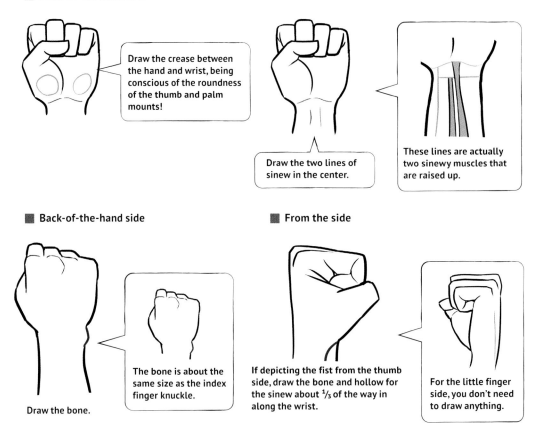

Draw the crease between the hand and wrist, being conscious of the roundness of the thumb and palm mounts!

Draw the two lines of sinew in the center.

These lines are actually two sinewy muscles that are raised up.

### ■ Back-of-the-hand side

### ■ From the side

Draw the bone.

The bone is about the same size as the index finger knuckle.

If depicting the fist from the thumb side, draw the bone and hollow for the sinew about $\frac{1}{3}$ of the way in along the wrist.

For the little finger side, you don't need to draw anything.

## 2 Points to note when the wrist is bent

Here, we look at how far the wrist bends and the relationship between the hand and wrist when it is bent. It's very simple, so make sure you get it down.

### ■ From the front

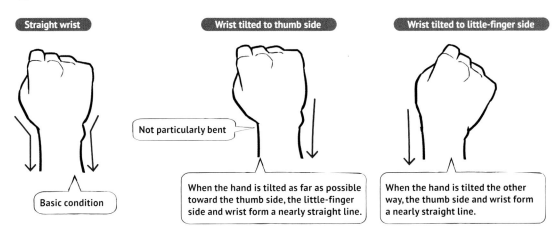

**Straight wrist**

Basic condition

**Wrist tilted to thumb side**

Not particularly bent

When the hand is tilted as far as possible toward the thumb side, the little-finger side and wrist form a nearly straight line.

**Wrist tilted to little-finger side**

When the hand is tilted the other way, the thumb side and wrist form a nearly straight line.

■ From the side

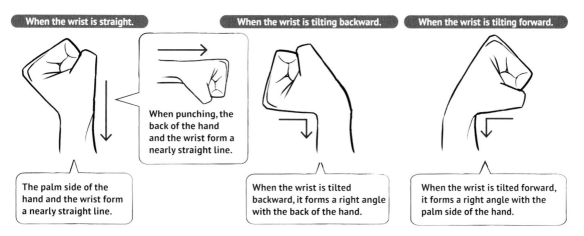

When the wrist is straight.

When punching, the back of the hand and the wrist form a nearly straight line.

The palm side of the hand and the wrist form a nearly straight line.

When the wrist is tilting backward.

When the wrist is tilted backward, it forms a right angle with the back of the hand.

When the wrist is tilting forward.

When the wrist is tilted forward, it forms a right angle with the palm side of the hand.

---

**Q Critical Point**

## How the fingers spread and bunch together

There are basic rules around the movements that occur when the fingers spread and bunch together.

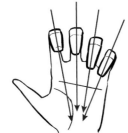

The fingers close in the direction of the base of the palm and the base of the finger joints.

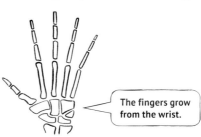

The fingers grow from the wrist.

The reason is due to the bone structure of the hand.

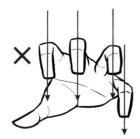

The fingers are not parallel when bunching together.

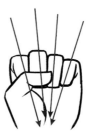

It's the same when the fist is clenched!

Part

**4**

Drawing Hands & Arms

Basic Ratios—Hands

127

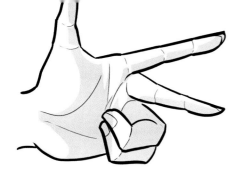

# Drawing Fingers

At first glance, fingers look overly detailed. But there are certain principles and tricks you can learn that will point the way to creating distinctive digits.

## Structure of the fingers

In this book, each section of the joints is named simply "end joint," "middle joint" and "base joint."

■ Detailed structure

● Distal phalanx
● Middle phalanx
● Proximal phalanx
● Carpal bone
● Parts used in a sketch

■ Parts used for drawing

● End joint
● Middle joint
● Base joint

## Drawing the fingers

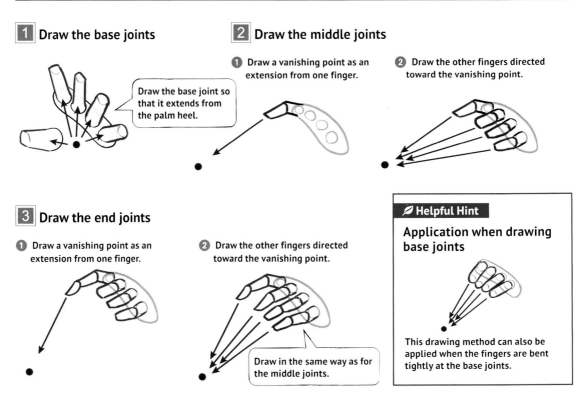

**1** Draw the base joints

Draw the base joint so that it extends from the palm heel.

**2** Draw the middle joints

❶ Draw a vanishing point as an extension from one finger.

❷ Draw the other fingers directed toward the vanishing point.

**3** Draw the end joints

❶ Draw a vanishing point as an extension from one finger.

❷ Draw the other fingers directed toward the vanishing point.

Draw in the same way as for the middle joints.

> 🖉 **Helpful Hint**
>
> **Application when drawing base joints**
>
> This drawing method can also be applied when the fingers are bent tightly at the base joints.

**4** Draw the tips of the fingers to complete the sketch!

Draw in parts properly even if they are hidden from sight.

**🔍 Critical Point**

### The thumb's range of motion

The red line below shows the thumb's range of motion.

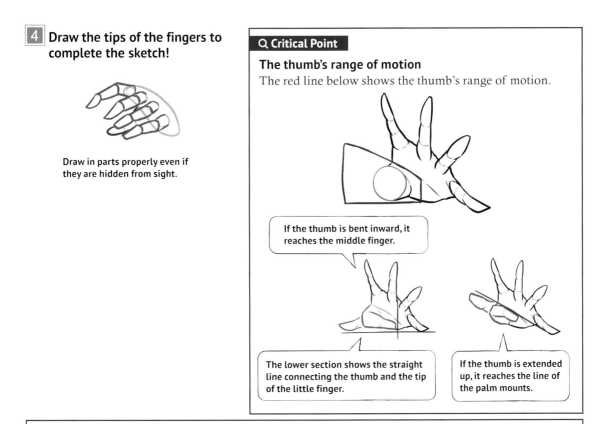

If the thumb is bent inward, it reaches the middle finger.

The lower section shows the straight line connecting the thumb and the tip of the little finger.

If the thumb is extended up, it reaches the line of the palm mounts.

**🔍 Critical Point**

### Location of the vanishing point

The more the fingers are bent toward the palm of the hand, the closer the vanishing point gets to the palm heel.

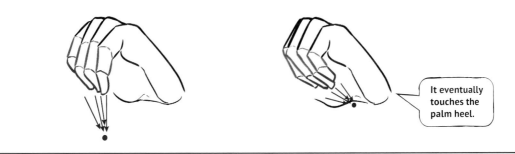

It eventually touches the palm heel.

**✒ Helpful Hint**

### When the bent fingers are not all facing the same direction

When the bent fingers are not all facing the same direction, use two vanishing points. The fingers may be divided into 2-2 or 1-3 formations.

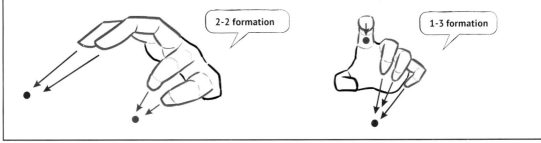

2-2 formation

1-3 formation

129

# Drawing bent fingers

Drawing bent fingers in general and fingers that are holding an object are essential skills to learn!

## 1 How to draw bent fingers

There are two main methods for drawing bent fingers. Use the method that suits your skill level and interests.

■ Joining three cylinders or squares.

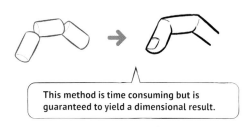

> This method is time consuming but is guaranteed to yield a dimensional result.

■ Drawing a rough silhouette and filling in nails and joints to create dimension.

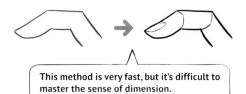

> This method is very fast, but it's difficult to master the sense of dimension.

## 1 Drawing fingers holding an object

Fingers holding an object can be featured by incorporating the vanishing-point method.

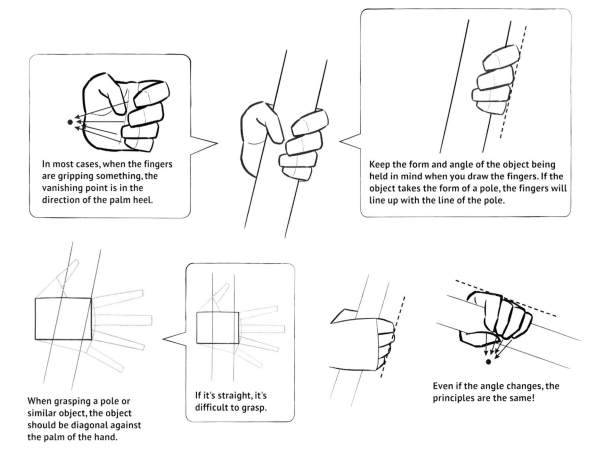

In most cases, when the fingers are gripping something, the vanishing point is in the direction of the palm heel.

Keep the form and angle of the object being held in mind when you draw the fingers. If the object takes the form of a pole, the fingers will line up with the line of the pole.

When grasping a pole or similar object, the object should be diagonal against the palm of the hand.

If it's straight, it's difficult to grasp.

Even if the angle changes, the principles are the same!

# Points to watch out for when drawing fingers

### ■ Finger shape
Use a straight line to draw the back of the finger and a curved line for the front.

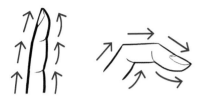

### ■ Length of fingertip
Make the fingertip slightly shorter than the other parts of the finger to easily achieve a natural look.

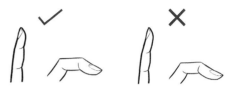

### ■ Dimension of fingers
To create a sense of dimension, draw the lines for the nail and joint as if drawing a cube.

---

**Q Critical Point**

## Nails' appearance

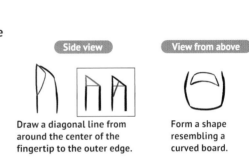

| Front view | Side view | View from above |
| --- | --- | --- |
| Shaped like a rounded-off square. | Draw a diagonal line from around the center of the fingertip to the outer edge. | Form a shape resembling a curved board. |

---

**Q Critical Point**

## Easy method for drawing hands holding objects
When drawing hands holding objects, group the fingers together in order to reduce the time involved and to prevent the sketch from becoming messy.

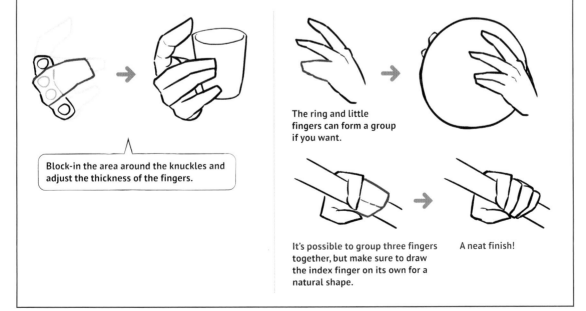

Block-in the area around the knuckles and adjust the thickness of the fingers.

The ring and little fingers can form a group if you want.

It's possible to group three fingers together, but make sure to draw the index finger on its own for a natural shape.

A neat finish!

# Basic Ratios—Arms

In terms of the number of muscles and the level of complexity, the arms pose a premiere challenge, but pared down to their essentials, they're extremely simple. You'll want to include strong, flexed biceps and firm forearms in many of your characters, so make sure you master this part.

## Structure of the arms

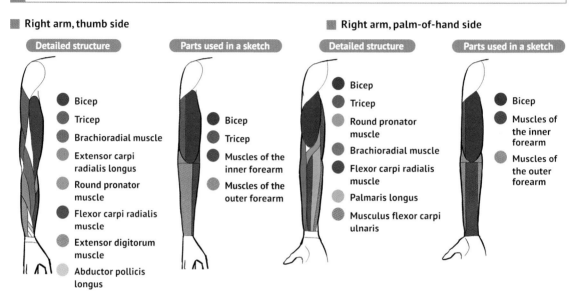

■ Right arm, thumb side

**Detailed structure**

- Bicep
- Tricep
- Brachioradial muscle
- Extensor carpi radialis longus
- Round pronator muscle
- Flexor carpi radialis muscle
- Extensor digitorum muscle
- Abductor pollicis longus

**Parts used in a sketch**

- Bicep
- Tricep
- Muscles of the inner forearm
- Muscles of the outer forearm

■ Right arm, palm-of-hand side

**Detailed structure**

- Bicep
- Tricep
- Round pronator muscle
- Brachioradial muscle
- Flexor carpi radialis muscle
- Palmaris longus
- Musculus flexor carpi ulnaris

**Parts used in a sketch**

- Bicep
- Muscles of the inner forearm
- Muscles of the outer forearm

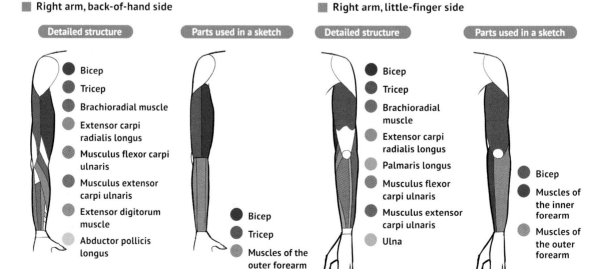

■ Right arm, back-of-hand side

**Detailed structure**

- Bicep
- Tricep
- Brachioradial muscle
- Extensor carpi radialis longus
- Musculus flexor carpi ulnaris
- Musculus extensor carpi ulnaris
- Extensor digitorum muscle
- Abductor pollicis longus

**Parts used in a sketch**

- Bicep
- Tricep
- Muscles of the outer forearm

■ Right arm, little-finger side

**Detailed structure**

- Bicep
- Tricep
- Brachioradial muscle
- Extensor carpi radialis longus
- Palmaris longus
- Musculus flexor carpi ulnaris
- Musculus extensor carpi ulnaris
- Ulna

**Parts used in a sketch**

- Bicep
- Muscles of the inner forearm
- Muscles of the outer forearm

# Ratios in the arm

This subject was covered in Part 1 also, but the ratio of arm length to torso is extremely important, so review the essentials here.

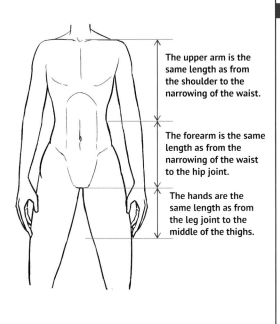

The upper arm is the same length as from the shoulder to the narrowing of the waist.

The forearm is the same length as from the narrowing of the waist to the hip joint.

The hands are the same length as from the leg joint to the middle of the thighs.

🔍 **Critical Point**

### The length of the forearms and upper arms

There is a tendency to think of the forearms and upper arms as being the same length, but the forearm is actually slightly longer. Making the forearm too short will create an ungainly look so take care with this.

Length of forearm = length of upper arm + shoulder

♕ **Tips & Tricks**

### The appearance of the arm depending on its rotation

The rotation of the arm depends on the forearm. The upper arm only moves slightly, and does not rotate much.

▮ Example shows the front of the right arm.

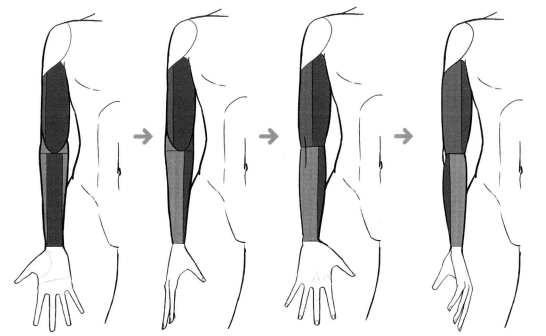

## Drawing the upper arm (front view)

**1** Block-in the arm

Draw in the arm as an extension of the blocking-in for the shoulder to create stable positioning for the arm.

**2** Draw in the bulging of muscle

Draw in the bulging at the inner arm in a higher position than that of the outer arm.

**3** Erase unnecessary lines to complete the sketch!

The drawing method is the same regardless of the angle of the arm!

✓ ✗

If the arm is hanging close to the body, the latissimus dorsi is hidden out of sight by the arm.

🔍 **Critical Point**

**When adding muscle**

Simply make the biceps and triceps larger!

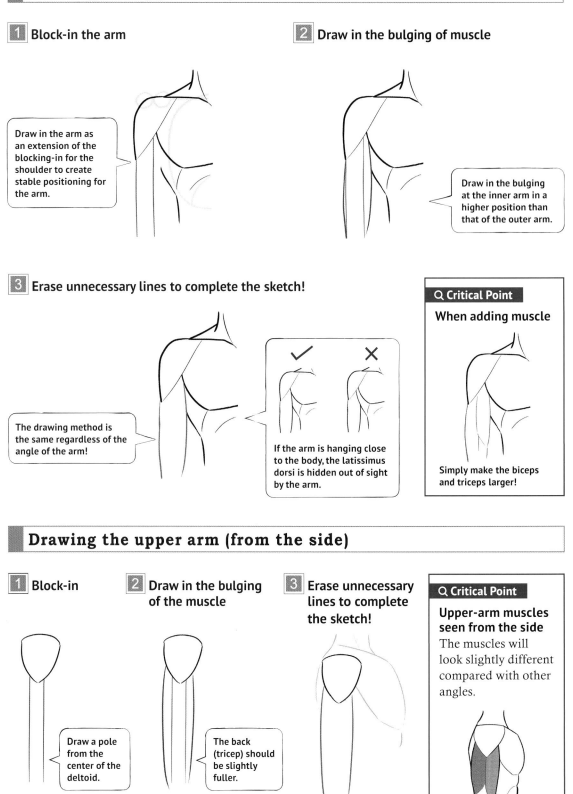

## Drawing the upper arm (from the side)

**1** Block-in

Draw a pole from the center of the deltoid.

**2** Draw in the bulging of the muscle

The back (tricep) should be slightly fuller.

**3** Erase unnecessary lines to complete the sketch!

🔍 **Critical Point**

**Upper-arm muscles seen from the side**
The muscles will look slightly different compared with other angles.

# Drawing the forearm (from the front and side)

**1** Block-in

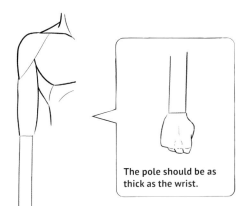

The pole should be as thick as the wrist.

**2** Draw in the bulging of muscle

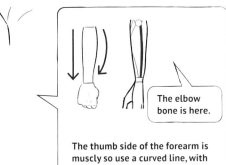

The elbow bone is here.

The thumb side of the forearm is muscly so use a curved line, with a nearly straight line for the little-finger side due to the elbow bone.

**3** Erase unnecessary lines to complete the sketch!

---

### 🖉 Helpful Hint

**The relationship between the hand, arm and elbow**

The direction of the forearm changes not with the direction of the hand, but with the direction of the elbow.

✓      ✗

---

# Drawing the forearms (inner side)

When drawing the inner side of the forearms, the bulging of the forearm muscle is symmetrical.

**1** Block-in

The drawing method is the same as for the side view!

**2** Draw in the bulging of muscle

Draw the bulging of the muscle to be symmetrical.

**3** Erase unnecessary lines to complete the sketch!

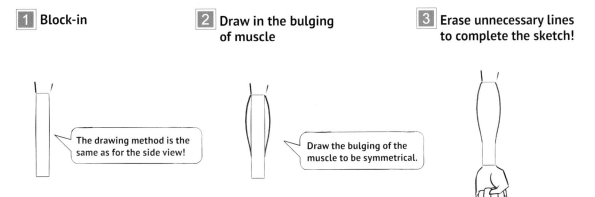

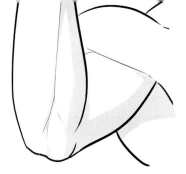

# Drawing Elbows

Elbows aren't always an eye-catching part of the body, and they're easily avoided or overlooked by illustrators. They're as difficult to draw as knees, but just as important to learn.

## Drawing the elbows (inner side)

**1** Draw the line that divides the upper and lower parts of the arm

**2** Draw the elbow

**3** Erase unnecessary lines to complete the sketch!

Make sure the dividing line isn't too long.

Use the ends of the dividing line as peaks to draw in "mountains" on each side.

## Drawing the elbows (outer side)

**3** Draw a circle at the end of the upper arm

**4** Draw in the hollow of the elbow

**5** Erase unnecessary lines and complete the sketch!

Steps **1** and **2** are the same as for "Drawing the elbows (inner side)."

Draw the lower hollow to trace the bone.

Join the ends of the upper arm to form a circle!

### Structure of the elbow

Olecranon

The elbow bone is created by the protrusion in the forearm bone.

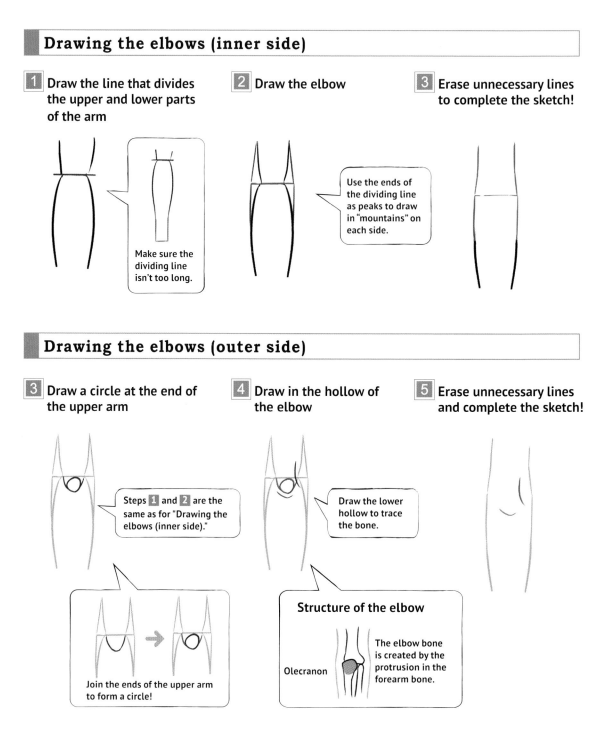

## Drawing the elbow as viewed from the side (back-of-the-hand side)

**1** Draw in the hollow next to the elbow

The elbow viewed from this angle.

Draw the hollow in about a third of the way from the edge.

1 | 1 | 1

**2** Erase unnecessary lines and complete the sketch!

## Drawing the elbow as viewed from the side (palm-of-the-hand side)

**1** Draw the elbow as if to fill in the joint

Don't draw it too big!

The elbow viewed from this angle.

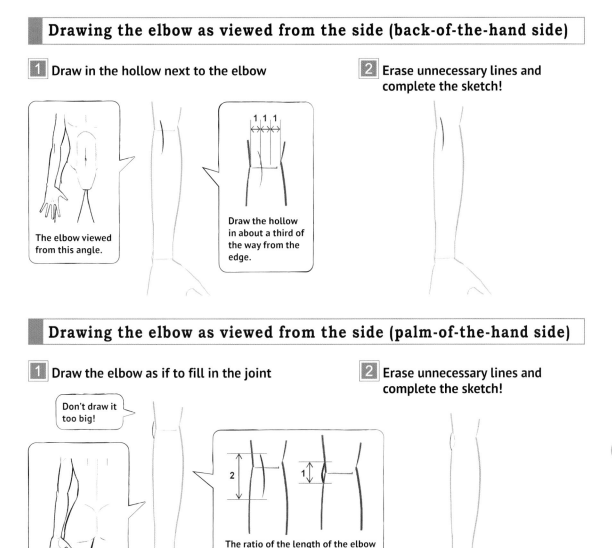

2

1

The ratio of the length of the elbow viewed from the little-finger side to the length of the socket viewed from the thumb side is 2:1.

**2** Erase unnecessary lines and complete the sketch!

### ✐ Helpful Hint

#### How the elbow bends
Even if the elbow is bent as much as possible, the upper and lower parts of the arms do not meet.

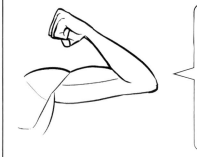

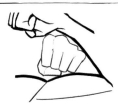

A space is created that is around the size of a clenched fist.

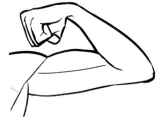

Even if the elbow is bent to its limit, the knuckles do not touch the shoulders.

# Drawing a bent elbow (from the side)

## 1 Draw the arm

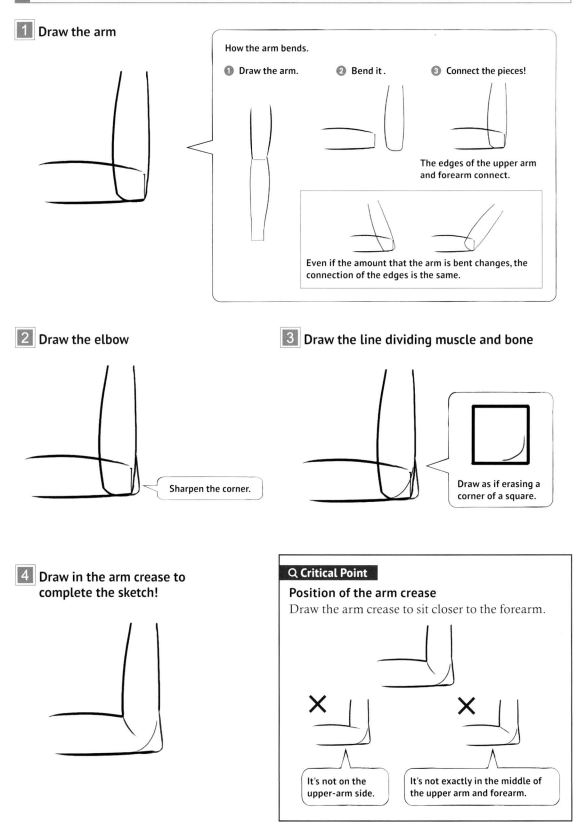

How the arm bends.

① Draw the arm.   ② Bend it.   ③ Connect the pieces!

The edges of the upper arm and forearm connect.

Even if the amount that the arm is bent changes, the connection of the edges is the same.

## 2 Draw the elbow

Sharpen the corner.

## 3 Draw the line dividing muscle and bone

Draw as if erasing a corner of a square.

## 4 Draw in the arm crease to complete the sketch!

### 🔍 Critical Point

**Position of the arm crease**

Draw the arm crease to sit closer to the forearm.

✕ It's not on the upper-arm side.

✕ It's not exactly in the middle of the upper arm and forearm.

# Drawing a bent elbow (from the front)

**1** Draw the forearm

**2** Draw a protrusion on the side near the chest

> The protrusion should be about half as big as the arm.

**3** Erase unnecessary lines to complete the sketch!

---

**Q Critical Point**

### Drawing men

Draw the muscle in the forearm to create a firm, defined elbow.

Use the protrusion drawn in Step **2** as the base to draw in forearm muscles in an inverted capital Y shape.

---

# Drawing the olecranon of a bent elbow

**1** Simplify the elbow bone so it looks like this diagram

**2** Slot the simplified elbow into the arm and trace the outer edge of the olecranon

**3** Erase unnecessary lines to complete the sketch!

**⚑ Tips & Tricks**

### Bone structure of elbow

● Elbow
● Humerus

Bent elbow

Extended elbow

> Even on a different angle, the drawing method is the same!

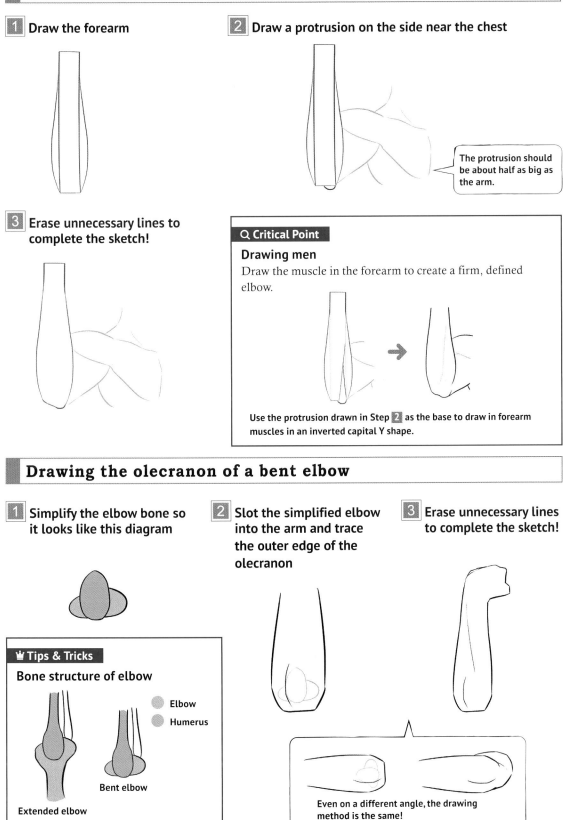

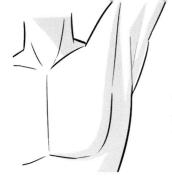

# Drawing Underarms

There are few resources to refer to when grappling with this structurally difficult body part and few opportunities to study it. But once you learn the muscle structure, underarms are actually quite simple to draw.

## Structure of the underams

■ Detailed structure

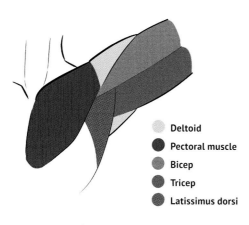

- ● Deltoid
- ● Pectoral muscle
- ● Bicep
- ● Tricep
- ● Latissimus dorsi

■ Parts used in a sketch

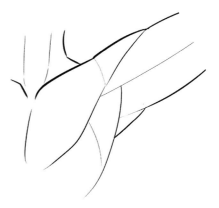

Be aware of all the muscles when sketching the underarms.

---

**🔍 Critical Point**

### How the muscles of the armpit fit together

The hollow created where the pectorals, latissimus dorsi and arm muscles meet is the armpit.

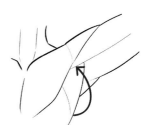

The latissimus dorsi slides under the bicep.

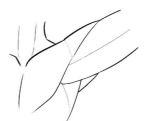

The bicep and tricep are not both connected to the chest!

# Drawing the underarms (from the front)

**1** Draw the shoulder, chest and arm

**2** Draw a line to divide the arm in half

> Rather than placing it in the very middle, draw the line to make the bicep narrower.

**3** Draw a curved line to pierce the bicep

> Draw the line to go through the middle of the deltoid.

**4** Connect the latissimus dorsi and the line at the center of the arm to create a triangle

> The hollow between the arm muscles, latissimus dorsi and pectoral muscles is triangular.

**5** Draw the back of the deltoid

> If it's too big, it'll appear muscly, so take care!

**6** Erase unnecessary lines to complete the sketch!

> To express masculinity, leave the line in the arm as muscle.

# Drawing the underarms (from the side)

## 1 Draw the torso, arm and shoulder

Draw in the line that separates the bicep and tricep muscles.

## 2 Draw in a line as if to go around the arm

This line circling the arm is the rotator cuff line.

## 3 Connect the rotator cuff line and arm muscle line to form a triangle

Make sure the triangle isn't too large.

## 4 Erase unnecessary lines to complete the sketch!

If creating a muscular physique, emphasize the latissimus dorsi and deltoid.

---

### Q Critical Point

#### Drawing the armpit with the arm is down

Alter how the underarms look when the arms are down depending on the character's physique.

■ For a woman with large breasts

For a woman with quite large breasts, draw a rounded "y"-shaped line to emphasize the fullness of the breasts. The "y" crease is formed due to the breasts and the pectoral muscles being on different levels.

■ For a man or for a woman who doesn't have large breasts

For a man or for a woman whose breasts are not large, the line at the edge of the pectorals becomes the armpit crease.

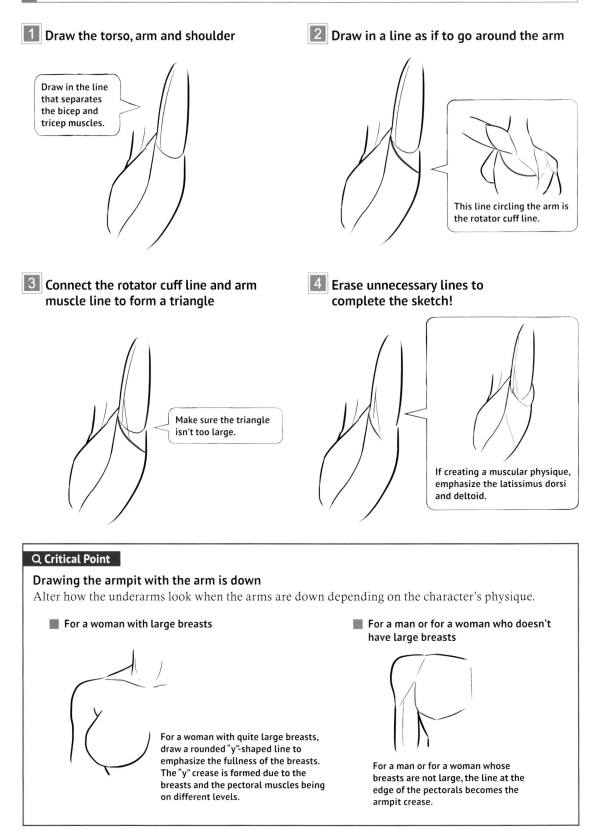

# Drawing Legs & Feet

**Drawing Thighs**

**Drawing Calves**

**Drawing Knees**

**Drawing Feet**

# Drawing Thighs

Crucial for maintaining balance in the body overall, the thighs also lend your characters a sense of strength and stamina. Thighs may seem quite complicated in form, but only four parts are needed for your sketches.

## Structure of the thighs

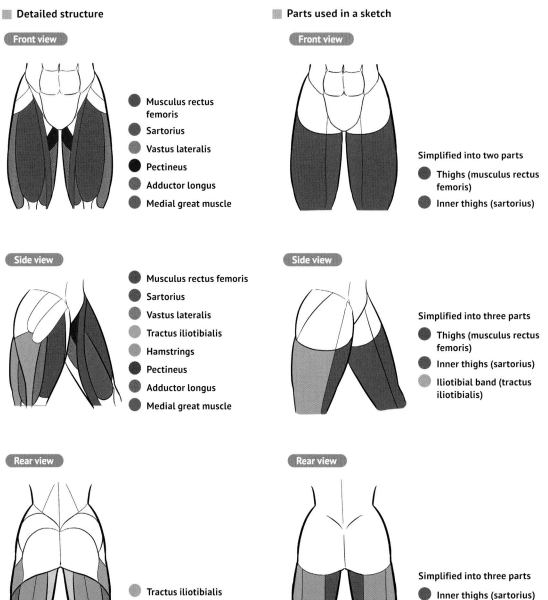

### Detailed structure

**Front view**

- Musculus rectus femoris
- Sartorius
- Vastus lateralis
- Pectineus
- Adductor longus
- Medial great muscle

**Side view**

- Musculus rectus femoris
- Sartorius
- Vastus lateralis
- Tractus iliotibialis
- Hamstrings
- Pectineus
- Adductor longus
- Medial great muscle

**Rear view**

- Tractus iliotibialis
- Hamstrings
- Adductor longus
- Vastus lateralis

### Parts used in a sketch

**Front view**

Simplified into two parts

- Thighs (musculus rectus femoris)
- Inner thighs (sartorius)

**Side view**

Simplified into three parts

- Thighs (musculus rectus femoris)
- Inner thighs (sartorius)
- Iliotibial band (tractus iliotibialis)

**Rear view**

Simplified into three parts

- Inner thighs (sartorius)
- Iliotibial band (tractus iliotibialis)
- Rear side (hamstrings)

# Drawing the thighs (front view)

## 1 Create the blocking-in

**Leg length**
Make sure the knees, ankles and feet are the same length on both legs.

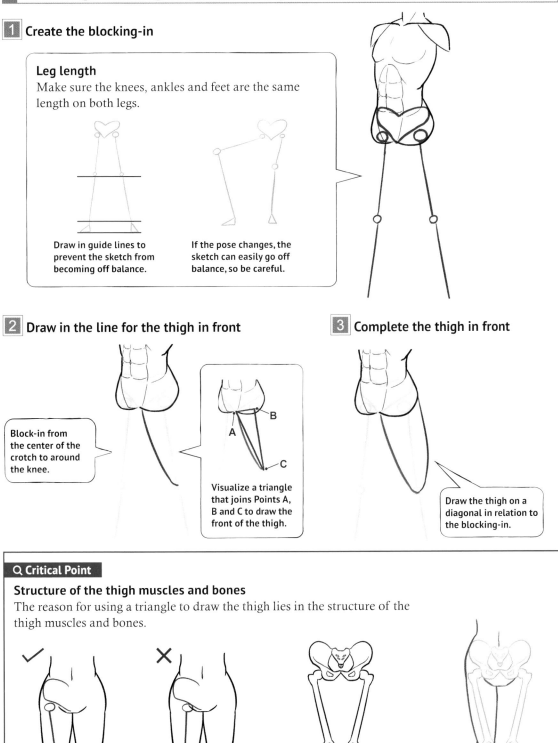

Draw in guide lines to prevent the sketch from becoming off balance.

If the pose changes, the sketch can easily go off balance, so be careful.

## 2 Draw in the line for the thigh in front

Block-in from the center of the crotch to around the knee.

Visualize a triangle that joins Points A, B and C to draw the front of the thigh.

## 3 Complete the thigh in front

Draw the thigh on a diagonal in relation to the blocking-in.

---

### Q Critical Point

**Structure of the thigh muscles and bones**
The reason for using a triangle to draw the thigh lies in the structure of the thigh muscles and bones.

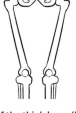

The thigh bone is on a diagonal angle to the leg.

It's not straight.

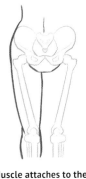

Even if the thigh bone (femur) is positioned to stand straight, it's still slightly on a diagonal.

Muscle attaches to the thigh like so.

145

**4** **Draw the thigh at the back**

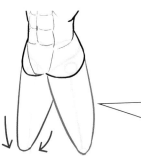

Be aware of the buttocks as you draw the thighs.

Even from the front, keep the position of the buttocks in mind and draw in a line.

The line at the back of the legs joins to the buttocks.

✕        ✓

Using half the crotch as a base from which to draw the thighs results in a skinny leg.

**5** **Erase unnecessary lines to complete the sketch!**

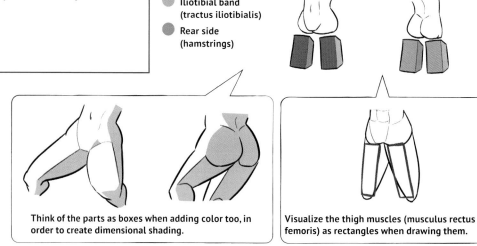

**🔍 Critical Point**

## Dimension in the thighs

Thinking of these four parts of the thigh as boxes makes it easier to indicate dimension.

Front view        Rear view

● Thighs (musculus rectus femoris)
● Inner thighs (sartorius)
● Iliotibial band (tractus iliotibialis)
● Rear side (hamstrings)

Think of the parts as boxes when adding color too, in order to create dimensional shading.

Visualize the thigh muscles (musculus rectus femoris) as rectangles when drawing them.

# Drawing the thighs (rear view)

Capturing the thighs from behind is nearly the same as drawing them from the front.

**1** **Create blocking-in**

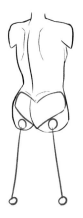

**2** **Draw the thigh in front**

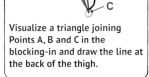

(Front) (Rear)

Visualize a triangle joining Points A, B and C in the blocking-in and draw the line at the back of the thigh.

**3** **Draw the thigh at the back**

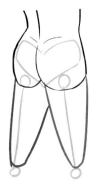

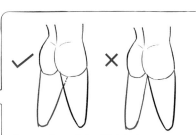

Be conscious of the thigh in front, even when drawing a rear view and be sure to draw the inner thigh so it's thick enough.

**4** **Erase unnecessary lines to complete the sketch!**

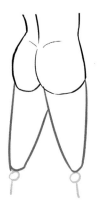

> ### Q Critical Point
>
> **Dimension in the back side of the thighs**
> When drawing the back side of the thighs (hamstrings), keep a rectangular shape in mind to easily bring out dimension and form.
>
>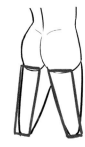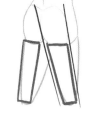
>
> The buttocks are the width of the rectangle!

# Drawing Calves

The calf muscles collectively create a complicated shape. They're crucial for getting the balance in the lower body right, so use the bones as a base for creating an accurate sense of the calves' form.

## Structure of the calves

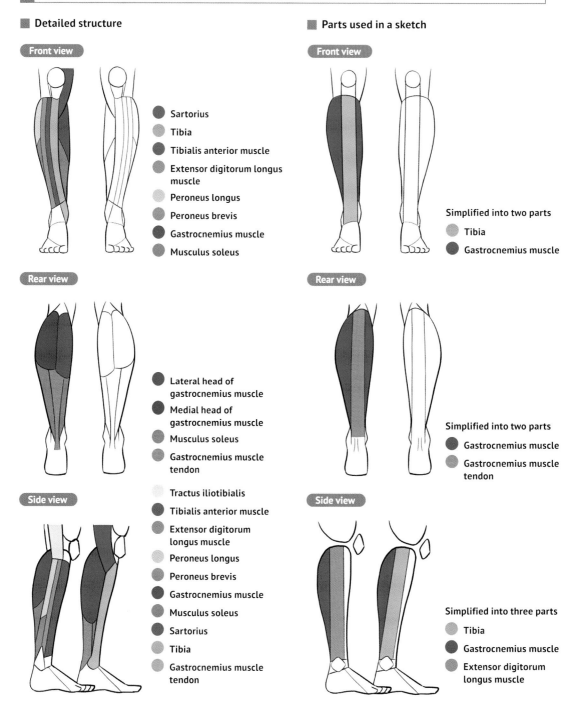

■ Detailed structure

■ Parts used in a sketch

**Front view**

- Sartorius
- Tibia
- Tibialis anterior muscle
- Extensor digitorum longus muscle
- Peroneus longus
- Peroneus brevis
- Gastrocnemius muscle
- Musculus soleus

**Front view**

Simplified into two parts
- Tibia
- Gastrocnemius muscle

**Rear view**

- Lateral head of gastrocnemius muscle
- Medial head of gastrocnemius muscle
- Musculus soleus
- Gastrocnemius muscle tendon
- Tractus iliotibialis
- Tibialis anterior muscle
- Extensor digitorum longus muscle
- Peroneus longus
- Peroneus brevis
- Gastrocnemius muscle
- Musculus soleus
- Sartorius
- Tibia
- Gastrocnemius muscle tendon

**Rear view**

Simplified into two parts
- Gastrocnemius muscle
- Gastrocnemius muscle tendon

**Side view**

**Side view**

Simplified into three parts
- Tibia
- Gastrocnemius muscle
- Extensor digitorum longus muscle

# Drawing the calves (front view)

**1** Draw the leg bones

**2** Draw in the calf muscles

**3** Erase unnecessary lines to complete the sketch!

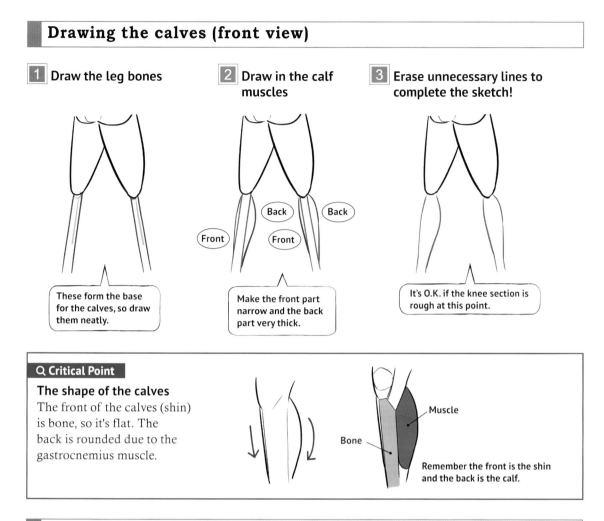

These form the base for the calves, so draw them neatly.

Make the front part narrow and the back part very thick.

It's O.K. if the knee section is rough at this point.

Back · Back · Front · Front

---

**Q Critical Point**

**The shape of the calves**
The front of the calves (shin) is bone, so it's flat. The back is rounded due to the gastrocnemius muscle.

Muscle

Bone

Remember the front is the shin and the back is the calf.

---

# Drawing the calves (rear view)

Think of drawing the back of the calves in the same way as drawing the front.

**1** Draw the leg bones

**2** Draw in the calf muscles

**3** Erase unnecessary lines to complete the sketch!

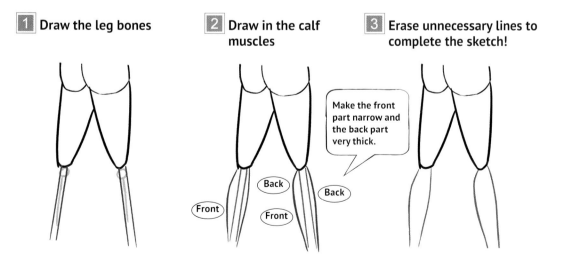

Make the front part narrow and the back part very thick.

Back · Back · Front · Front

## Drawing the calves (outer side)

**1** Draw the leg bones

**2** Draw the muscles of the calves

**3** Erase unnecessary lines to complete the sketch!

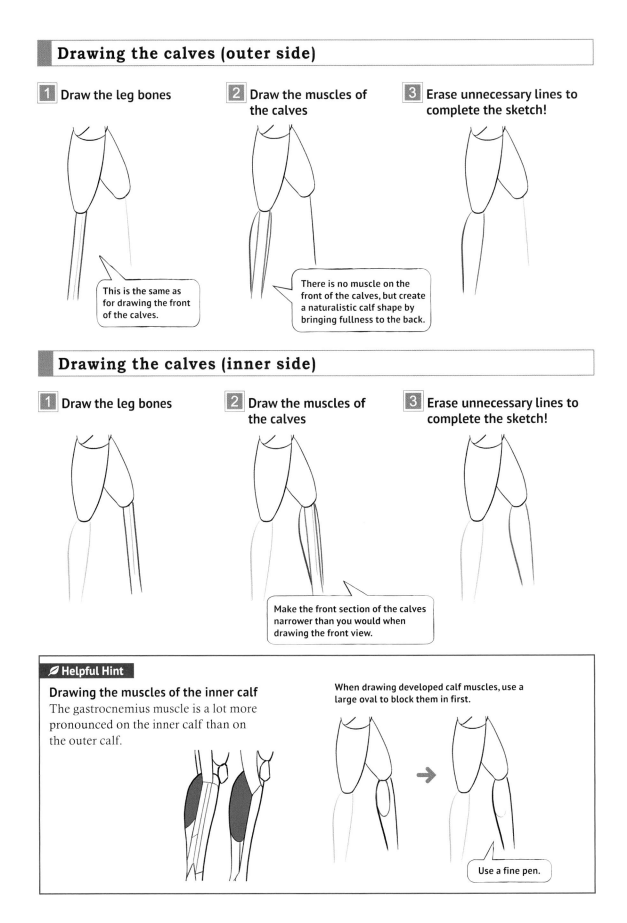

This is the same as for drawing the front of the calves.

There is no muscle on the front of the calves, but create a naturalistic calf shape by bringing fullness to the back.

## Drawing the calves (inner side)

**1** Draw the leg bones

**2** Draw the muscles of the calves

**3** Erase unnecessary lines to complete the sketch!

Make the front section of the calves narrower than you would when drawing the front view.

### 🖉 Helpful Hint

**Drawing the muscles of the inner calf**

The gastrocnemius muscle is a lot more pronounced on the inner calf than on the outer calf.

When drawing developed calf muscles, use a large oval to block them in first.

Use a fine pen.

### The calves when standing straight

When the legs are close together in a standing position, they are not straight.

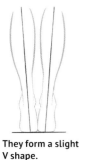

**They form a slight V shape.**

### Muscular calves

Calf muscles are not particularly noticeable on the average person. Even on an athlete, it's really only the division of the calves and tendons that's visible.

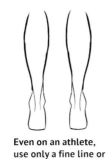

**Even on an athlete, use only a fine line or light shading to paint in the section below the calf muscle.**

**For someone like a bodybuilder with a muscular physique, make the calf muscles large to emphasize them.**

**Regardless of how fit and muscular someone is, their calf muscles are never so developed and rounded that they split into two.**

### Drawing muscular calf muscles

The muscles of the calves do not stand out much except on people with highly developed physiques. However, if you can understand how to draw muscular calves, it will help in mastering dimension.,

**1** Draw the silhouette

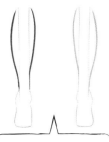

**The inner calf muscle is small but full while the outer muscle is large and narrow.**

**2** Draw in reference lines for the calves

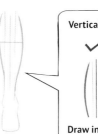

**Horizontal reference lines**

Draw in horizontal reference lines to cross through the center of the inner calf.

**Vertical reference lines**

✓ ✗

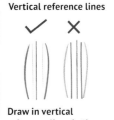

Draw in vertical reference lines in the center of the calf itself, not along the bone.

**3** Draw in a diagonal line and create two mountains

**Draw in a line on a diagonal angle to the horizontal reference line, keeping the angle within reason.**

**Use the points where the vertical reference lines and the diagonal lines cross to draw in two upside-down mountains.**

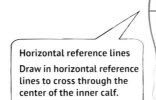

**4** Draw the muscles of the calves

**5** Erase unnecessary lines to complete the sketch!

# Drawing Knees

Due to the complicated way the bones and muscles connect and the fact that they're often drawn from various angles, the knees can be particularly difficult to depict. Learn the important muscles and try to commit them to memory.

## Structure of the knees

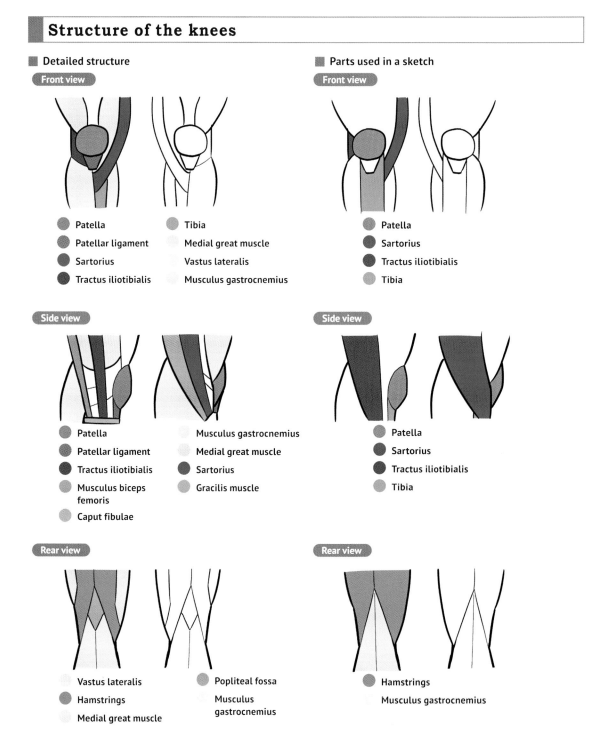

■ Detailed structure

**Front view**

- Patella
- Patellar ligament
- Sartorius
- Tractus iliotibialis
- Tibia
- Medial great muscle
- Vastus lateralis
- Musculus gastrocnemius

**Side view**

- Patella
- Patellar ligament
- Tractus iliotibialis
- Musculus biceps femoris
- Caput fibulae
- Musculus gastrocnemius
- Medial great muscle
- Sartorius
- Gracilis muscle

**Rear view**

- Vastus lateralis
- Hamstrings
- Medial great muscle
- Popliteal fossa
- Musculus gastrocnemius

■ Parts used in a sketch

**Front view**

- Patella
- Sartorius
- Tractus iliotibialis
- Tibia

**Side view**

- Patella
- Sartorius
- Tractus iliotibialis
- Tibia

**Rear view**

- Hamstrings
- Musculus gastrocnemius

# Drawing an extended knee

**1** Draw the legs

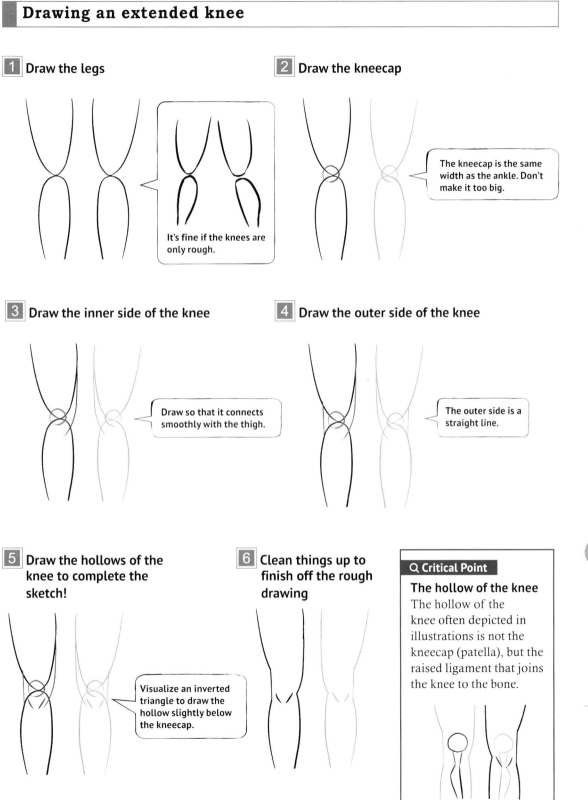

It's fine if the knees are only rough.

**2** Draw the kneecap

The kneecap is the same width as the ankle. Don't make it too big.

**3** Draw the inner side of the knee

Draw so that it connects smoothly with the thigh.

**4** Draw the outer side of the knee

The outer side is a straight line.

**5** Draw the hollows of the knee to complete the sketch!

Visualize an inverted triangle to draw the hollow slightly below the kneecap.

**6** Clean things up to finish off the rough drawing

### Q Critical Point

**The hollow of the knee**
The hollow of the knee often depicted in illustrations is not the kneecap (patella), but the raised ligament that joins the knee to the bone.

# Drawing the leg with the outer side visible

**1** Draw the leg

Inner section | Outer section

Only draw both legs at this stage.

**2** Draw the kneecap

Express the direction of the kneecap by altering the thickness of the knee.

**3** Draw the outer edge of the knee

This is the same as when drawing the front view.

**4** Draw the inner section of the knee and the hollow of the knee to complete the sketch for one leg

For a knee viewed from a diagonal angle, draw the hollow of the knee next to the kneecap.

**5** Clean things up to finish off the rough drawing for one leg

× Take care that the calf doesn't jut out awkwardly from the knee.

🔍 **Critical Point**

**A tip for drawing the outer side of the knee**

Use a straight line for the outer side and a curved line for the inner side.

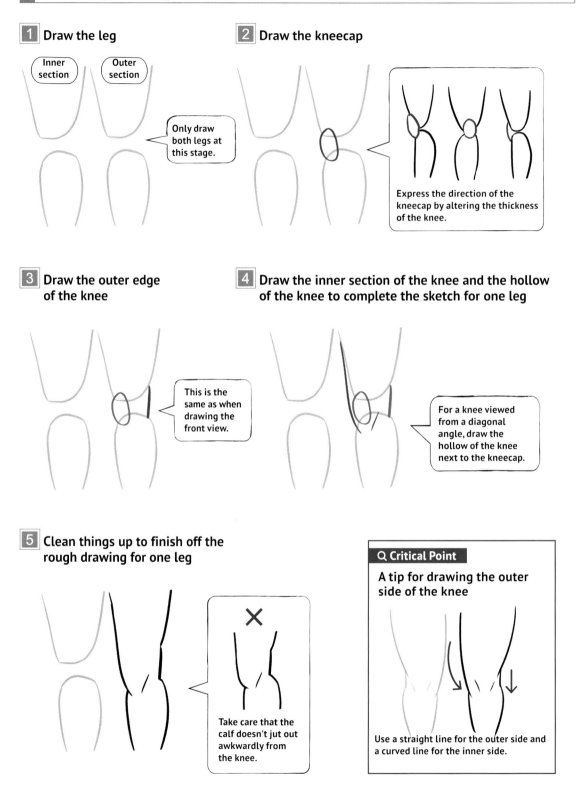

# Drawing the leg with the inner side visible

**1** Draw the kneecap

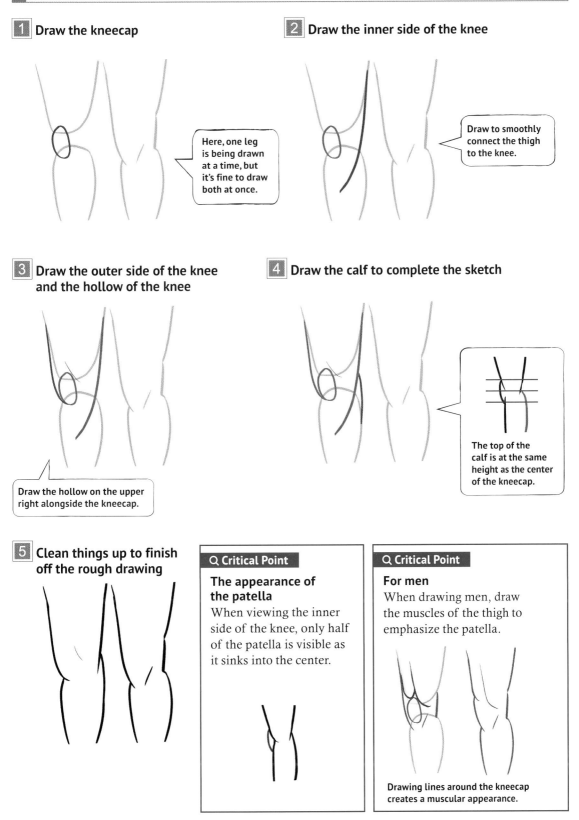

Here, one leg is being drawn at a time, but it's fine to draw both at once.

**2** Draw the inner side of the knee

Draw to smoothly connect the thigh to the knee.

**3** Draw the outer side of the knee and the hollow of the knee

Draw the hollow on the upper right alongside the kneecap.

**4** Draw the calf to complete the sketch

The top of the calf is at the same height as the center of the kneecap.

**5** Clean things up to finish off the rough drawing

### 🔍 Critical Point

**The appearance of the patella**

When viewing the inner side of the knee, only half of the patella is visible as it sinks into the center.

### 🔍 Critical Point

**For men**

When drawing men, draw the muscles of the thigh to emphasize the patella.

Drawing lines around the kneecap creates a muscular appearance.

## The back of the knees viewed from directly behind

**1** Draw the kneecap

Draw the hamstrings in first.

The kneecap sets the position for the knee but will be erased later.

**2** Draw the thighs and calves

Add a slight curve to the inner side of the knee and make the outer side straight.

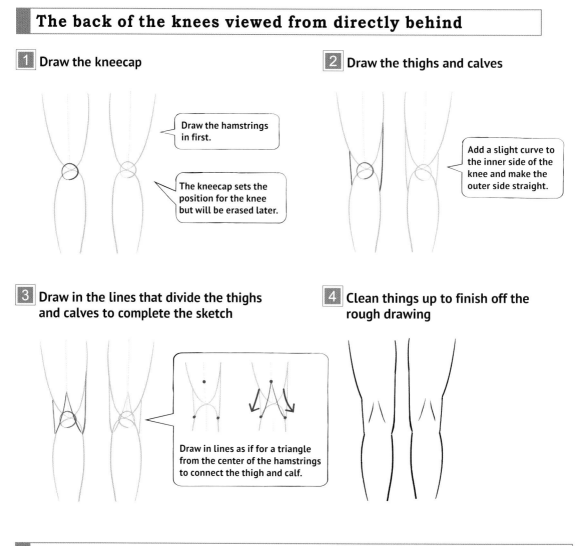

**3** Draw in the lines that divide the thighs and calves to complete the sketch

Draw in lines as if for a triangle from the center of the hamstrings to connect the thigh and calf.

**4** Clean things up to finish off the rough drawing

## The back of the knees viewed from a diagonal angle

Even if the angle changes, the drawing method remains the same.

**1** Draw the knee and the back of the knee

Draw in the knee to fill in the gap between the thigh and calf.

**2** Draw in the lines that separate the thigh and calf to complete the sketch

**3** Clean things up to finish off the rough drawing

Make sure the outline for the back side of the knee doesn't get mixed up with the /\ shape that indicates the back of the knee!

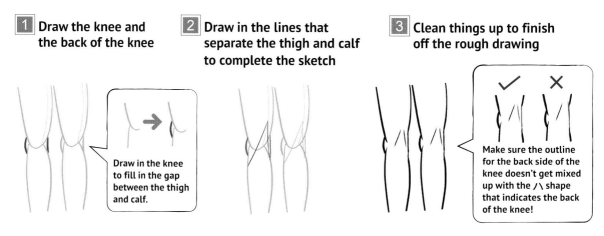

# Drawing a bent knee (side view)

## 1 Bend the leg

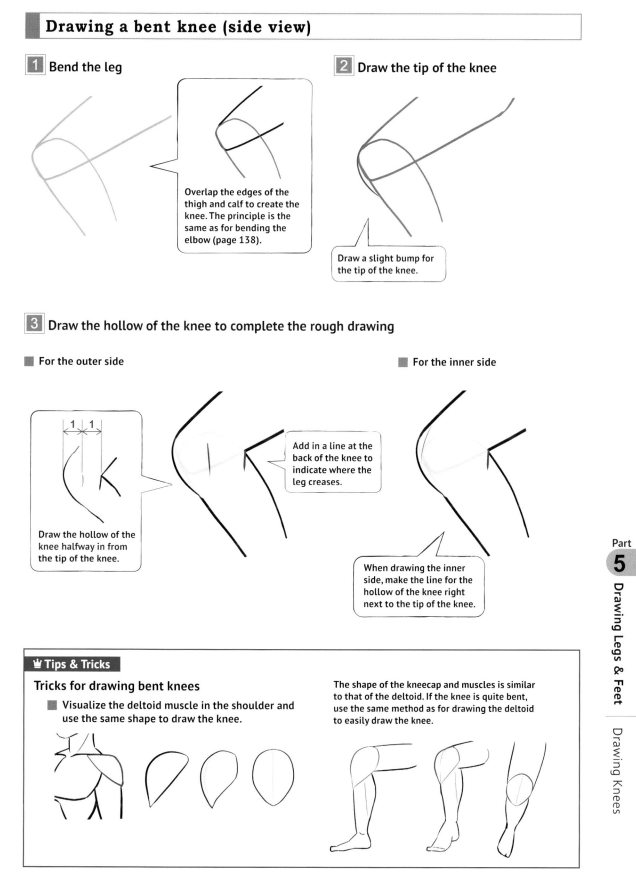

Overlap the edges of the thigh and calf to create the knee. The principle is the same as for bending the elbow (page 138).

## 2 Draw the tip of the knee

Draw a slight bump for the tip of the knee.

## 3 Draw the hollow of the knee to complete the rough drawing

### For the outer side

Draw the hollow of the knee halfway in from the tip of the knee.

Add in a line at the back of the knee to indicate where the leg creases.

### For the inner side

When drawing the inner side, make the line for the hollow of the knee right next to the tip of the knee.

---

### ♛ Tips & Tricks

#### Tricks for drawing bent knees

■ Visualize the deltoid muscle in the shoulder and use the same shape to draw the knee.

The shape of the kneecap and muscles is similar to that of the deltoid. If the knee is quite bent, use the same method as for drawing the deltoid to easily draw the knee.

# Drawing a bent knee (from the front)

**1** Draw the leg

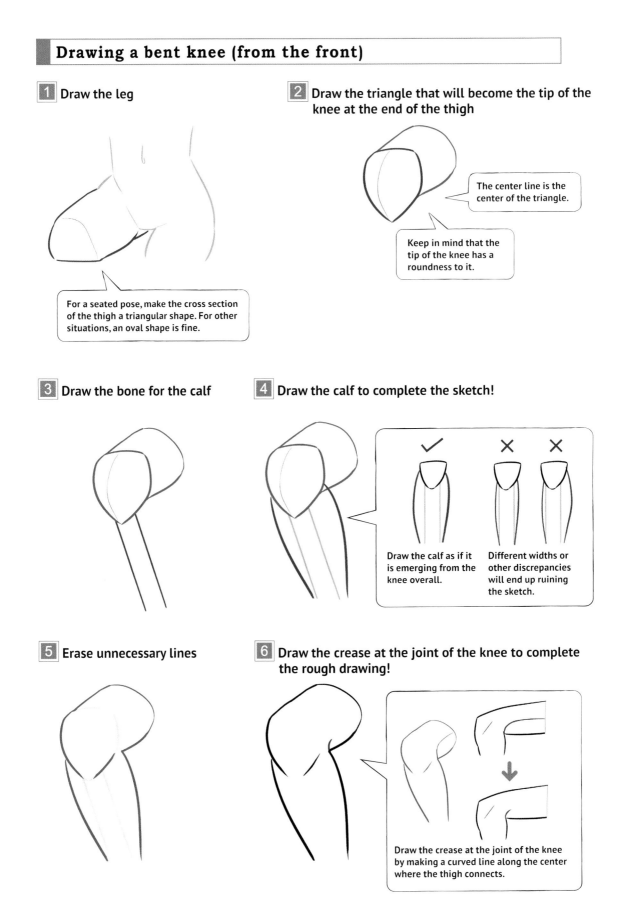

For a seated pose, make the cross section of the thigh a triangular shape. For other situations, an oval shape is fine.

**2** Draw the triangle that will become the tip of the knee at the end of the thigh

The center line is the center of the triangle.

Keep in mind that the tip of the knee has a roundness to it.

**3** Draw the bone for the calf

**4** Draw the calf to complete the sketch!

Draw the calf as if it is emerging from the knee overall.

Different widths or other discrepancies will end up ruining the sketch.

**5** Erase unnecessary lines

**6** Draw the crease at the joint of the knee to complete the rough drawing!

Draw the crease at the joint of the knee by making a curved line along the center where the thigh connects.

# Drawing a bent knee (from the side)

**1** Draw the thigh

**2** Draw from the calf down

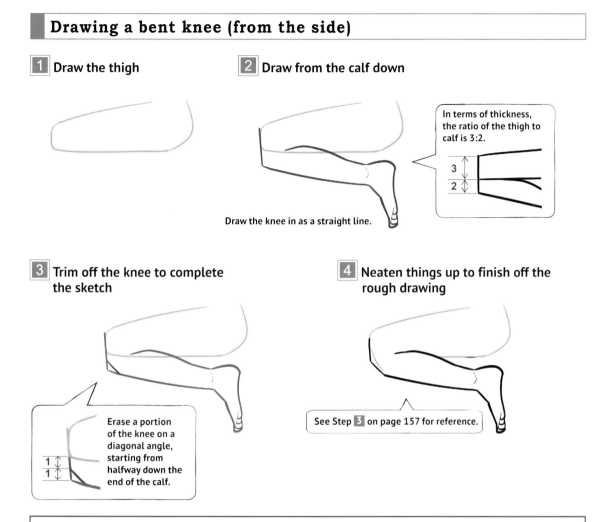

In terms of thickness, the ratio of the thigh to calf is 3:2.

3
2

Draw the knee in as a straight line.

**3** Trim off the knee to complete the sketch

**4** Neaten things up to finish off the rough drawing

Erase a portion of the knee on a diagonal angle, starting from halfway down the end of the calf.

1
1

See Step **3** on page 157 for reference.

---

### 🖋 Helpful Hint

#### The degree of bend in the knee

The thighs and calves only touch when there is weight bearing down on them, so unless squatting or held together with the hands, there's a space between the thighs and calves.

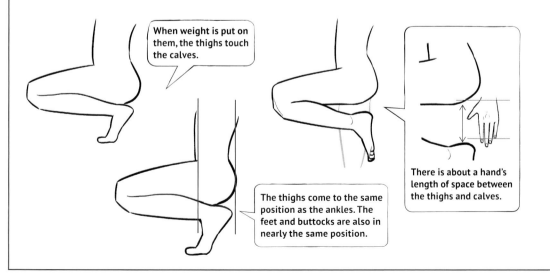

When weight is put on them, the thighs touch the calves.

The thighs come to the same position as the ankles. The feet and buttocks are also in nearly the same position.

There is about a hand's length of space between the thighs and calves.

# The relationship between the thighs and calves

## 1 How the thighs and calves appear when the knees are bent

When the knees are bent and the thighs are over the calves, the calves appear to protrude more.

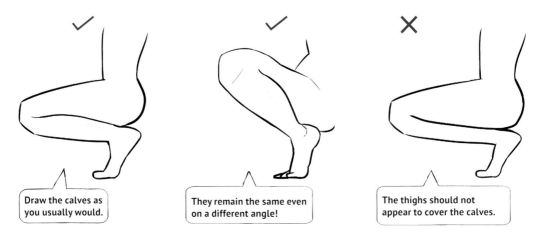

Draw the calves as you usually would.

They remain the same even on a different angle!

The thighs should not appear to cover the calves.

## 2 The shape of the thighs and calves when the knees are bent

When the knees are bent, the thighs and calves are compressed.

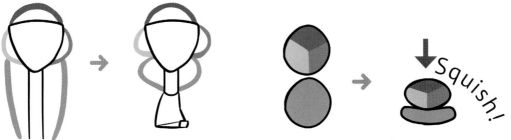

The calves are the most compressed.

Even on a different angle, the calves appear significantly compressed, more so than the thighs.

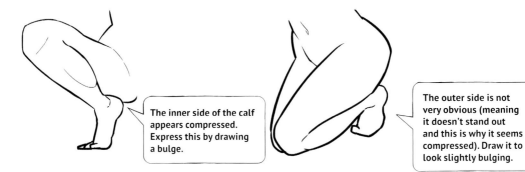

The inner side of the calf appears compressed. Express this by drawing a bulge.

The outer side is not very obvious (meaning it doesn't stand out and this is why it seems compressed). Draw it to look slightly bulging.

### 3 The crease that appears when the knee is slightly bent

When the knee is slightly bent, a crease appears in the center of the thigh and calf.

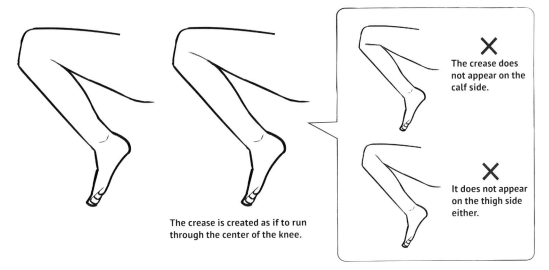

The crease is created as if to run through the center of the knee.

**✕** The crease does not appear on the calf side.

**✕** It does not appear on the thigh side either.

### 4 The thighs and calves when sitting with the legs bent beneath

Even when in a seated position with the legs bent beneath, the relationship between the thighs and calves does not change significantly.

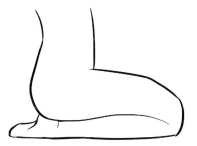

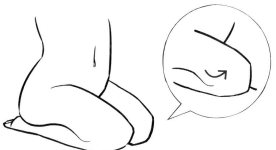

The calves appear to protrude more. As the weight of the body is resting on them, the thighs appear thick.

When viewed on a diagonal angle, the tip of the crease between the thigh and calf is slightly raised.

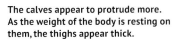
**🖋 Helpful Hint**

#### The thighs when seated on a chair
There are many opportunities for drawing figures seated on chairs, so learn how the thigh muscles sit.

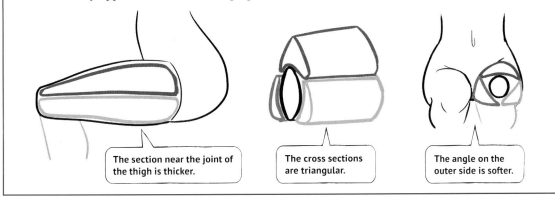

The section near the joint of the thigh is thicker.

The cross sections are triangular.

The angle on the outer side is softer.

# Drawing Feet

The feet are one extremely complicated pair of parts. Rather than learning how the bones and muscles fit together, focus instead on their form. To start, let's divide them into two simple parts: the ankles and the tips of the toes.

## Structure of the feet

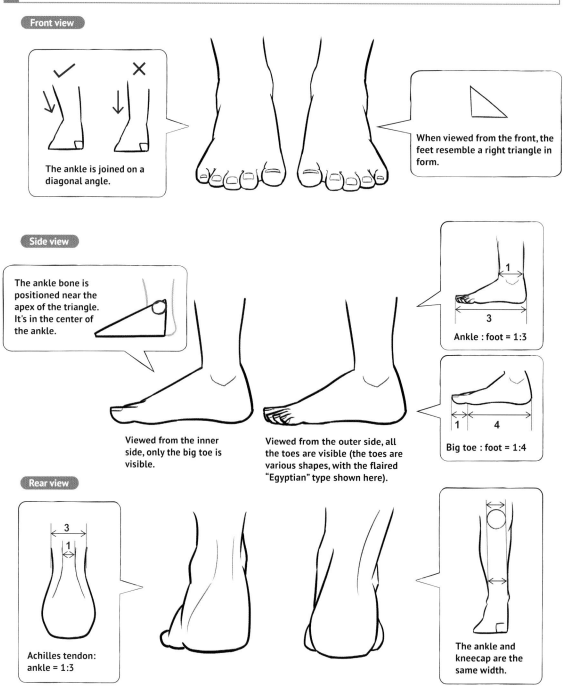

**Front view**

✓ ✗

The ankle is joined on a diagonal angle.

When viewed from the front, the feet resemble a right triangle in form.

**Side view**

The ankle bone is positioned near the apex of the triangle. It's in the center of the ankle.

1
3
Ankle : foot = 1:3

1 4
Big toe : foot = 1:4

Viewed from the inner side, only the big toe is visible.

Viewed from the outer side, all the toes are visible (the toes are various shapes, with the flaired "Egyptian" type shown here).

**Rear view**

3
1
Achilles tendon: ankle = 1:3

The ankle and kneecap are the same width.

# Drawing the feet (front view)

**1** Block-in the back section of the foot

Incline the shape slightly toward the little-toe side.

Drawing in the center line makes it easy to block-in the tips of the toes.

**2** Block-in the tips of the toes

The base of the triangle forms the tips of the toes.

Keep in mind which way the toes will face.

**3** Draw in the toes

The trick is to draw all the toes diagonally after the second one.

**4** Draw the ankle bone

Outer side

Inner side

The ankle bone is higher on the inner side.

Draw the ankle bone at around the same height as the apex of the triangle.

**5** Erase unnecessary lines to complete the sketch!

Leave a little of the toe lines to make them easier to visualize!

**6** Clean things up to finish off the rough drawing

Drawing the nails

Make the big toenail sit on top of the toe, with the other nails all visible from the front.

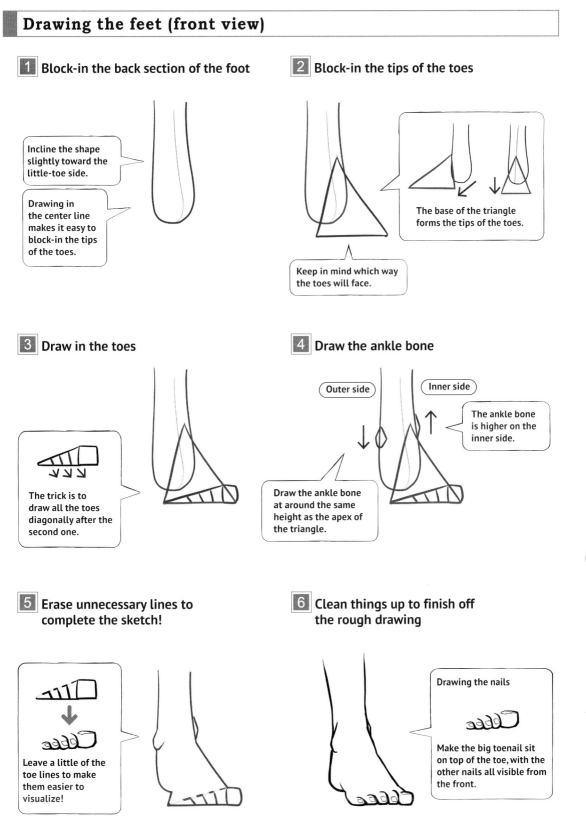

## Drawing the feet (side view)

**1** Block-in the back section of the foot with the heel at the base

Draw a circle that touches the base of the blocking-in for the back section of the foot.

**2** Block-in the tips of the toes

Do this in the same way as for drawing the toes from the front!

**3** Draw the Achilles tendon

Draw the bar of the Achilles tendon to join with the circle of the heel.

**4** Draw the ankle bones and toe to complete the sketch!

Draw a square for the toe.

The ankle bone is joined to the ankle.

**5** Clean things up to complete the rough drawing

### Q Critical Point

**Triangles and bars**

Using triangles and bars, the feet can be drawn from any angle. Whether viewed from above, below or from the back of the heel, the toes should be triangular while the heel should be a bar shape.

Angle below

Overhead angle

Rear angle

# Drawing the feet (side view)

**1** Draw the ankle and feet

**2** Draw the ankle bone and tips of the toes

The ankle bone is in the center of the ankle. Draw the toes as squares.

**3** Erase unnecessary lines to complete the sketch!

**4** Draw in the toes to finish off the rough drawing!

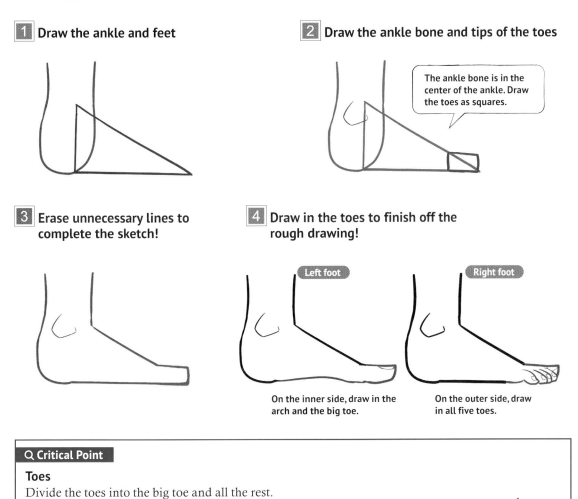

Left foot

Right foot

On the inner side, draw in the arch and the big toe.

On the outer side, draw in all five toes.

---

**🔍 Critical Point**

## Toes

Divide the toes into the big toe and all the rest.

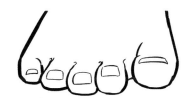

The big toe is about twice as big as the other toes.

Only the big toe faces up. The rest of the toes face down.

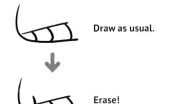

Draw as usual.

Erase!

The little toe sits slightly farther back than the other toes.

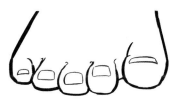

There is a slight gap between the big toe and the second toe.

# Structure of the soles of the feet

There are a lot of curved lines in the soles of the feet, making it extremely difficult to get the balance right when drawing them. Try thinking of them as five circles and one triangle.

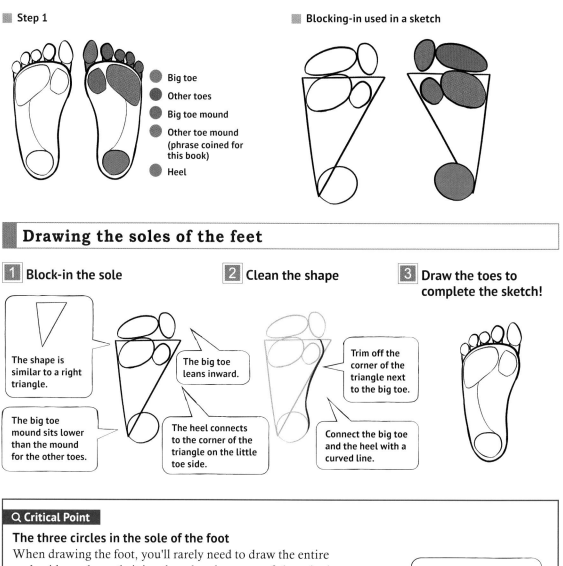

■ Step 1

- Big toe
- Other toes
- Big toe mound
- Other toe mound (phrase coined for this book)
- Heel

■ Blocking-in used in a sketch

# Drawing the soles of the feet

**1 Block-in the sole**

The shape is similar to a right triangle.

The big toe mound sits lower than the mound for the other toes.

The big toe leans inward.

The heel connects to the corner of the triangle on the little toe side.

**2 Clean the shape**

Trim off the corner of the triangle next to the big toe.

Connect the big toe and the heel with a curved line.

**3 Draw the toes to complete the sketch!**

---

**Q Critical Point**

### The three circles in the sole of the foot

When drawing the foot, you'll rarely need to draw the entire underside, and mostly it involves drawing parts of the sole that are visible when standing on tiptoes. Regardless of the angle, the shape remains the same: a triangle that connects the big toe mound, the mound of the other toes and the heel. Use the heel—which connects to the ankle—as the pivot point for drawing the triangle.the

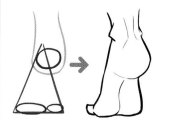

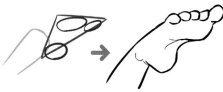

Regardless of the pose, the shape of the sole remains the same!

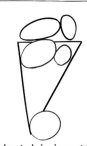

The key to bringing out the look of the sole of the foot is the circles in the big toe mound, the mound of the other toes and the heel!

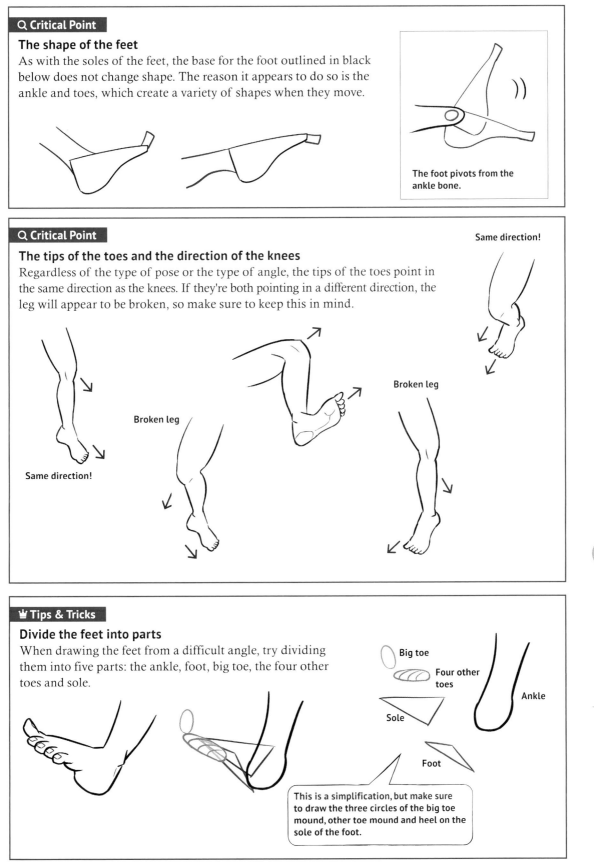

## The shape of the feet

As with the soles of the feet, the base for the foot outlined in black below does not change shape. The reason it appears to do so is the ankle and toes, which create a variety of shapes when they move.

The foot pivots from the ankle bone.

## The tips of the toes and the direction of the knees

Regardless of the type of pose or the type of angle, the tips of the toes point in the same direction as the knees. If they're both pointing in a different direction, the leg will appear to be broken, so make sure to keep this in mind.

Same direction!

Broken leg

Broken leg

Same direction!

## Divide the feet into parts

When drawing the feet from a difficult angle, try dividing them into five parts: the ankle, foot, big toe, the four other toes and sole.

Big toe

Four other toes

Ankle

Sole

Foot

This is a simplification, but make sure to draw the three circles of the big toe mound, other toe mound and heel on the sole of the foot.

Part

**5**

Drawing Legs & Feet | Drawing Feet

# Drawing a Character

Using the lessons from this book, let's try to draw a character. It'll give you the perfect opportunity to review the key points about each body part you're drawing.

**1** Roughly decide on what you are drawing

In order to expand on the image you have in mind for your character, make a sketch that expresses your idea. This is only to flesh out your vision, so it doesn't matter if it's rough.

**2** Block-in

If the body ratios and the length of the body parts are measured accurately, you don't need to make the blocking-in too detailed.

**3** Sketch the face

Block-in the nose and accurately determine its position (page 20).

Make sure to use guide lines to sketch the chin (page 21).

**4** Sketch the torso

Learn the shape of the deltoid and work it in (page 82).

Draw in the line that divides the abdominal and oblique muscles to create dimension in the torso (page 89).

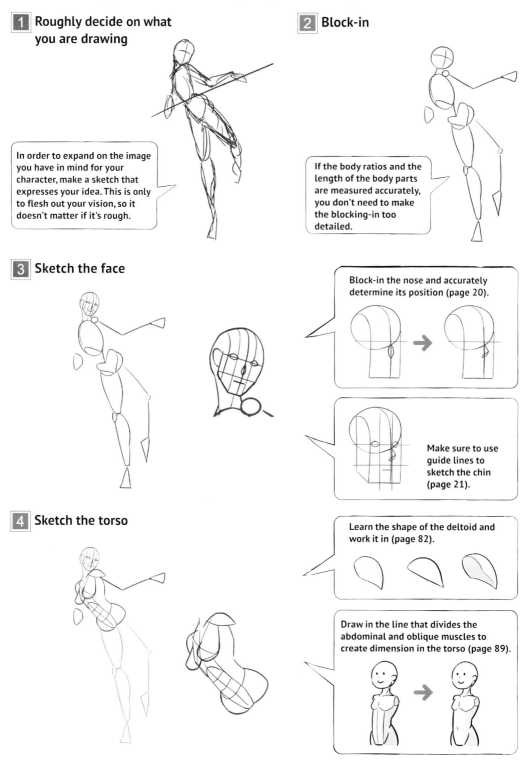

## 5 Sketch the feet and legs

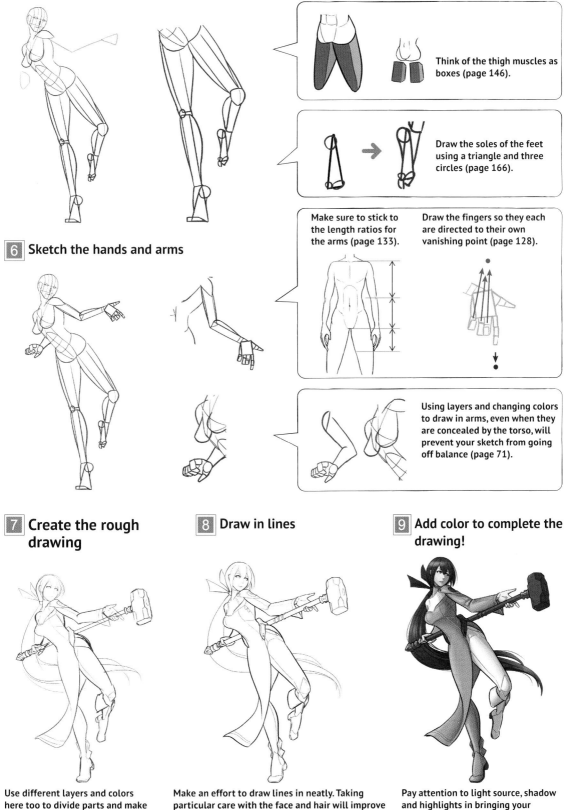

Think of the thigh muscles as boxes (page 146).

Draw the soles of the feet using a triangle and three circles (page 166).

## 6 Sketch the hands and arms

Make sure to stick to the length ratios for the arms (page 133).

Draw the fingers so they each are directed to their own vanishing point (page 128).

Using layers and changing colors to draw in arms, even when they are concealed by the torso, will prevent your sketch from going off balance (page 71).

## 7 Create the rough drawing

Use different layers and colors here too to divide parts and make correction easier (page 71).

## 8 Draw in lines

Make an effort to draw lines in neatly. Taking particular care with the face and hair will improve the quality of your drawing.

## 9 Add color to complete the drawing!

Pay attention to light source, shadow and highlights in bringing your creation to life in full color.

# Muscle Diagrams

## Front view

- Trapezius
- Pectorals
- Latissimus dorsi
- Obliquus externus abdominis muscle
- Rectus abdominis muscle
- Gluteus maximus
- Mesogluteus
- Tensor facsciae latae

- Deltoid
- Biceps brachii
- Triceps brachii
- Radial flexor muscle
- Extensor digitorum muscle
- Brachioradial muscle
- Extensor carpi radialis longus
- Extensor carpi radialis brevis

- Abductor pollicis longus
- Abductor pollicis brevis
- Palmaris longus
- Musculus rectus femoris
- Sartorius
- Pectineus
- Adductor longus
- Gracilis muscle

- Medial great muscle
- Vastus lateralis
- Musculus gastrocnemius
- Musculus soleus
- Extensor digitorum longus muscle
- Tibialis anterior muscle
- Musculus fibularis brevis
- Other muscles
- Bone

■ Detailed structure

■ Parts used in a sketch

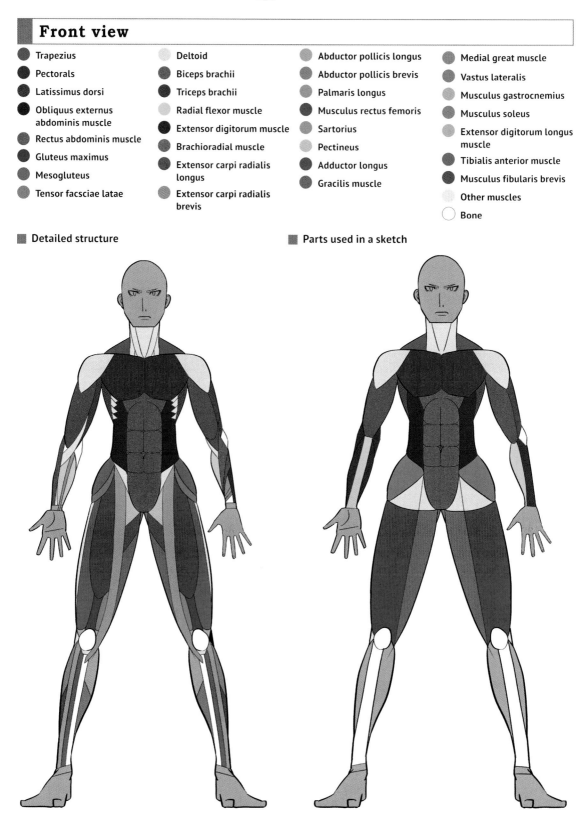

# Rear view

- Trapezius
- Latissimus dorsi
- Obliquus externus abdominis muscle
- Gluteus maximus
- Mesogluteus
- Tensor facsciae latae

- Deltoid
- Biceps brachii
- Triceps brachii
- Brachioradial muscle
- Extensor carpi radialis longus
- Extensor carpi radialis brevis

- Abductor pollicis longus
- Extensor digitorum muscle
- Musculus extensor carpi ulnaris
- Musculus flexor carpi ulnaris
- Adductor longus
- Hamstrings

- Vastus lateralis
- Musculus gastrocnemius
- Musculus soleus
- Other muscles
- Bone

■ Detailed structure

■ Parts used in a sketch

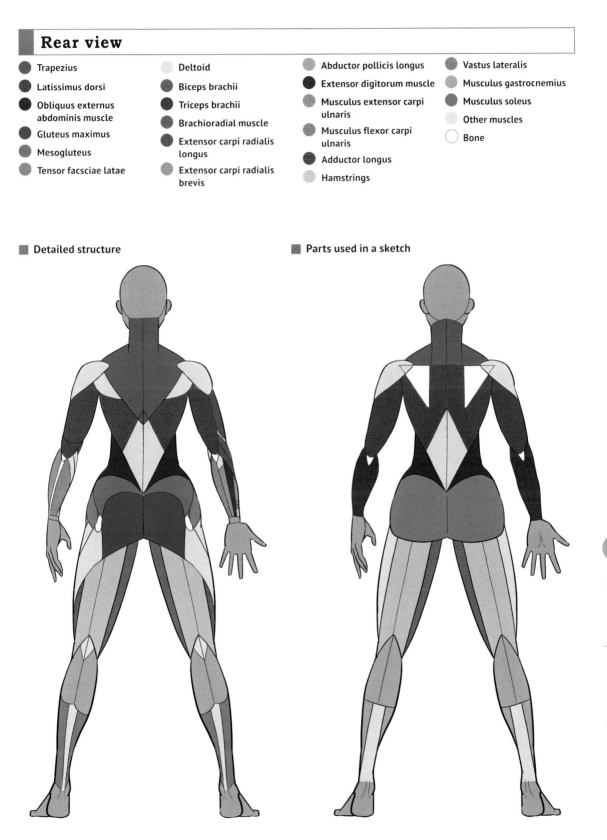

# Side view

- Trapezius
- Pectorals
- Latissimus dorsi
- Obliquus externus abdominis muscle
- Rectus abdominis muscle
- Gluteus maximus
- Mesogluteus
- Tensor facsciae latae

- Deltoid
- Biceps brachii
- Triceps brachii
- Brachioradial muscle
- Extensor carpi radialis longus
- Extensor digitorum muscle
- Musculus extensor carpi ulnaris
- Musculus flexor carpi ulnaris

- Musculus rectus femoris
- Sartorius
- Adductor longus
- Gracilis muscle
- Medial great muscle
- Vastus lateralis
- Hamstrings
- Musculus gastrocnemius

- Musculus soleus
- Extensor digitorum longus muscle
- Tibialis anterior muscle
- Musculus fibularis brevis
- Other muscles
- Bone

## Detailed structure

## Parts used in a sketch

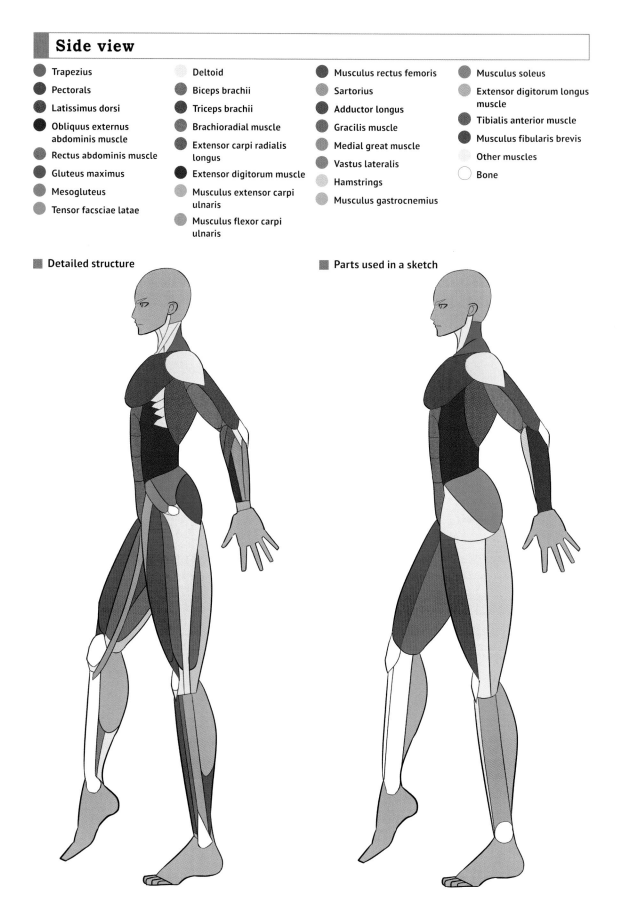

172

# Drawing a Muscular Figure

Generally speaking, the muscles of the arms, legs and stomach are frequently in use and the easiest to develop.

## Before training

## After training

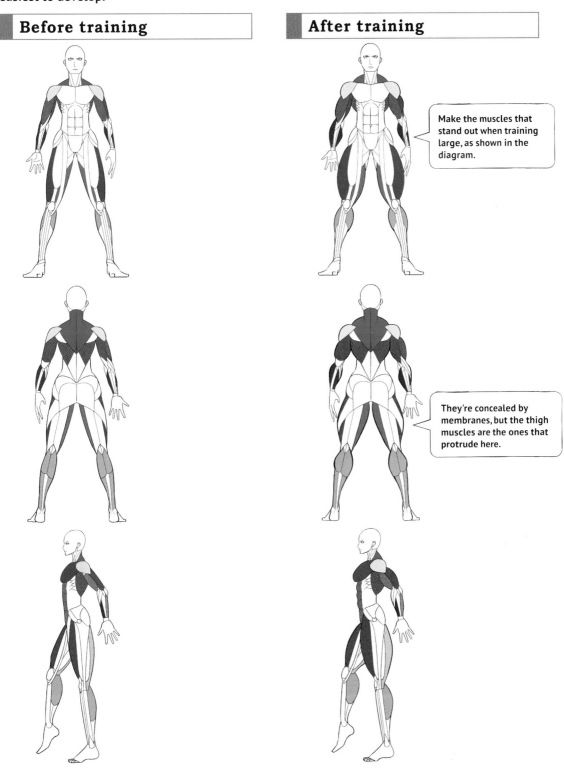

Make the muscles that stand out when training large, as shown in the diagram.

They're concealed by membranes, but the thigh muscles are the ones that protrude here.

# Contrapposto and the Letter K Principle

## Contrapposto

Contrapposto is the term used to describe the shoulder joints and hip joints being on contrasting angles with each other. Incorporating this into your work will bring dynamism to the figure and create a more naturalistic pose.

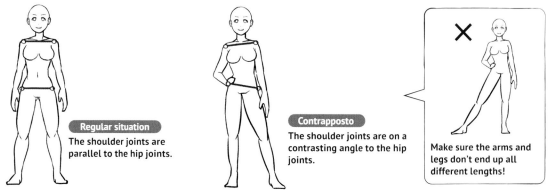

**Regular situation**
The shoulder joints are parallel to the hip joints.

**Contrapposto**
The shoulder joints are on a contrasting angle to the hip joints.

✕

Make sure the arms and legs don't end up all different lengths!

## The letter K principle

When one side of the chest is stretched, the other side curves into a ＜ shape. Combining the straight line and the ＜ shape creates the letter K, so in this book, this is referred to as the Letter K principle. Creating a pose with this principle in mind makes for a more naturalistic body line.

The left is straight, the right is shaped like the Japanese letter ＜.

＜ → **K**

It looks like the letter K!

It's the same from the side and from behind.

## Examples of contrapposto and the letter K principle

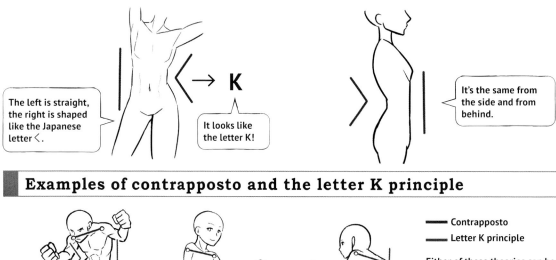

—— Contrapposto

—— Letter K principle

Either of these theories can be used in various poses!

# Index

Published by Tuttle Publishing, an imprint of Periplus Editions (HK) Ltd.

**www.tuttlepublishing.com**

Digital Illust no Shintai Kakikata Jiten
Copyright © 2016 Matsu (A•TYPEcorp.)
English translation rights arranged with
SB Creative through Japan UNI Agency, Inc., Tokyo

Library of Congress Cataloging-in-Publication Data in process

ISBN 978-4-8053-1561-3

English Translation ©2020 Periplus Editions (HK) Ltd

Distributed by
*North America, Latin America & Europe*
Tuttle Publishing
364 Innovation Drive
North Clarendon, VT 05759-9436 U.S.A.
Tel: 1 (802) 773-8930; Fax: 1 (802) 773-6993
info@tuttlepublishing.com
www.tuttlepublishing.com

*Japan*
Tuttle Publishing
Yaekari Building, 3rd Floor
5-4-12 Osaki
Shinagawa-ku
Tokyo 141 0032
Tel: (81) 3 5437-0171; Fax: (81) 3 5437-0755
sales@tuttle.co.jp
www.tuttle.co.jp

*Asia Pacific*
Berkeley Books Pte. Ltd.
3 Kallang Sector, #04-01
Singapore 349278
Tel: (65) 6741-2178; Fax: (65) 6741-2179
inquiries@periplus.com.sg
www.tuttlepublishing.com

23 22 21 20    10 9 8 7 6 5 4 3 2

Printed in Malaysia        2012VP

TUTTLE PUBLISHING® is a registered trademark of Tuttle Publishing, a division of Periplus Editions (HK) Ltd.

## Books to Span the East and West

Our core mission at Tuttle Publishing is to create books which bring people together one page at a time. Tuttle was founded in 1832 in the small New England town of Rutland, Vermont (USA). Our fundamental values remain as strong today as they were then—to publish best-in-class books informing the English-speaking world about the countries and peoples of Asia. The world is a smaller place today and Asia's economic, cultural and political influence has expanded, yet the need for meaningful dialogue and information about this diverse region has never been greater. Since 1948, Tuttle has been a leader in publishing books on the cultures, arts, cuisines, languages and literatures of Asia. Our authors and photographers have won many awards and Tuttle has published thousands of titles on subjects ranging from martial arts to paper crafts. We welcome you to explore the wealth of information available on Asia at **www.tuttlepublishing.com**.